Here you'll find a collection of love letters from 101 Black women to their hair, to other Black women and girls, and to themselves. In powerful and illuminating interviews, these women talk about their relationships to their natural hair—their experiences with the big chop, learning to care for and style their hair, struggling with society's expectations, and their journeys to self-acceptance.

With insightful interviews and photographs that highlight the beauty and joy of natural hair, *My Beautiful Black Hair* shows us that as we come together and share our stories, we can begin to overcome doubt, fear, and systemic oppression to find liberation, community, and love.

In a world that tells Black women they are never enough, *My Beautiful Black Hair* declares the opposite: We are all beautiful beings full of love and light. Our hair is an extension of our beauty, and the women featured in this book showcase the many ways that natural hair can be exquisite, lovely, and powerful.

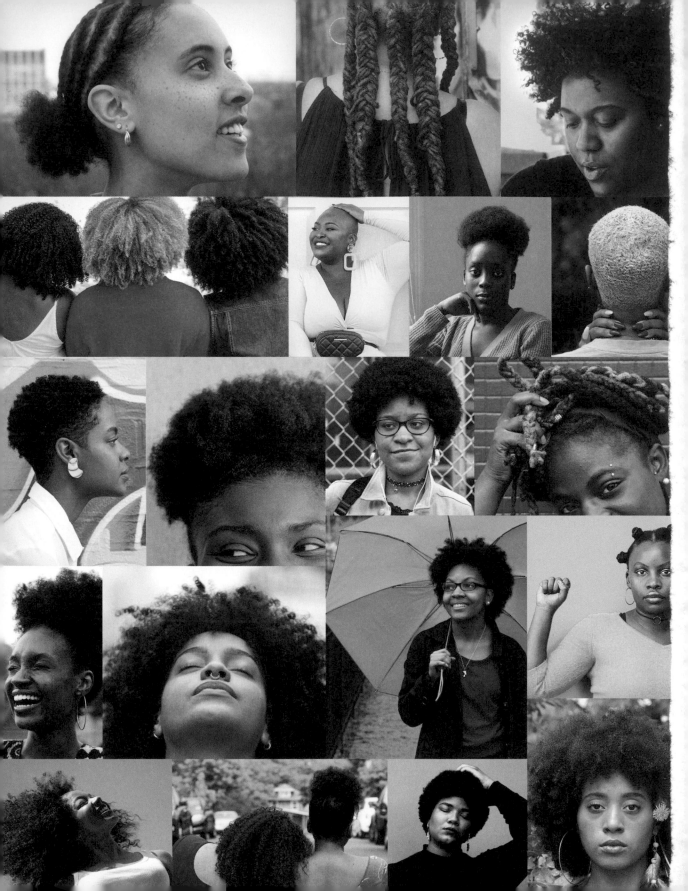

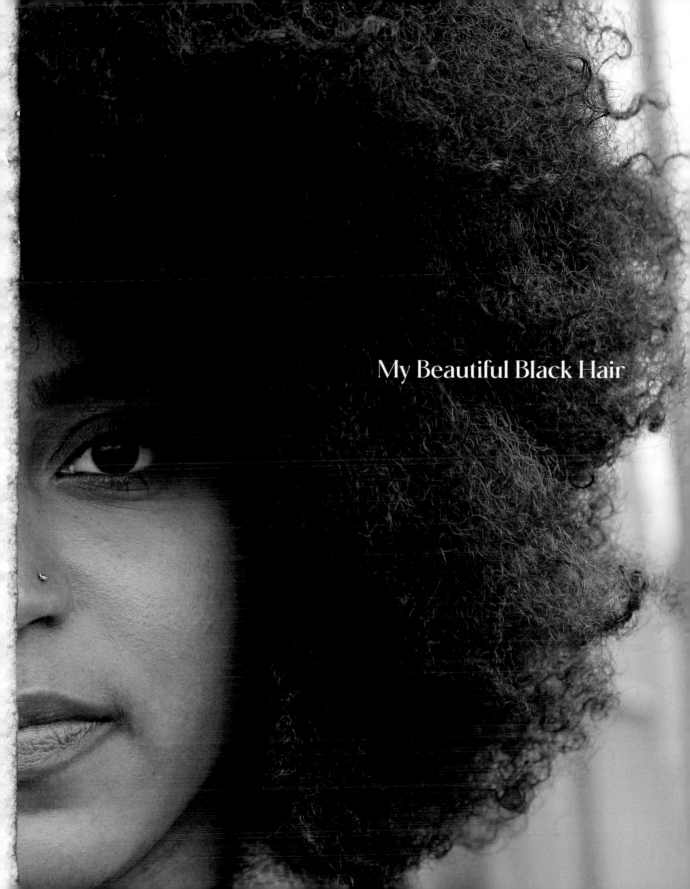

My Beautiful Black Hair

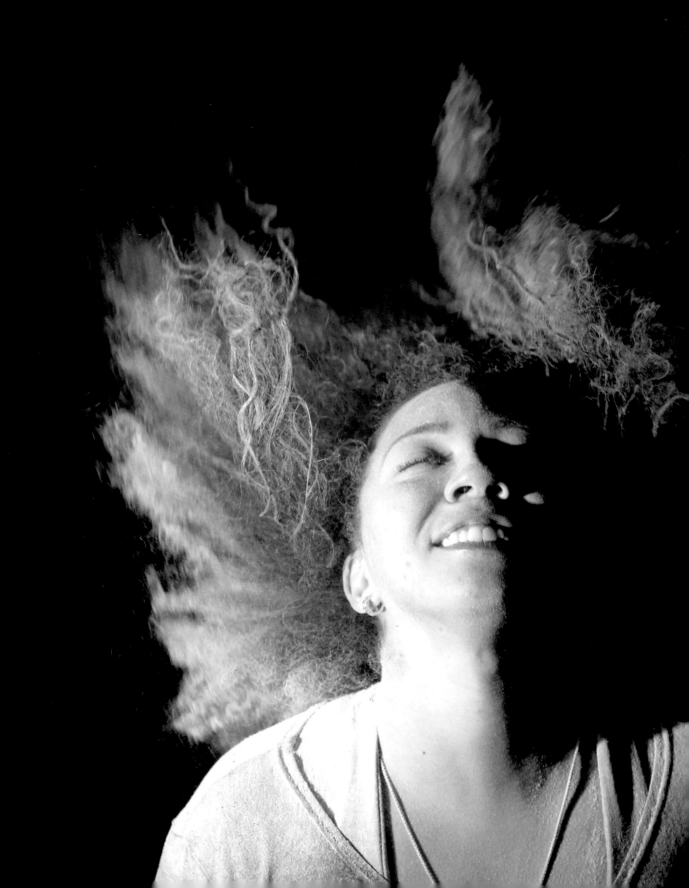

St. Clair Detrick-Jules

Foreword by
Alexandra Elle

My Beautiful Black Hair: 101 Natural Hair Stories from the Sisterhood

CHRONICLE BOOKS
SAN FRANCISCO

Library of Congress Cataloging-in-Publication Data

Names: Detrick-Jules, St. Clair, author.
Title: My beautiful black hair : 101 natural hair stories from the
 sisterhood / St. Clair Detrick-Jules.
Other titles: 101 natural hair stories from the sisterhood
Description: San Francisco : Chronicle Books, [2021]
Identifiers: LCCN 2021002862 | ISBN 9781797212197 (hardcover) | ISBN
 9781797212203 (ebook)
Subjects: LCSH: Hairstyles--Psychological aspects--Anecdotes. |
 African-American women--Portraits. | African-American women--Interviews.
 | Hairdressing of Blacks--Social aspects--Anecdotes. | Women,
 Black--Psychology--Anecdotes. | Self-acceptance in women--
Anecdotes.
Classification: LCC TT972 .D488 2021 | DDC 646.7/2408996073--dc23
LC record available at https://lccn.loc.gov/2021002862

Manufactured in China.

Design by Vanessa Dina.

Typesetting by AJ Hansen. Typeset in Atlas Grotesk and Moneta.

Kanekalon is a registered trademark of Kaneka Corporation.

Some of the interviews that appear in this book have been edited slightly for
clarity and space.

10 9 8 7 6 5 4 3 2 1

Chronicle books and gifts are available at special quantity
discounts to corporations, professional associations, literacy
programs, and other organizations. For details and discount
information, please contact our premiums department at
corporatesales@chroniclebooks.com or at 1-800-759-0190.

Chronicle Books LLC
680 Second Street
San Francisco, California 94107
www.chroniclebooks.com

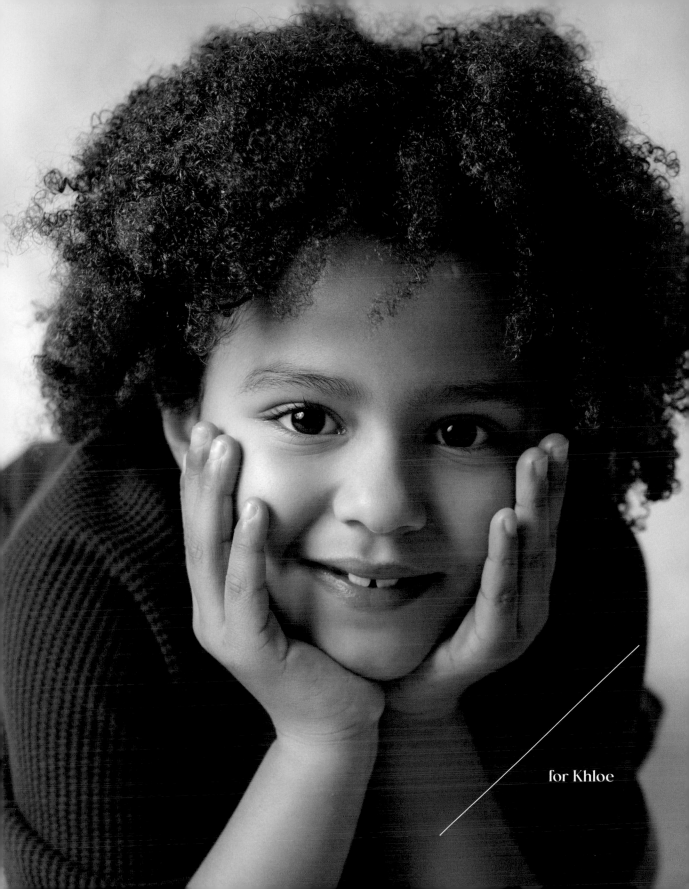

for Khloe

Foreword 10 A Brief History of Our Hair Story 12 Introduction 16 *Letter from St. Clair 23*
Alexandra Elle Dr. Afiya M. Mbilishaka

"The Big Chop" / Going Natural 24

Attayah Douglas 27 / Christine Pembroke 28 / Dina Harry, Danisha Almonte Luciano, and Catherine Lantigua 30 /
Alexis Taylor 35 / *Letter from Dzifa 36* / Lattesha Webb 39 / Carmaya Humble 40 / Lissette De Jesus 43 /
Pharice Brown 44 / Ebony Farmer-Mangum 46 / *Letter from Dajae 49* / Giovanna Harris 50 /
Hassiet Asberom 53

Embracing Blackness 54

Keyla Ynoa 57 / Angie Shepherd 58 / Francesca Polanco 60 / *Letter from Hassiet 62* /
Elise Bryant 65 / Asha Hadiya 67 / Alexis Vazquez 68 / Perla Montas 71 / Phylicia A. Cotton 72 /
Letter from Danyeli 75 / Briana Walker 77 / Michele Edwards 78 / Kendra Woolridge 81 /
Albamarina Nahar 82

Hair as Identity 84

Brigid Carmichael 87 / Elana Nelson 88 / Dajae Scott 91 / Kennedy Jennings 92 /
Letter from Albamarina 94 / Maia Smith 97 / Danyeli Rodriguez Del Orbe 98 / Tiffany Warner 101 /
Micailah Guthrie 102 / Bethann Mwombela 104 / *Letter from Asha 107* / Nin Maluka Jackson 109 /
Verica Williams 110 / Nadia Harper 113

Self-Love / Self-Discovery 114

Mariame Fofana 117 / *Letter from Elise 119* / Maya Garnett 120 / Josie Jackson 123 / Zahra Ahmed 124 /
Sara Prendergast 127 / Krishaun Smith 128 / Dai Parker 131 / Analee Jimenez 133 / Imahia Stanford 134 /
Patricia Albert 137 / *Letter from Ellin 138* / Celai West 141

Sisterhood 142

Rebecca and Laura Funderburk *145* / Avant Griffith and Afra M. Abdullah *146* / Ellin Phiri *148* /
Letter from Dajah 151 / Tia Johnson *153* / Leeann Jimenez *154* / Lesly Afranie and Maya Finoh *158* /
Jasmine Perez *159* / Maya Fleming *161* / *Letter from Malika 162* / Kayla White *166* /
Alexis Palmer *167* / Germania Martinez and Emani Hill *168*

Mothers and Daughters 170

Karyn-Siobhan Robinson and Siobhan Robinson-Marshall *174* / Sihnuu Hetep and Yazi Berg *177* /
Letter from Nin 181 / Briana Velazquez *182* / Rashida Holt *185* / Michelle Mutisya *186* /
Sabrina and Naomi Prather *190* / Alena Blaise, Amanda Barclay, and Kilala Vincent *192* /
Sally Ventura *194* / Johanna Figueroa *197* / *Letter from Michele 198* / Breanna Brummett-Swayze *200* /
Kaelyn Stewart, Ruth Benson, and Rochelle Rice *202*

White Spaces 204

Nimesha Gerlus *207* / Dzifa J. Avalime *208* / Kamarah Noel *210* / Helga Yarí Paris-Morales *213* /
Malika Benton *215* / Ebony Walters *216* / *Letter from Maya 219* / Ashley Nicholson *220* / Dajah Massey *223* /
Letter from Rosa 224 / De'Nea Barton *227* / Christie Hoyte Hayes *228*

Liberation 230

Adeola Adebamowo *232* / Candy Schibli *235* / Brandi Clarke *236* / Hannah M. Childress *238* /
Adam Mbai *240* / Sage Sarai *243* / Zoey Needham *245* / Ebony Sturdivant *246* / Bianca Martinez *248* /
Rosa Baez *251* / *Letter from Keyla 253*

Thanks *255*

"We have a wounded history. But without that wounded history, we wouldn't have our resilience."

KEYLA YNOA

FOREWORD

My nana would sit me between her legs, big yellow comb in hand, a glob of grease nearby in the jar's plastic cap, ready to part and plait. I had the thickest mane and the most tender scalp—getting my hair done was a chore for everyone involved. But she managed to wrangle my cottony coils into near-perfect braids that would hang long and kiss my shoulders. Sometimes, she even put beads on the ends for me to shake and twirl. Hair days were a ritual for years with my grandmother, filled with intention and care. I can remember every product smell, every comb and brush sensation, and the feeling of her hands making magic appear right before my eyes. Then one day, I grew up, and my relationship with my hair changed. I hated it. It wasn't loose enough, or long enough, or straight enough, or anything else enough. I asked for my first relaxer at age ten, and that became my ritual. Every eight weeks, my mom would touch up my new growth. My scalp would burn and itch as she smoothed the creamy, smelly chemicals through my hair until it was time to rinse. I ruined my hair in-between with heat, bad hair cuts, weaves, too tight braids, and sun-in (with hopes of having blonde highlights that never showed up). It took me years to realize that I was enough, and so was my hair.

When I was twenty, I went natural and stayed natural. The rituals I had with my grandmother slowly started to resurface, but this time, it was up to me to proudly part, grease, plait, and take care of what I'd run from for so long. Unlearning the myth that black hair is bad or ugly unless it looks a certain way and relearning that "good hair" is the healthy hair that grows out of my scalp reshaped how I looked at myself. Embracing my texture and dedicating the time to learn how to care for my strands taught me that true love has to start with self, even if those around you don't understand.

What a gift St. Clair has given us all by capturing black hair's authenticity and beauty and the stories that live within us. What a treasure Khloe will have, seeing that her crown is to be worn proudly and without shame or settling. Every kink, curl, wave, and coil is sacredly placed atop our heads—this book captures that perfectly. This message and visual storytelling is something my younger self needed. There is no greater feeling than offering the gift of self-acceptance to those around us by simply leading by example. *My Beautiful Black Hair* is a divine example of courage, self-love, acceptance, and diversity. It's a stunning collection that everyone needs to sit with, explore, and share with the little black girl in their life. The images and stories in this book represent and embody sisterhood to the fullest. Lean in and be ready to see yourself in some way, shape, or form.

ALEXANDRA ELLE,
author of *After the Rain*

A BRIEF HISTORY OF OUR HAIR STORY

Dr. Afiya M. Mbilishaka
Clinical Psychologist, Natural Hairstylist, and Author of *PsychoHairapy*

To fully appreciate the psycho-emotional scope of a book on Black women loving themselves and their natural hair, it must be understood through a culturally—and historically informed—lens. The story of Black women and their natural hair begins where everything begins: in Africa. In traditional African societies, hair acted as a powerful social signifier, communicating essential identity information to the social and spiritual world, including—but certainly not limited to—age, religion, wealth, education, ethnic group, and marital status. Hair was critical in rituals that prepared women to transition between stages of their physical and emotional development, such as the arc of their reproductive age, marriage, childbirth, spiritual initiation, and death. In many parts of Africa, the person responsible for "doing" hair was given special prominence; these were artisans entrusted with creating identity, and many hairstyles took days to achieve. These were indeed African crowns.

This was lost in the Americas, where the enslaved people were not permitted to properly groom themselves. As the years of slavery gave way to decades and then centuries, another critical problem arose: Given the legalized systemic rape of Black women and girls by white men—both slaveholders and others—

hair-based caste systems emerged within the plantation context. Black women with straight or loosely curled hair were categorized as more feminine and tasked with house duties, while those with tightly coiled hair were relegated to labor alongside men in the fields. While systemic rape was legal, what became illegal in many parts of the South was natural Black hair in public spaces. These same anti-Black hair attitudes, backed by the legal system, remain in place today, with schools across the country denying Black girls (and sometimes boys) the right to wear their natural hair at school, labeling it "against school dress codes." And in 2018, the Supreme Court refused to hear an appeal in the case of Chastity Jones, a young Black woman whose job offer was rescinded because she wears her hair in locs; a manager told her, "They tend to get messy." Employment opportunities, educational opportunities, romantic relationships, and even relationships within Black families—all are affected by the coil of Black hair. Straightened hair continues to be valued over tightly coiled hair, and we're clearly in need of a paradigm shift to decolonize one of our most sacred spaces: our crowns.

The good news is that Black women have shaped an antidiscrimation narrative into the CROWN Act, the first legislation in this country's history to make it illegal for schools and employers to discriminate against Black people's natural hair and hairstyles. It first passed in California in 2019, was signed into law in 2020, and is now making its way across the country. Into this ongoing natural hair revolution steps *My Beautiful Black Hair*, a visual tour-de-force celebration of the joyousness of Black women wholeheartedly embracing what was given by nature and blessed by the gods: their natural hair.

The self-discovery of beauty within the lives of Black women with natural hair is critical in restoring balance, order, and justice to our communities. This very book, and the visual narratives collected in it, aims to disrupt the centuries of conditioning that teach us natural hair—and, in particular, tightly coiled hair—is ugly or unattractive. As we know, the truth is often quite simple, and right in front of us. The truth of *My Beautiful Black Hair* is that natural hair is not ugly or messy or hard to manage; natural hair—and the confidence that a Black woman has around her hair—empowers both herself and generations to come.

As a practitioner of psychohairapy, I see the images and stories in this book as case studies for the process of embracing hair as it grows out of the scalp in its most natural form. These women—and children—speak of liberation, of self-love, of celebration. Research scientists and therapists have begun including hair as a social and psychological variable in the lives of Black women, something I explore in my book *PsychoHairapy*, which utilizes hair as an entry point into mental health. The intention of the book is perhaps the same as that of *My Beautiful Black Hair*: to facilitate informed, intentional conversations on the psychological significance of hair.

The women featured in this book have undergone a psychological process of jumping into the deep end of their consciousness to explore their self-identity and affirm their own African aesthetic, an aesthetic that has been demonized since their ancestors' first contact with colonizers and enslavers. They have emerged from this internal process and now exude confidence, racial pride, and self-love. This book is therapeutic to not only the participants but also the reader, who gains an additional layer of defense against systems that attempt to deny their beauty and humanity, and it offers all readers affirmations in the healing power of knowing your true self-worth, from the crown down.

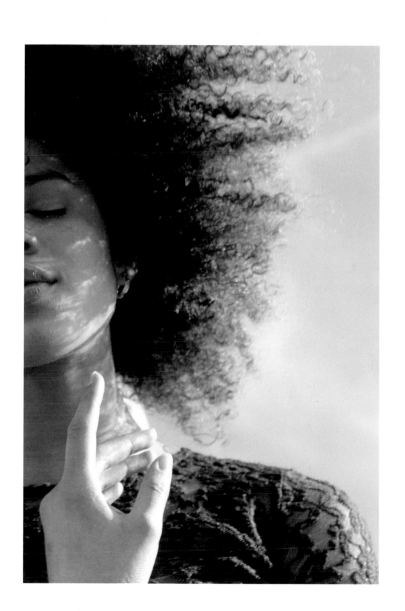

INTRODUCTION

There is something radical about loving your hair in a world that tells you not to; it shows an incredible amount of strength and self-love. But I was not always radical.

I was in third grade when I learned that flat irons existed. Sitting in my friend's basement apartment in Washington, DC, I watched as her mom ran the hot, clamp-like jaws through my friend's wavy hair. The steam escaped out the sides as her waves disappeared, becoming pin straight. That night, I asked my mom, "Why didn't you ever tell me I could straighten my hair?" And at the time, I didn't understand her answer, which was something about "Blackness" and "being proud."

For the next twelve years, I straightened my hair for every formal event. The night before my high school's senior portrait day, I was horrified when my mom announced that she was going out and wouldn't be able to straighten my hair for me. I stood in front of my bathroom mirror for hours, burning my ears and the back of my neck, trying to flatten away all traces of Blackness from my hair. And then there were times when the fate of my hair couldn't be left up to the whims of my mom's social life: The day of my prom, I left school early to visit the professional hairdresser at our local hair salon—and I walked out feeling burned yet beautiful.

It's hard to pinpoint exactly when in my life I was no longer ashamed of my curls, but I can pinpoint moments. There was the time I arrived at Brown University and was all of a sudden surrounded by a group of talented, beautiful Black women embracing their natural hair and I started seeing

beauty as something that could exist within a Black body—including mine. There was the time I went back to my local hair salon for a haircut after spending a semester in Ecuador and I politely rejected my local hairdresser's kind offer to straighten my hair for free after cutting it. And then there was the extended six-month period when I interviewed and photographed one hundred Black women about their natural hair stories and felt, with each new story I was hearing, that I was born with the hair I was meant to have.

It was my little sister Khloe who inspired me to conduct these interviews, take these photos, and create this book, *My Beautiful Black Hair*. A little bit of background: Khloe is my sister on my father's side. We grew up in different worlds—time, place, language, mothers, and fathers (there's no doubt my dad has changed and grown since he had me at just twenty-two years old). I grew up in Washington, DC, in the United States. Khloe lives in the south of France with our dad, her mom (my stepmom), and our two other siblings, Kenzo and Zoe.

When Khloe was four, classmates at her majority white school told her that her hair was ugly—*and she believed it*. I'd been hoping the day would never come when she'd look in the mirror and find fault with her hair, and I always made it a point to tell her how beautiful her hair is. But still, when our dad called me and told me she was "having problems" with her hair and didn't want to go back to school, I wasn't surprised. A pain, sharp and familiar, clutched me; I was reminded of the years I spent at a predominantly white elementary school—similar to my sister's current school, with classmates similar to her white classmates. They made comments about my hair—just like her classmates make comments about her hair now too.

My dad's phone call reminded me of all the times I looked in the mirror and wished the face looking back at me was framed by straight, silky hair. The thought of my determined, smart, lovely four-year-old sister, who'd barely even begun her life, sitting at home, crying, because some classmates made her think her hair was ugly, made *me* want to cry. *How does this all start so young*, I thought, *and why does it have to?* I can guess—and I have spent a lot of time guessing—about the complexities of exactly why so many young Black girls don't like their hair and, also, why white girls as young as three and four see

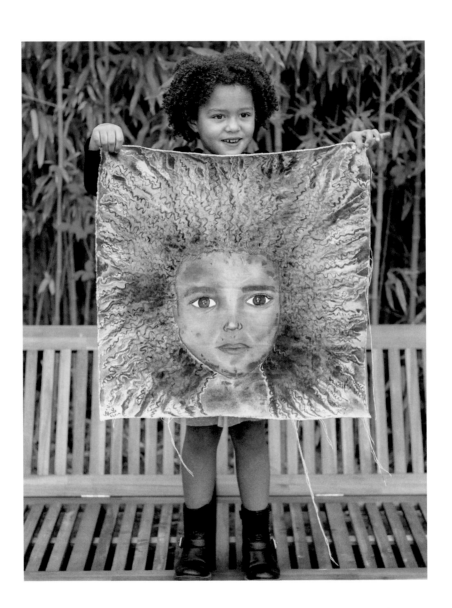

Black hair as ugly, and feel comfortable telling Black girls how they feel about their hair. *Same old cycle of the supremacy of whiteness*, I thought, a cycle that would harm Khloe's view of herself and her Blackness probably up until she too went off to college.

I was determined to break that cycle for Khloe. And not just for my little sister, but for all sisters of the Black diaspora. After giving myself time to process this news about my sister, I decided to take action. Because while we have a right to be angry about global anti-Blackness and misogyny, we also have a right to be joyful and proud and self-loving, and I wanted my sister—and all Black women who were once in Khloe's shoes—to exercise that right. Starting now.

I turned to my sisters—Black women I had grown up with, gone to college with, met through friends, and admired from afar—and they rose to the occasion. What began as a small project to help Khloe turned into a two-year-long, multicity endeavor to capture the beauty, resilience, and joy of 101 Black women with natural hair. As a self-declared introvert with a fear of rejection, I started by recruiting my friends—women I'd known for years—to participate. I left every session with a profound sense of gratitude for being trusted with another woman's natural hair story. And the more stories I heard, the more stories I wanted to share through this project. I found the courage to reach out to strangers—often through Instagram using the #naturalhair hashtag—and ask them to help me with this work. Although they had no connection to my sister, their responses were humbling:

"I'd LOVE to!"

"I would be honored to hold a space in that beautiful book."

"I would love to be a part of your photography book for your little sister!"

"I normally have an hourly rate for modeling, but I think this is such a sweet idea that I just want to be a part of it." [a professional model I reached out to]

And the more Black women trusted me with their natural hair stories—the more they shared vulnerable pieces of their lives with me, telling me about how standing at the intersection of Blackness and womanhood has impacted them—the more I felt a duty to honor their stories and the more passionate I became about this book. There are 101 Black women and girls with natural hair featured in this book, and therefore 101 unique narratives, ideas, and perspectives. These women's stories, which are transcribed from my interviews, delve into topics ranging from personal anecdotes about hair-based discrimination in school and the workplace to discussions about the politicization of the afro and its relationship to the Black Lives Matter movement.

Each woman's narrative is accompanied by a photo—or photos—of her from our photo shoot. The photos are, for the most part, candid; they do not represent a glammed-up version of Black womanhood, but rather the truth of who we are: students, teachers, artists, activists, engineers, doctors, mothers, daughters, and sisters. I like to think of both the interviews and photos presented in this book as being unapologetic and holding truth. I tried to capture not only the beauty of these women, but also their strength and resilience. I hope Khloe sees herself reflected in them. I hope she comes away from it with greater insight into who she is, where she comes from, and where she fits into the diaspora. My hope is the same for every Black woman who comes across this book who remembers being in Khloe's shoes.

To be clear, this book is meant to empower all Black women. It is not meant to exclude Black women who manipulate their natural hair texture, and it is not meant to suggest that they love themselves—and their Blackness—any less than Black women who embrace their natural hair texture. Black women and girls risk losing financial stability, educational opportunities, social acceptance, and, in some cases, familial relationships when they wear their hair natural. So I stand with those women who haven't gone natural; I don't support anything that divides us or has us pointing fingers at one another. What I do want to emphasize, though, is that natural hair is to be celebrated, loved, and honored. Our hair should not be a source of shame, but rather a source of joy.

And this book is full of joy: the joy of Black women loving their natural hair, embracing their Blackness, and embracing self-love. It's been a joy to work on this project and to collaborate with 101 Black women, all of whom are full of love and light. I hope that everyone who opens this book finds in these pages some of that joy.

This joy comes in spite of the pain—and there's plenty of pain. Within these pages lie stories of years of struggles, of perms and flat irons, of self-hatred and doubt. Yet within these pages also lies joy; despite the pain, all the women in this book have overcome societal standards of beauty and have emerged victorious—natural hair and all. I hope I do their stories justice. I hope these women's insightful narratives lead us to engage in deeper, nuanced conversations about hair, about beauty standards, about gender, about race, and about identity. I hope everyone who reads this book comes away with an even stronger sense of self-love.

It's not just about hair. It's about how we choose to live our lives. If we take the words of wisdom that these women are offering Khloe into our own lives, then we feel—and become—indestructible.

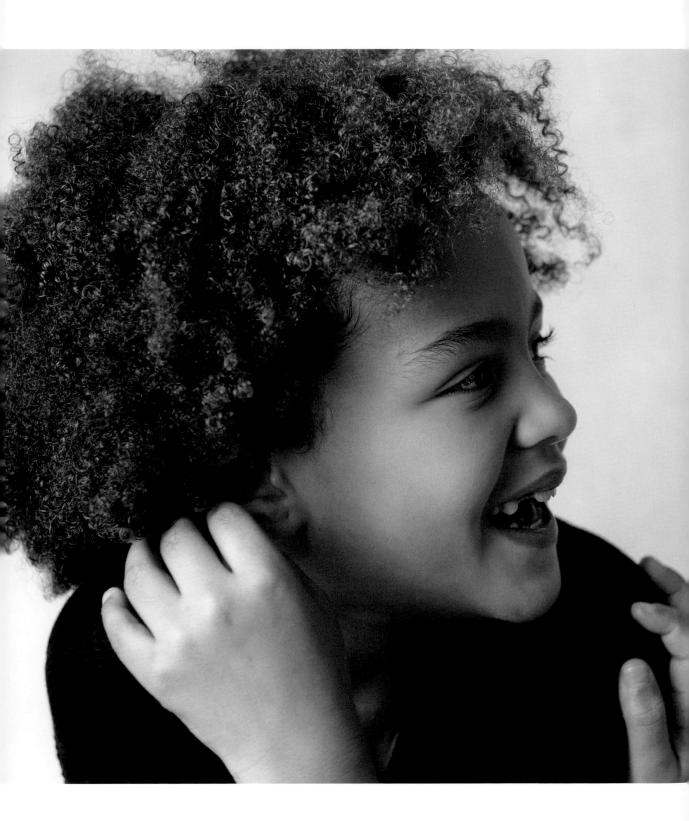

Dear **Khloe**,

My beautiful, powerful little sister.

When I was eighteen—a couple months before I started college—you burst into this world, a bundle of energy ready to take up space and radiate love. You are so full of life, Khloe, so it seems only fitting that your hair is equally alive. Your afro reaches for the sun, and the sun grazes its tips. When you run on the beach, tracing the outlines of recent waves, your hair becomes alive. It bounces and dances and sings. Your hair hugs your face, holds it tight, whispers in your ear to remind you that you are the descendant of Africans, of *Africa*. You and I have different white mothers, but we are connected by our Black father, by our Black ancestors, brought from Africa in chains to the Caribbean. The power, the strength, the eventual liberation of our ancestors live within us. I am grateful for our Blackness, because our Blackness makes us powerful, makes us sisters.

When Dad called to tell me you were ashamed of your afro, I became furious at the world for making you feel this way. Some people say that change must be gradual, that Black girls with natural hair must be patient as the media slowly but surely begins giving us a hint of representation here and there. But I don't believe in gradual change. So I took matters into my own hands. Because you matter, and you deserve to know—*today*—that your natural crown is beautiful.

So I want to lead by example. I want to teach you how to love yourself by loving myself, by introducing you to other Black women who love themselves. As Black women, we have to stop waiting for the world to love us, and we have to start loving ourselves, unconditionally.

Khloe, I want you to know that I love you unconditionally. **But more importantly, I want you to love yourself unconditionally.**

Your sister,
St. Clair

"The Big
Going

Chop"/
Natural

"You just have to take that leap of faith . . ."

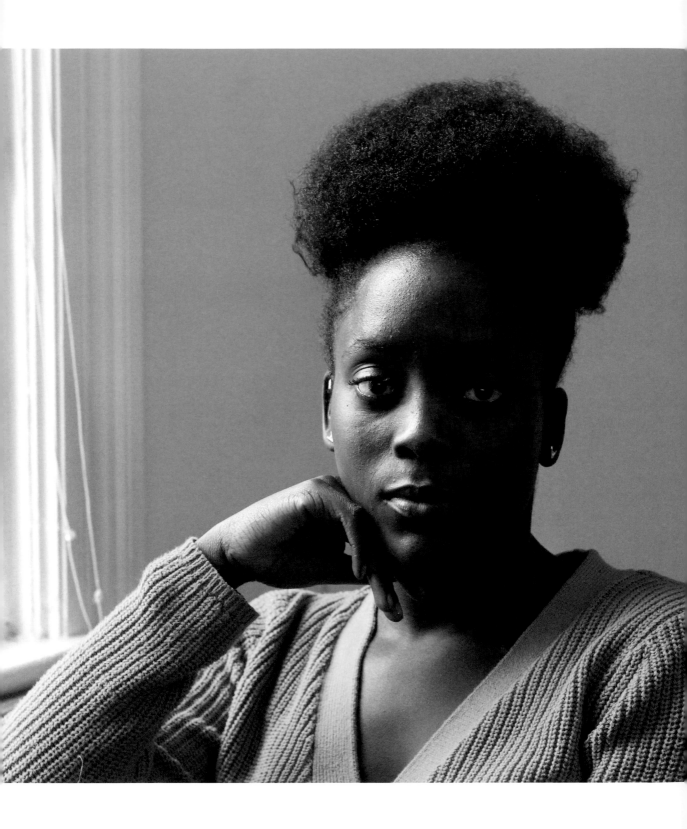

From age nine to fifteen, I had relaxed, chemically straightened hair. And then on October 16, 2010, after the natural hair movement really started budding, I went natural. I'd been transitioning for fifteen months, so I had fifteen months of new-hair growth, and then at the bottom I had the little stringy ends from the chemically straightened hair. So I cut all the straight pieces off and I had a little afro puff. And slowly but surely, I gained this reverence for what my hair actually was naturally and for who I was naturally; I kind of moved into my authentic self by embracing my natural hair texture. And not everyone in my family agreed with me at the time. Both of my sisters were relaxed, my mom was relaxed, and a lot of my cousins were relaxed. My grandma said to me, "Attayah, how are you gonna comb your hair? What are you gonna do with your hair?" So yeah, going natural was a process. But once the process started, I never looked back.

I think there are lots of conversations that natural hair brings up in terms of what it means to have natural hair, and what that means for exploring different kinds of hairstyles and different kinds of textures. I just think it's all about not rejecting how your hair naturally grows out of your head, and not labeling it as inferior or ugly, and not villainizing it in any way, shape, or form. I don't think it's supposed to reduce how creative you can be and how explorative you can be with your hair in terms of texture, length, color, volume— whatever. Because your hair is a work of art; **the artistry of who you are as a person just extends through your crown**. But do so with a reverence for how your hair naturally is. Don't do it in opposition to, in rejection of, or to distance yourself from your natural hair. I think that's what the natural hair movement is about.

ATTAYAH DOUGLAS

We've been so conditioned to think that our natural hair isn't "right," so I was super nervous about doing the big chop. But one day, I was waiting for my hairstylist to blow my hair out at the salon. I'd just come from under the sink, and I noticed my roots were thick and curly, and the ends were stringy, limp pieces of hair. When I realized that the thick bouncy hair was my new growth, and that the ends were what they were destined to be, I made up my mind to cut off the unhealthy parts **and let my true texture flourish**. Now I find that having natural hair helps me be more authentic.

CHRISTINE PEMBROKE

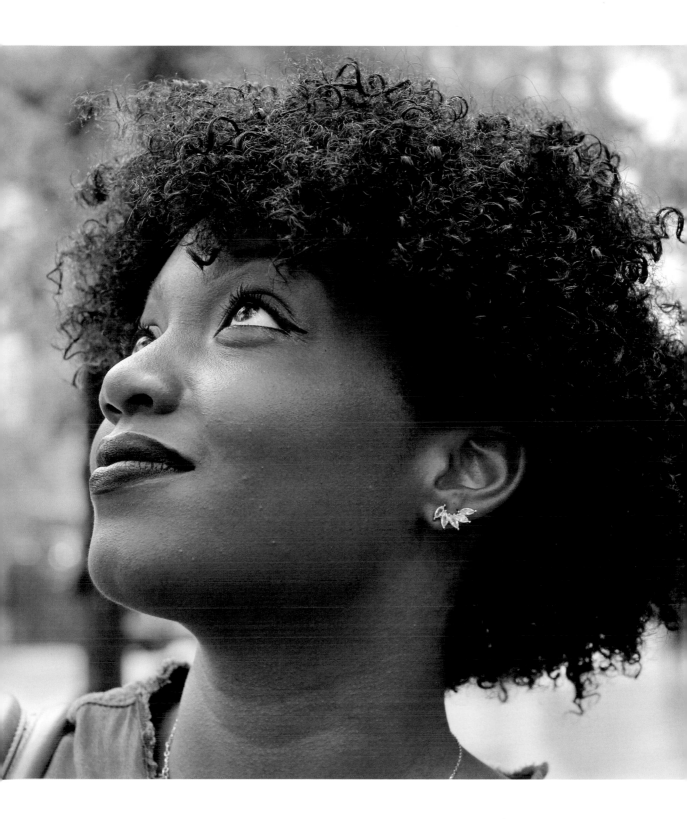

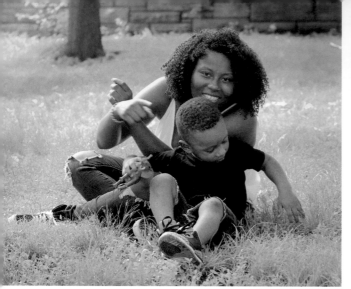

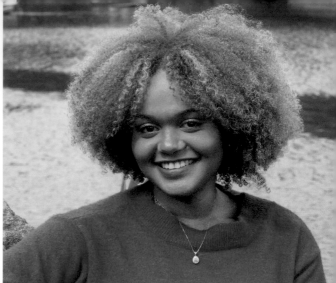

My mom started perming my hair when I was eight years old. But in 2011, I decided that I wanted to go natural; I wanted to see what my real, natural hair texture was. And when I first did the big chop in 2011, I felt like I looked so ugly. But now, seven years later, I feel like it's one of the best decisions I've made. **I love my natural hair, and I wouldn't have it any other way.** And after I went natural, almost everybody in my family went natural too. I started telling them, "This is how you do it. This is how you can care for your hair. This is what your hair needs." Everybody was like, "Oh, OK!" and they started doing it too. There's just a lack of education on how to care for natural hair.

DINA HARRY

My grandmother had gotten so tired of my natural hair when I was little that she just permed it. And for years, my hair was permed. Society pushed into my head the idea that straight hair was beautiful and that I looked better with straight hair. But eventually I started seeing other women with natural hair and noticing that more people were going natural. I saw how beautiful it was on them, and I wondered if *I* would look as good with *my* natural hair too. So I actually did the big chop on my birthday, and I transitioned for seven months. Half my hair was straight from the past perms, and the other half was natural. And now, **seeing how my hair bounces continues to validate my decision to go natural.**

DANISHA ALMONTE LUCIANO

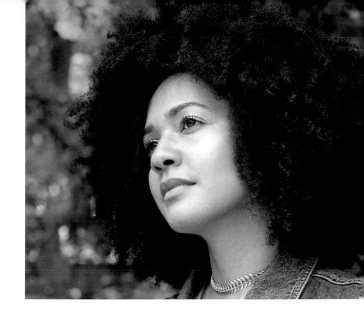

Whenever I go to see family members, they're like, "Oh, you still haven't straightened your hair?" And I'm like, "No, I'm not gonna do it. This is it. Forever. This is how I was born, and this is how it's gonna be." And to see them continuously labor over denying themselves—to the point where they don't go to the beach and they don't live life because they're afraid that their real hair will show—is just so sad, because they're just literally missing out. And I feel like choosing not to miss out anymore, and choosing to be as you are, is liberating. And choosing to be yourself in that environment is almost like a rebellious act, but it's not, really; you're just being who you are. And I hope that every Black girl knows that whatever beauty she sees in other people is already in her as well, and that **her hair is the representation of all of her ancestors and all of the beautiful people that came before her**, and it's something she should be very proud of.

CATHERINE LANTIGUA

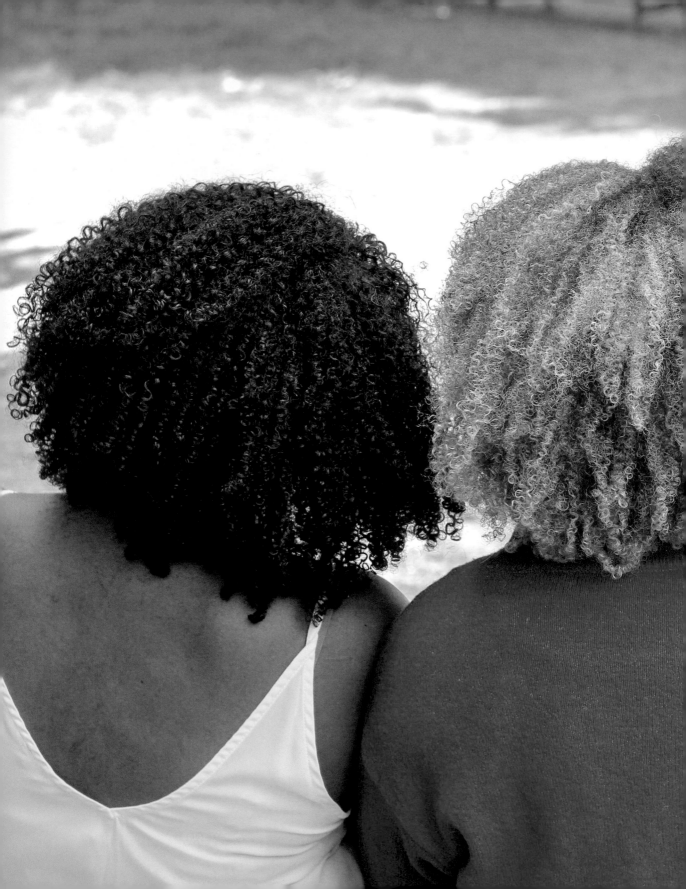

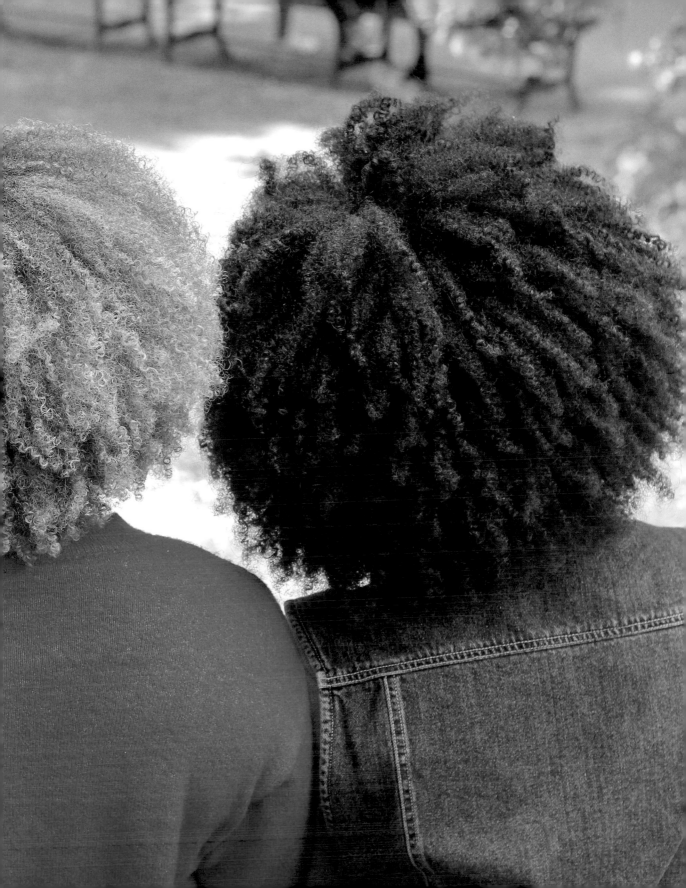

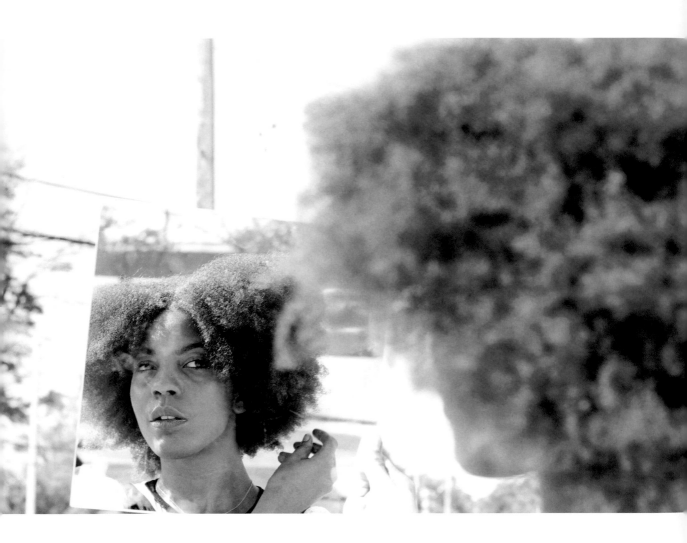

My aunt was a beautician, and she kept my hair perfectly permed and pressed all the time when I was younger. After we moved away from her, I stopped getting perms, but I was still consistently putting heat on my hair. I'm in college now, and I'm always on campus—including during the breaks—because I play basketball. So my sophomore year, all my suitemates were gone during winter break, and I was in the suite by myself. I got bored one day and decided to cut off all my heat-damaged hair. I got really into my natural hair after that. And it's taught me patience, because **having natural hair is like planting a flower**: You can't just plant the flower and expect it to grow and stay healthy on its own. You have to water it and nurture it. And as it blossoms, the love and care that you put into it can be seen from all around, because it's overflowing with the radiance of that love and care.

ALEXIS TAYLOR

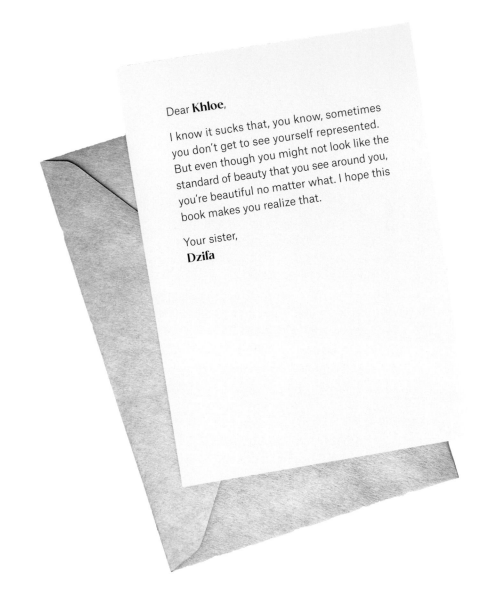

Dear **Khloe**,

I know it sucks that, you know, sometimes you don't get to see yourself represented. But even though you might not look like the standard of beauty that you see around you, you're beautiful no matter what. I hope this book makes you realize that.

Your sister,
Dzifa

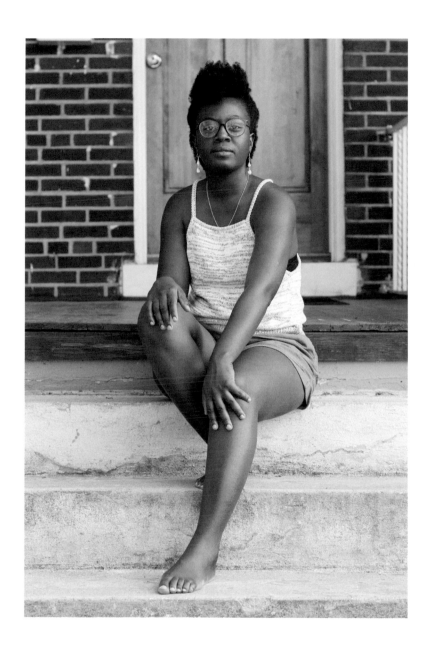

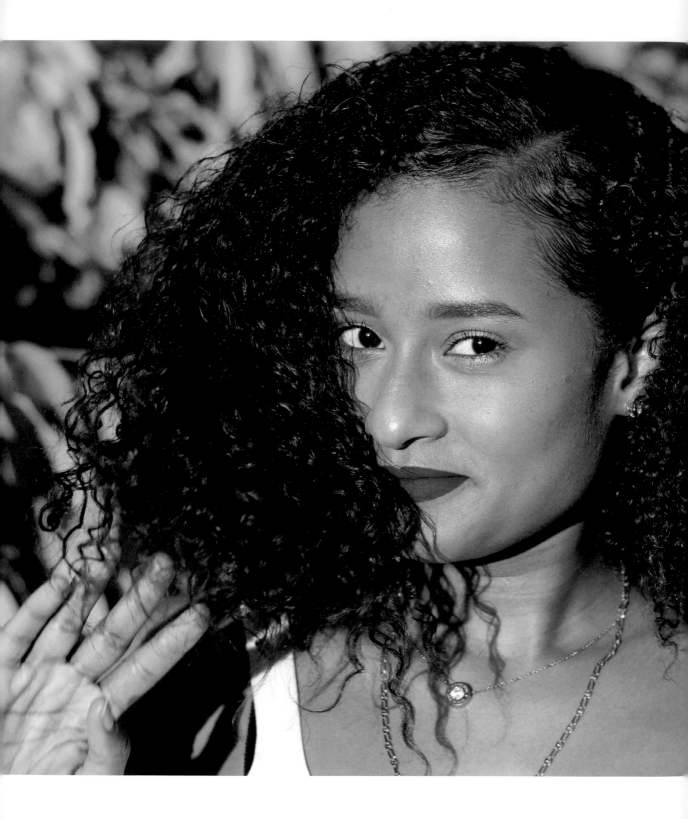

It was a love-hate relationship at first. I'd gotten perms until the middle of high school, and then I cut out my permed hair and just started wearing it natural. Some days I would love the way my curls came out, and then other days I just wanted to straighten my hair. But you gotta stick with it to make sure your hair's healthy. And in the past three years, I've gotten obsessed with healthy hair. The healthier your hair is, the curlier it's gonna be, and the 'fro is gonna look great. And now I love my hair. If I have a daughter, I don't want to ever put any type of chemicals in her hair. That will be her choice when she gets older, but as a young girl, I want her to love her natural hair. Your hair is your crown; you should cherish it.

LATTESHA WEBB

I'd never been to a barbershop before. When I got in the chair, the barber kept asking me why I was cutting my hair. And before he started cutting it, he asked, "Are you sure?" And I said, "Mm-hmm." And then I heard the scissors, and I was like, *Well I don't know about this now*. It was pretty scary, but in the end it's all worth it. Once you see the hair on the floor, you know you can't really go back. But even though I really loved my long hair, it was time for it to go. You just have to take that leap of faith and know that it's gonna be OK. It's empowering and liberating.

I didn't know how my dad was gonna react when he saw my short hair. He's very old school, and he has this belief that girls have to have long hair. So I'd told him I was getting a haircut, but I hadn't told him how short. And I came home and I told him he was gonna be shocked, and he said, "OK." And I took my hat off, and I was basically bald. His face was hard as a stone; he didn't smile or anything. But he knew that *I* liked it, so that was really the only thing that mattered to him. And it grew on him. **It's grown on me too. Literally**.

CARMAYA HUMBLE

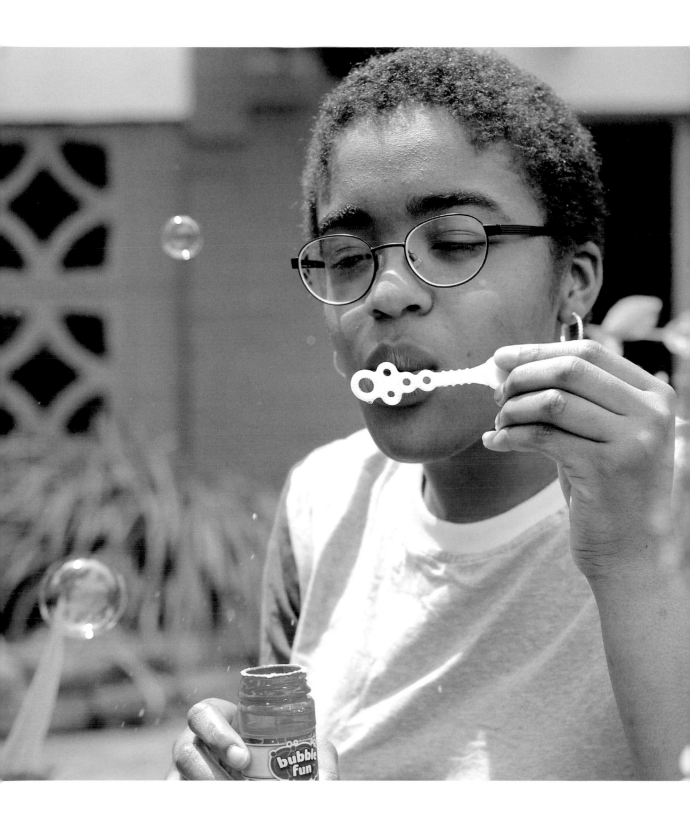

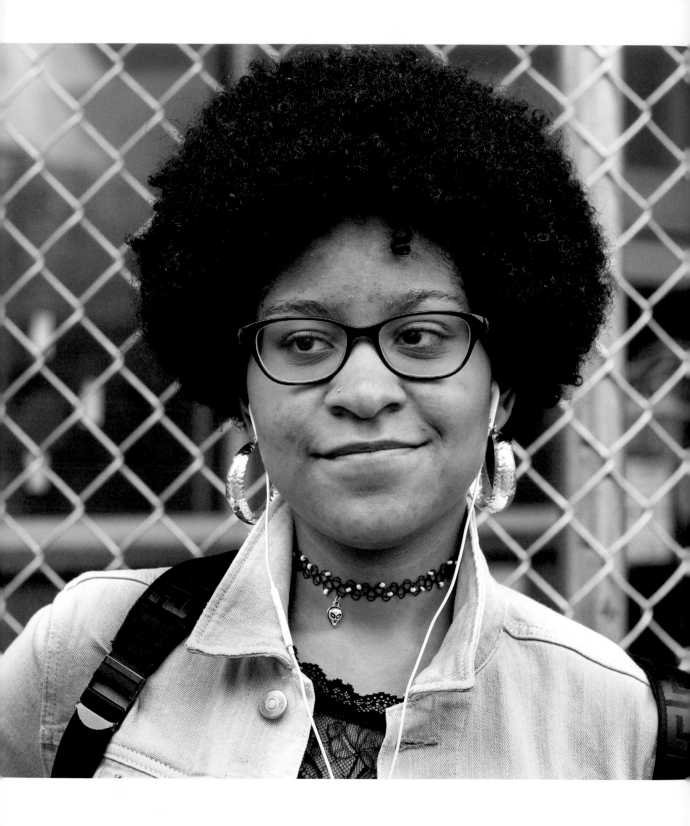

When I first started getting relaxers, I was too little to understand what was happening to my hair. But when I got to middle school, I was telling this girl, "Yeah, my parents put relaxers in my hair." And she was like, "What's that?" And I was like, *Wait, not everybody does this? I don't have to get relaxers?* So I started watching YouTube videos of women going natural, and I told my mom, "I'm going natural. I don't wanna do this anymore; I don't wanna live my whole life getting chemical burns from relaxers." But my first natural hair journey was short; I quickly went back to relaxers. But then I saw my best friends and so many other people in my high school going natural, and I was like, *Yo, how did I let myself give up so easily?* I started cutting my damaged hair off slowly, and then one day I came out of the shower and I saw how nice my curls were and how they gave life to my face. I still hadn't done the big chop yet, so my hair was still a little wonky—curly, but still a little wonky. So then I decided to get a pixie cut, and all the straight, damaged hair was cut off. That's when I was *officially* natural. And since then, **I've just felt so much lighter**.

LISSETTE DE JESUS

When I was pregnant with my first son, my doctor said that it wasn't good for me to relax my hair while pregnant because the chemicals in relaxers could harm my child. So that was one of the biggest reasons why I went natural: Because I didn't want anything to happen to my baby.

Now I've been natural for a little over twenty years. Since then, I've never used a single chemical on my hair. I don't blow-dry it; I don't flat-iron it. My hair is starting to turn gray, but I refuse to dye it. I believe that the hair that grows out of your head naturally is the hair you're *supposed* to have. **And I'm just enjoying it**.

PHARICE BROWN

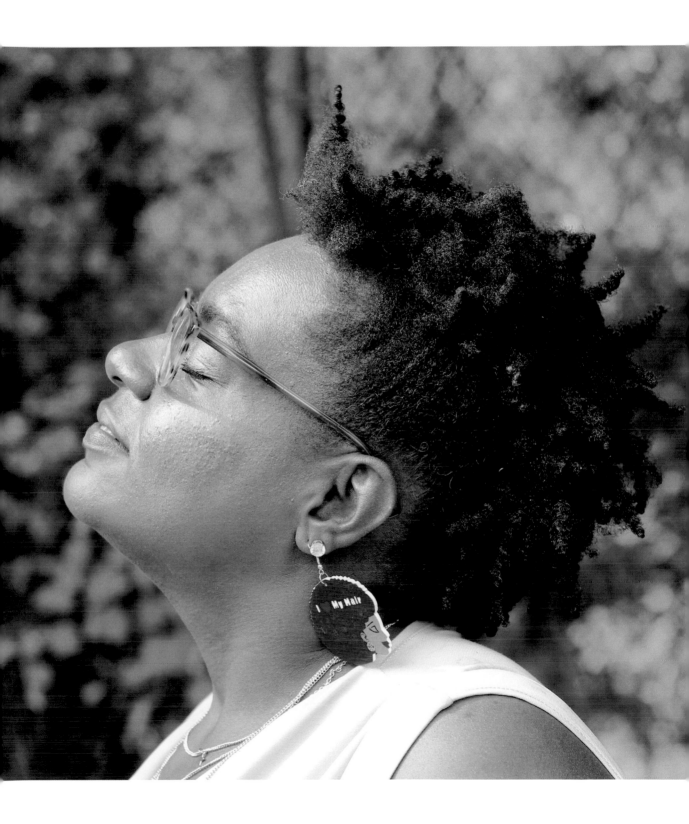

Growing up, I was always getting my hair straightened, but halfway through high school I had to stop because it was getting really damaged. But I wasn't trying to keep it natural forever; I was just trying to make sure that it was healthy enough that I could go back to straightening it again. But while I was waiting for my hair to be healthy again, a guy—who also had an afro—told me that he liked my hair the way it was, so I actually ended up deciding to keep it natural. My hair and I are on good terms now. I'm never going back to straightening my hair. And **all it took was a little bit of encouragement** for me to love my natural hair. So now I like to pass that positivity along. For example, I had a class with a girl who always came in wearing wigs for the first half of the semester, and then one day she came in with her natural hair. As soon as I saw her, I was like, "Oh my gosh, I love your hair." And I don't know if my compliment encouraged her to keep it that way, but after that I only ever saw her with natural hair.

EBONY FARMER-MANGUM

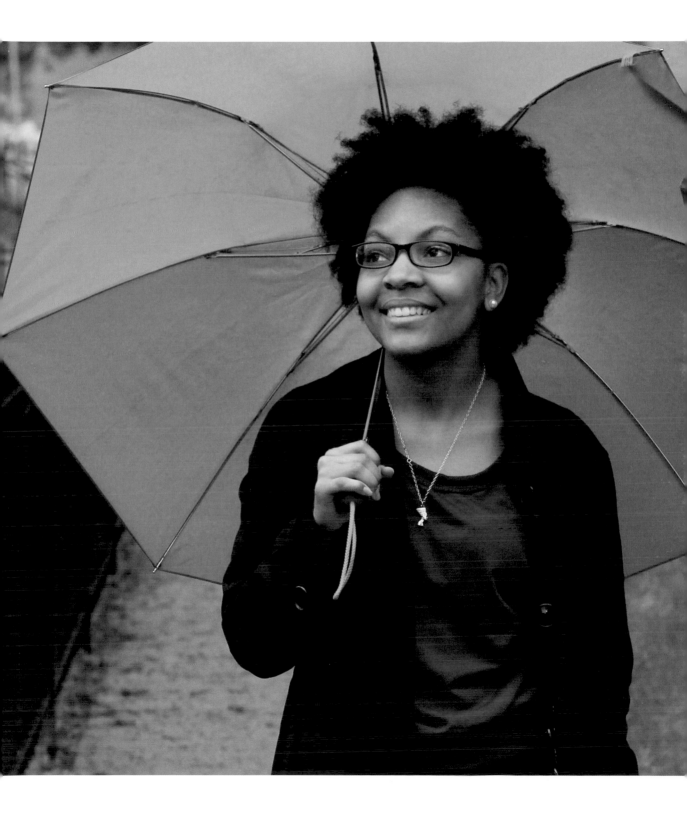

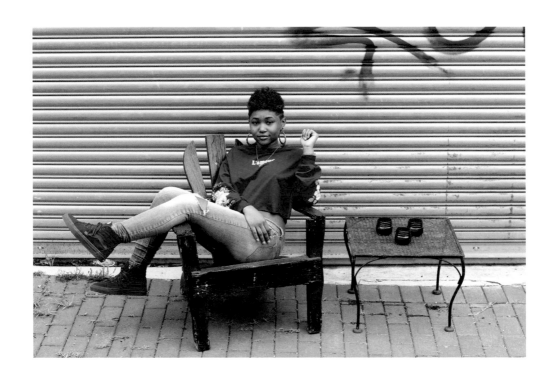

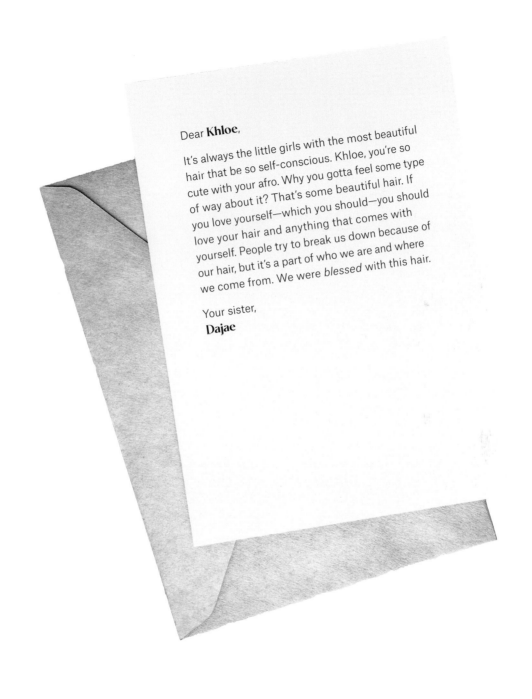

Dear **Khloe**,

It's always the little girls with the most beautiful hair that be so self-conscious. Khloe, you're so cute with your afro. Why you gotta feel some type of way about it? That's some beautiful hair. If you love yourself—which you should—you should love your hair and anything that comes with yourself. People try to break us down because of our hair, but it's a part of who we are and where we come from. We were *blessed* with this hair.

Your sister,
Dajae

It's a deep, complex issue that we only see the surface of. Everybody has different reasons for going natural. A person could look at me and think I wear my hair like this because I'm a soul sister who's woke and "for the culture." And I'm not against that at all, but that's not *why* I went natural. I was getting relaxers, bleaching my hair, dyeing it, and a bunch of other stuff that I had no business doing. Eventually it caught up with me, and I was like, **OK, either I have to stop doing this cold turkey, or I'm going to be bald**. I wasn't excited about having a bald head in high school, so I just let it go; I stopped manipulating my hair altogether. But you see people whose hair is literally falling from their heads—who are losing hair follicles—and they won't stop. Some people just can't seem to let go of that beauty ideal that they're chasing. Luckily, I was able to move on from it. And I like Khloe's hair. I've seen pictures of her hair, and I love it, because it looks like mine. [Laughs.]

GIOVANNA HARRIS

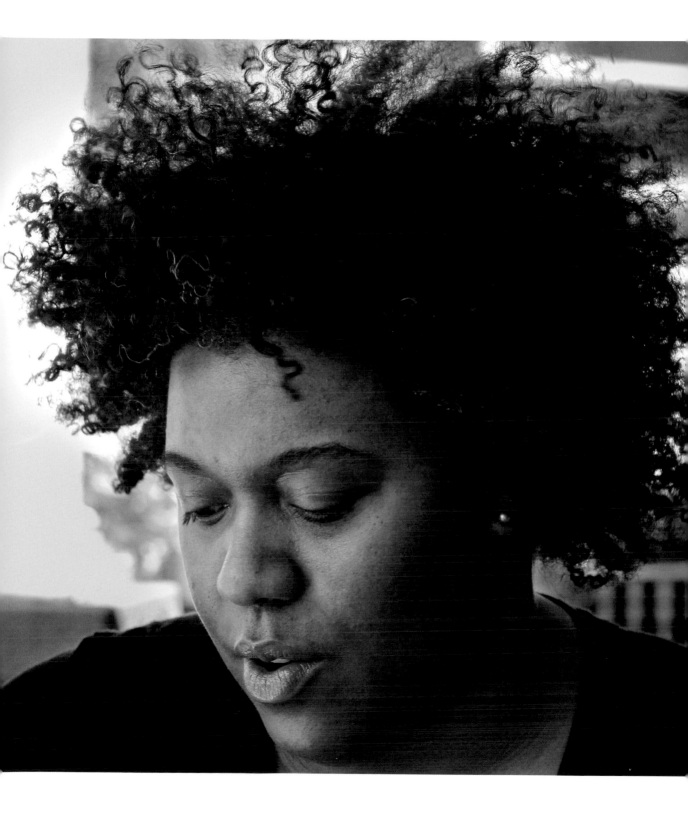

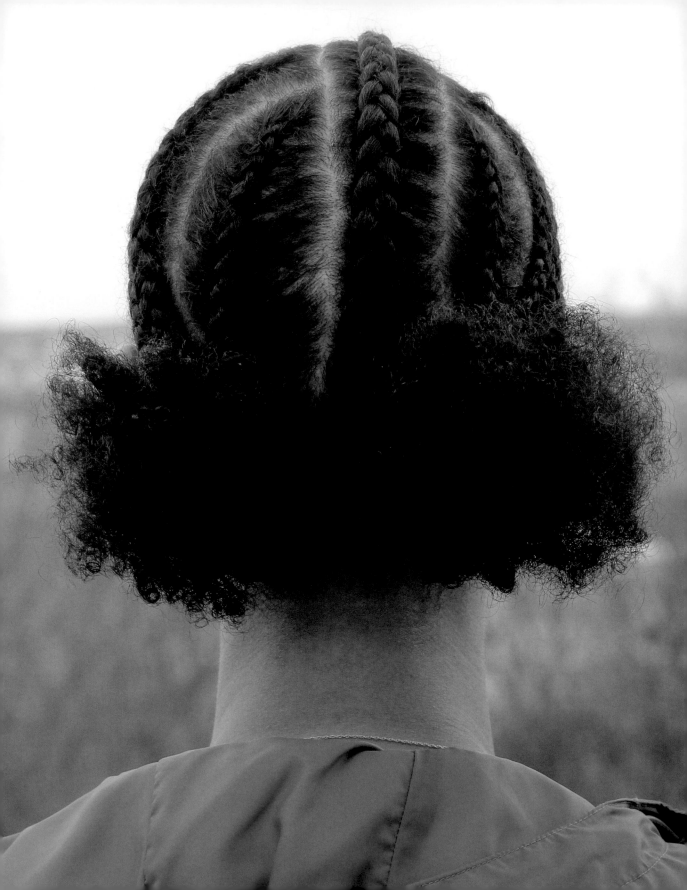

I was really scared of doing the big chop because I thought I was gonna look weird with so much of my hair cut off. It was definitely a different style, but I ended up liking it. It felt refreshing to cut off all the straight, damaged ends and just start regrowing my hair. I hadn't seen my hair in its natural state for years because I had relaxed it for so long. And I actually think coming to Brown and seeing so many confident women with natural hair was a big part of why I cut my hair in the first place. When I first chopped off the relaxed ends, my best friend here would always braid and style my hair for me, which was definitely really helpful. Being surrounded by friends who have curly hair and understand how to take care of it is **a beautiful blessing**.

HASSIET ASBEROM

Embrac
Black

ing
ness

"I was getting relaxers so often that I was essentially erasing my Blackness. Going natural meant that I had to fully accept my Blackness . . ."

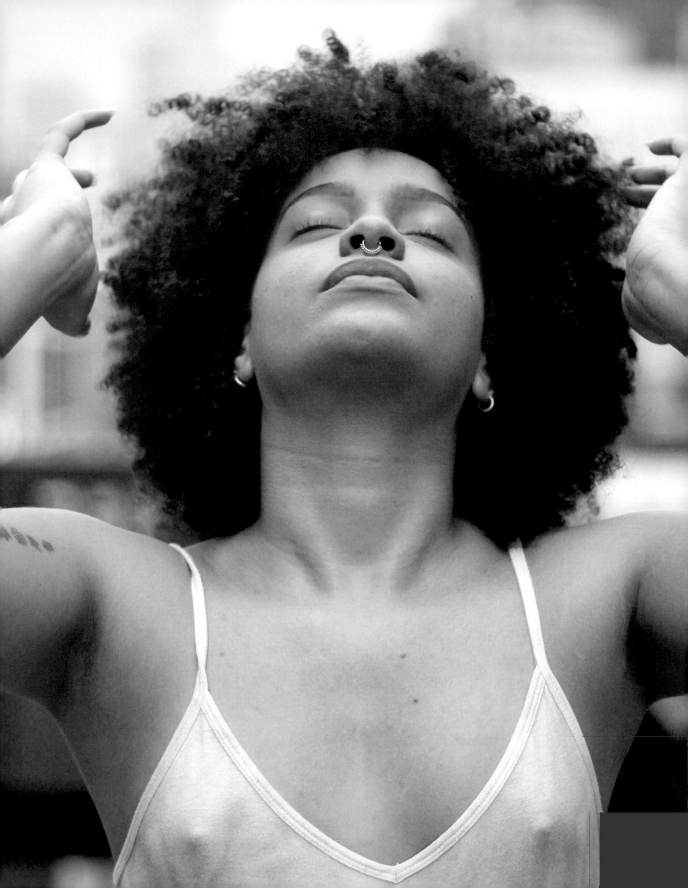

When I was eight or nine, I visited family in the Dominican Republic, and one of my aunts from my father's side placed perming product in my shampoo to straighten my hair. That's when I discovered that I was OK with being different, and that I wasn't willing to force-feed myself self-hatred. By applying heat to her hair, my aunt undoes her history. And she tried to do that with me—live her self-hatred through someone else. But I wasn't willing to allow her to do that.

The world does a lot onto us, does a lot onto our bodies—Black bodies. It does a lot onto our hair, by policing us, by placing certain people in front of us—whether it be in the modeling industry or in the entertainment industry—so we don't find kinship in media. We have a wounded history. But without that wounded history, we wouldn't have our resilience, and so I think we're in a time where we're starting to acknowledge and undo the trauma that is literally passed down—literally within our blood.

As soon as I went natural, I did not look back. I did *not* look back. I was like, *It's gotta go. That permed hair—the heat—it's not part of me anymore.* My look is bound to disrupt some things. But I'm OK with that disruption. I intentionally— whether it be an interview or a new job—wear my hair as big as possible. Just so people are aware, like, "Yeah, she's Black, undoubtedly." And that's how I wanna be recognized, like **my Blackness is not to be compromised or watered down for anybody**.

More women with 4A to 4C hair types should be at the forefront of natural hair movements or initiatives or advocacy, because their journey is *much* harder than mine. You know? I'm melanin-deprived compared to other Afro-Latinos with 4C hair, with darker skin. I tip my hat to them because they don't get the recognition that they deserve, but they put in twice the work.

And isn't that just like us, to forget about the Black women who put in all the work?

KEYLA YNOA

It's unfortunate: As Black women, we're legit like the only group that has to do anything to our hair to appeal to anyone; women of other races can just wake up and put a sloppy bun in their hair, and it's all cute. And, you know, they post a picture on Instagram in sweats, and they're great. But *I* roll out of bed like this, and people are like, "You're unkempt." Like, *excuse me?* No, I'm still cute! And when I realized that none of my non-Black friends were spending money on fake hair, I was like, *Why do I have to spend so much money on hair? I have hair!*

The reason natural hair is being more accepted into pop culture now is because we're *forcing* it to be more accepted. We're out here showing our protest by wearing our natural hair. We're being **unapologetically ourselves**, and we're saying, "Take us as we are, or have none of us at all."

Natural hair might just seem like a fad right now, but I feel like it's definitely gonna stay. I'm excited because generations from now, children aren't gonna know a life of not loving their natural hair. They're gonna be like, "You used to put *what* in your hair to straighten it? You *wanted* your hair straight? What?! That's crazy. Y'all was wildin' back then." I can't wait.

ANGIE SHEPHERD

I was getting relaxers so often that I was essentially erasing my Blackness. Going natural meant that I had to fully accept my Blackness, because this hair texture is something that you associate with being Black. I was like, *OK, I can't deny this anymore.* And going natural—along with paying more attention to the social and political climate—made me more aware and more conscious, and I realized that I'm not excluded from these things that are happening to people who look just like me.

My mom had started relaxing my hair when I was four, so I never knew what my natural hair looked like. Seeing my natural, kinky hair for the first time was bittersweet: bitter because I'd never seen it and it took some accepting, but sweet because it was a breath of fresh air. **It was like I was meeting myself for the first time**. Sometimes I'd forget that my hair wasn't straight anymore and I'd pass the mirror with this 'fro and I would get surprised. But now I see my hair as part of my identity. My hair *is* me. My hair has helped me find who I am.

FRANCESCA POLANCO

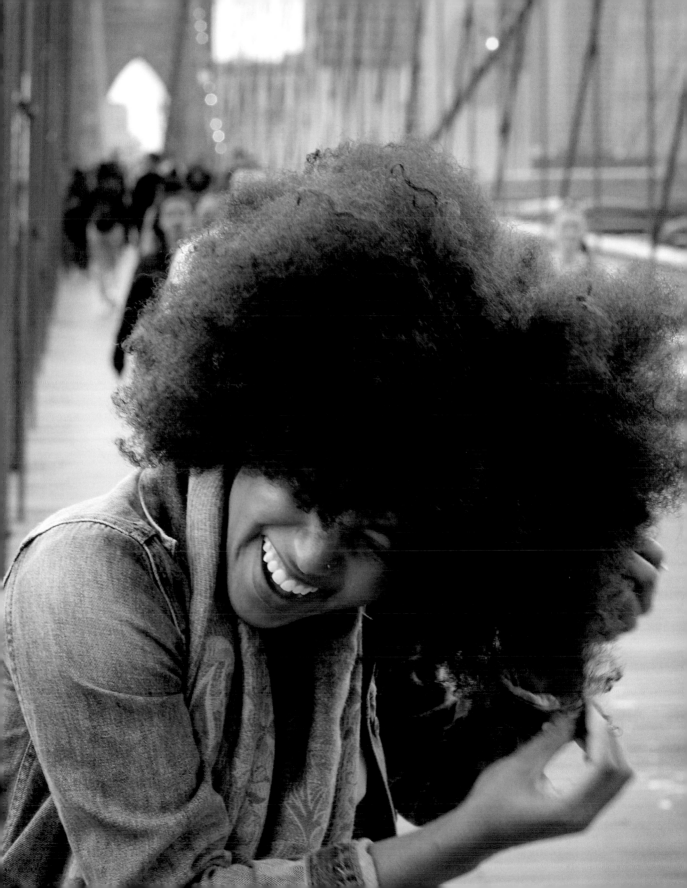

Dear **Khloe**,

Look in the mirror and say, "I love my hair. I'm different, but I love it. I don't have to be beautiful in the same way as everyone else." Just sit with your hair for an hour or two and play with it, figure out what it's like, figure out what it's about, and figure out what it's trying to tell you. Every morning when you wake up, your hair has something new to tell you. Your hair is a part of you, so let it be a part of your spirit too.

Your sister,
Hassiet

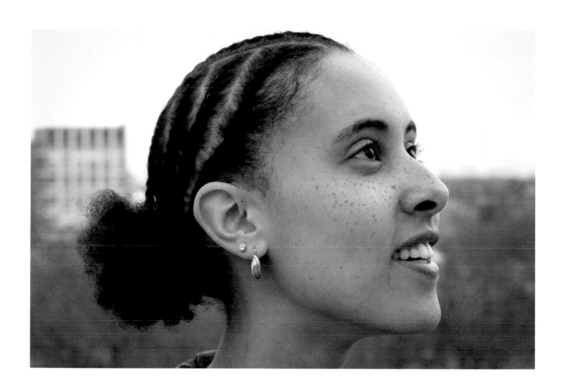

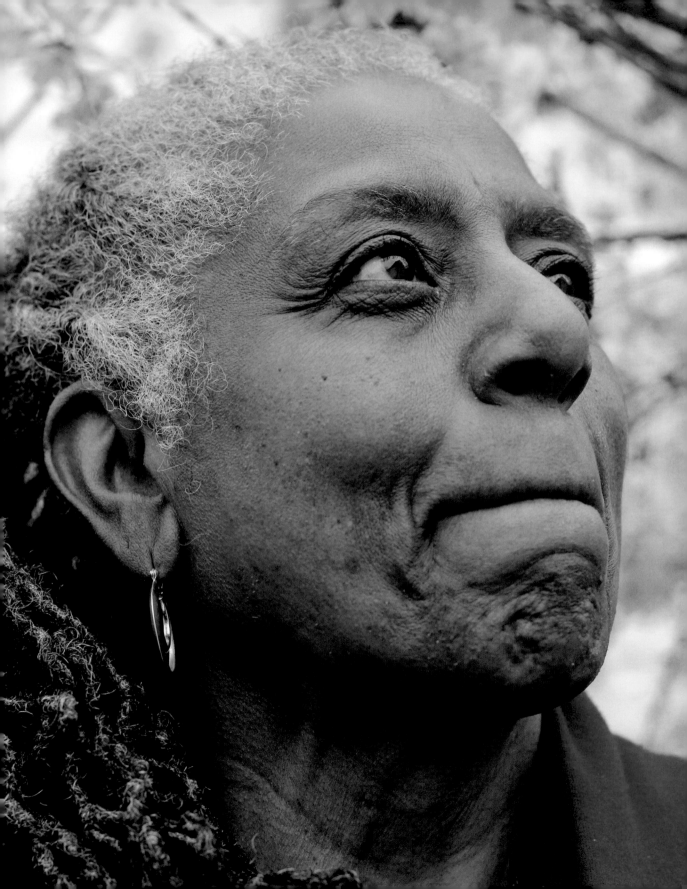

I went away to college in 1969. It was the Black Liberation era and the Black arts movement, and the songs "I'm Black and I'm Proud" and "To Be Young, Gifted and Black" were playing, and **to stop straightening one's hair was an act of liberation**. I found that the consciousness that came with feminism sometimes clashed in the context of Black liberation, but I knew I couldn't make a choice. I was both: Black and female. And both parts of me had to be liberated from the chains of oppression, both psychologically and spiritually.

By liberating my hair from European beauty standards, I was also liberating myself from the capitalist system that has Black women invested in buying hair from women in other countries who have to shave their heads and sell their hair just to make ends meet. And the fake Kanekalon hair has petrochemical by-products which feed into the same capitalist system that's polluting the earth. So I really want to see Black women liberated from putting heat on their hair, but I also want us to be liberated from fake hair and hair extensions.

I have sympathy for Black girls who straighten their hair because they feel ugly and unattractive and are treated as such. I know that society is constantly denying our beauty and making us believe that we are intrinsically not attractive. But I also know that playing in someone else's costume is not being your authentic self.

ELISE BRYANT

When my father was in the casket, he literally had a crown of glory around his head. He hadn't lost any hair from the chemotherapy. In fact, the sicker he got, the thicker his hair became. We used to go to Miss Sheila's hair salon, and he'd get his mini locs or his coils done, and I'd sit across from him and get my flat twists or my two-strand twists. And the night before his funeral, Miss Sheila took the time to do his hair in coils—the same way he liked it when he was living. I didn't understand how powerful that experience of getting our natural hairstyles done together would be for me. It's really beautiful that he, as a Black father, put in that time to teach his Black daughter to love her natural hair. My mother—and her patience and kindness when she was doing my hair every Sunday—played an equally large role in my journey toward accepting and loving my Blackness in its entirety.

My father was an activist, and both my parents taught me that our history doesn't start in 1619 on the shores of America. As African Americans, we've created our *own* culture, and I'm very proud of this culture that we've created in the midst of so much chaos and oppression. But I just think about how we could've had so much more if we weren't completely stripped from all forms of African culture—including our hair traditions.

So much of this knowledge was kept away from us when we were brought to this hemisphere, so relearning all that information—how to keep our hair moisturized, how to detangle it, how to trim it, how to style it in intricate patterns—is so important. Because the only thing we've been taught for so long is how to get our hair to look closer to white beauty standards; everything we've been told about our hair has been rooted in anti-Blackness. Slaves often had their hair shaved against their will because our hair was thought to be "unsanitary." Black women were often required to cover up their hair. And we no longer had time to practice self-care.

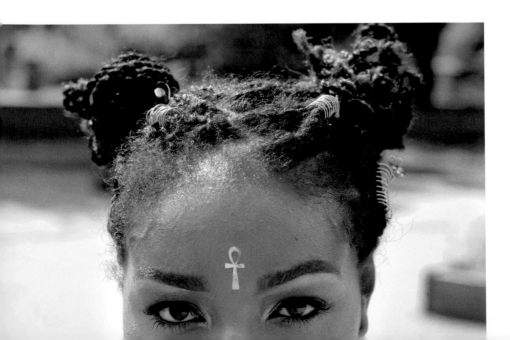

But we still found ways to use our hair as a means of freedom. A lot of our ancestors stored grains in their hair so they'd have food to escape with if their communities in Africa were raided, or so they'd have food to take with them if they were captured. And some of our enslaved ancestors even mapped out their escape routes with intricate braids.

We've always found a way to stay beautiful. **You can't stop Black women from glowing.** No matter how much you try to oppress us—no matter how much you try to push the white Euro-centric beauty standards on us—Black women and our natural physical features are still emulated globally. But Black women's needs have been put on the back burner for so long, you know? So now I see self-care for Black women as a revolutionary act. And my parents taught me that self-care *always* includes our hair.

ASHA HADIYA

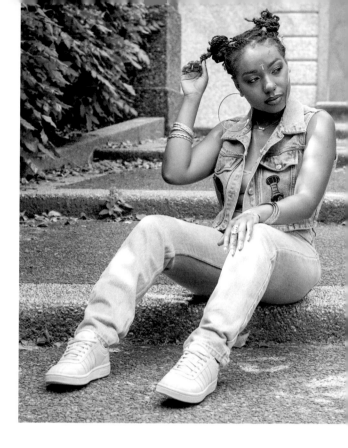

When I started getting my hair relaxed, I didn't realize the depth of what I was doing. I thought I was just making my hair easier to manage. But now I look at it like a psychological thing, where a lot of us Hispanics are trying to erase the traces of Blackness that we have in us by straightening our hair, by lightening our skin, by trying to look more European in any way we can. And I feel like psychologically it does do something to us, because we're enforcing the insecurity that we have in our minds instead of embracing what we were given.

I stopped getting relaxers and straightening my hair when I was a sophomore in college. It was scary, and it took a lot of strength to go through the process of unlearning a lot of what I had been taught as a little girl. I didn't actually start identifying as Afro-Latina or Black until I started that journey with my natural hair. And I think it's so important to raise the next generation of women of color to be **wholeheartedly proud of who they are**.

ALEXIS VAZQUEZ

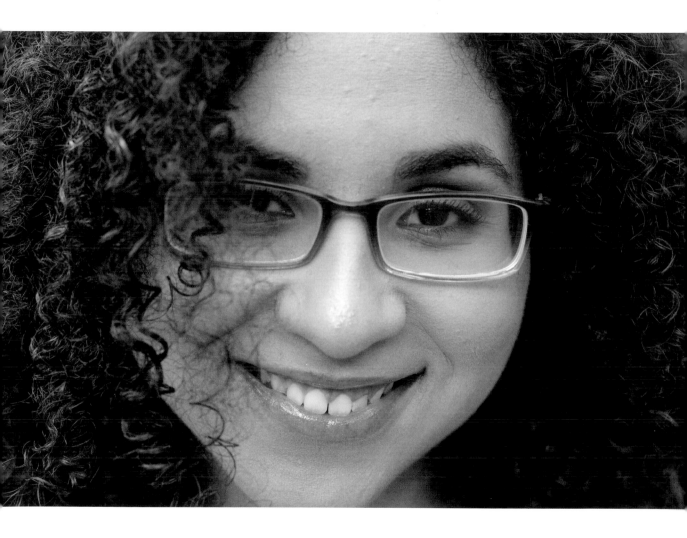

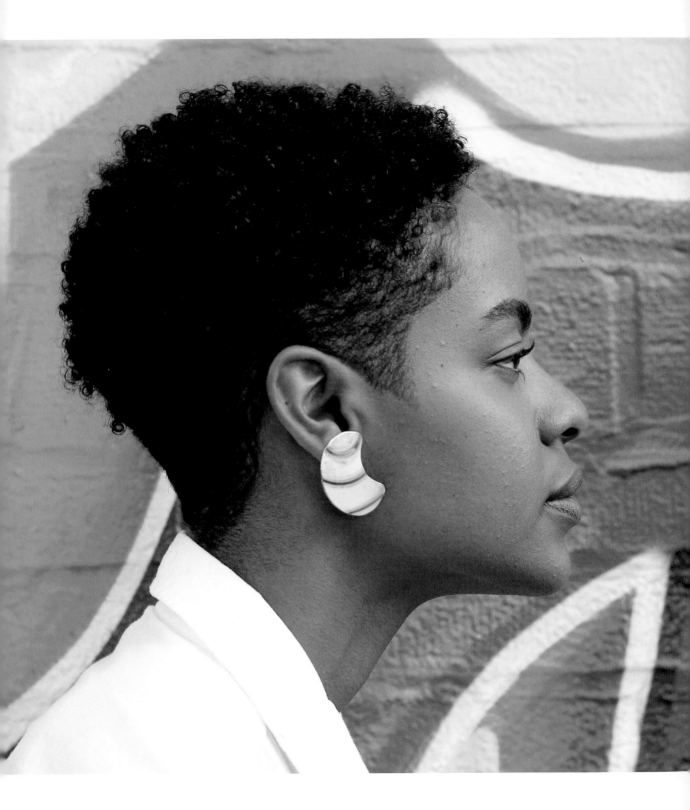

I'm going to relearn beauty, *and I'm going to learn how to take care of my hair.* That's what I told myself. Because for so long, I just felt like I depended so much on my straightened hair to validate my beauty. My family shamed me for no longer wanting straight hair. I think in the Dominican culture there's such an emphasis on straight, luscious hair—hair that doesn't look like it has any ancestral roots of Blackness or any type of non-whiteness involved. And I think that's telling of the Dominican imaginary—the way Dominicans see our social existence. Some Dominicans have this idea that the Dominican Republic is a "white" country when, in reality, there's Blackness embedded within our DNA. So when I started embracing my short, curly hair, there was a lot of shame involved because my family wasn't supportive of it. I had to unlearn the idea that kinky, curly hair is dirty and not as beautiful as straight hair. And the process of unlearning this was difficult, but it helped me emerge stronger and helped me grow and advocate for myself and for my natural hair, and for autonomy with my body in general.

Having curly hair now as a Dominican woman just makes me feel a little more radical in my Dominican-ness, you know? I'm excited that there's a huge curly hair movement happening now in the Dominican Republic. It's like, finally these two things can coexist: I can be a Dominican woman and have really short, kinky, curly hair and feel proud about that. But my Black identity always precedes my Dominican identity both in how I'm perceived and in how I choose to identify. I move through the world as a Black woman, first and foremost. So I think being Black has been just so much more important to me, and it's given me a more critical lens of the world and how I move through it above my Dominican-ness. And I feel complicated about saying that, but I think it's true.

PERLA MONTAS

I have this beautiful old picture of my mom from 1987 where she's standing at the bottom of the steps of her apartment building, and her hair is very big and full and pretty. I guess I'm like an extension of my mom in that way. I did get a perm in middle school because I started swimming, but I didn't really know how to take care of it, and the extra chemicals from the pool made things worse. Of course, everyone has hair that's unique to them and everyone's hair chemistry is different, so I think that people have to take whatever road works best for them. But for *me*, when I got a perm, my hair was just kind of lifeless and falling out. So I eventually cut all the dead ends off and relearned my natural hair, and now my pick is my hair tool of choice so I can make my hair as big and as vibrant as possible. When I'm modeling, it's almost like my signature. I just love seeing my hair **the same way I see myself: full of life**.

As I go through my twenties, I find myself having even more pride in who I am as a Black woman. My foundation is becoming more unshakeable. Even though it's discouraging to see racism, I would never change who I am or the community I belong to. Because at the end of the day, the issue stands with the system—it's never really about who I am as a Black person and as a woman. If people participate in misogynoir, I can't control that; I can only control who I allow in my space and where I put my energy. So I only spend time with people who encourage me and lift up all parts of me—including my hair.

PHYLICIA A. COTTON

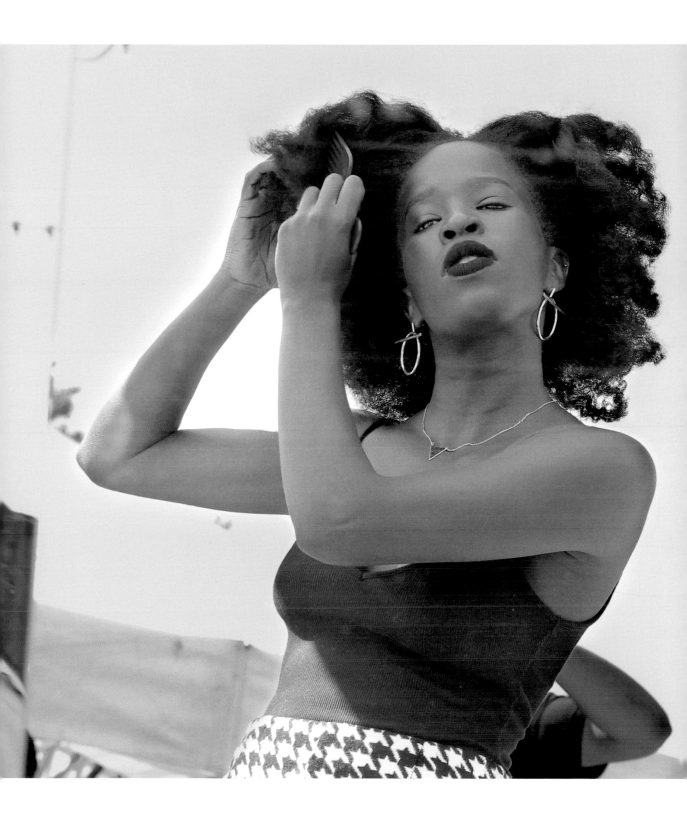

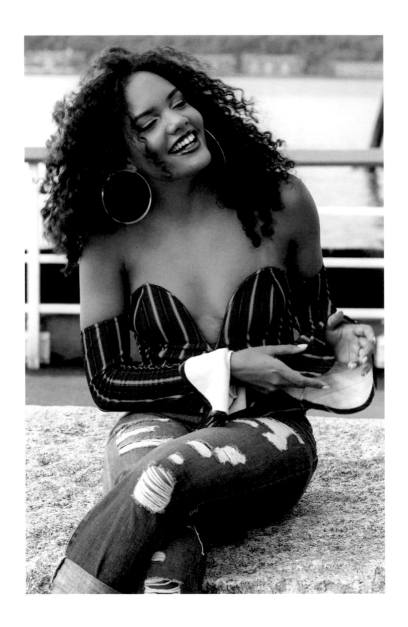

Dear **Khloe**,

You should touch your hair every morning and tell it that it's beautiful because it comes out of you. Your ancestors gave you that gift of curly, big, puffy hair, and it would be a disservice to them not to love your curls.

Your sister,
Danyeli

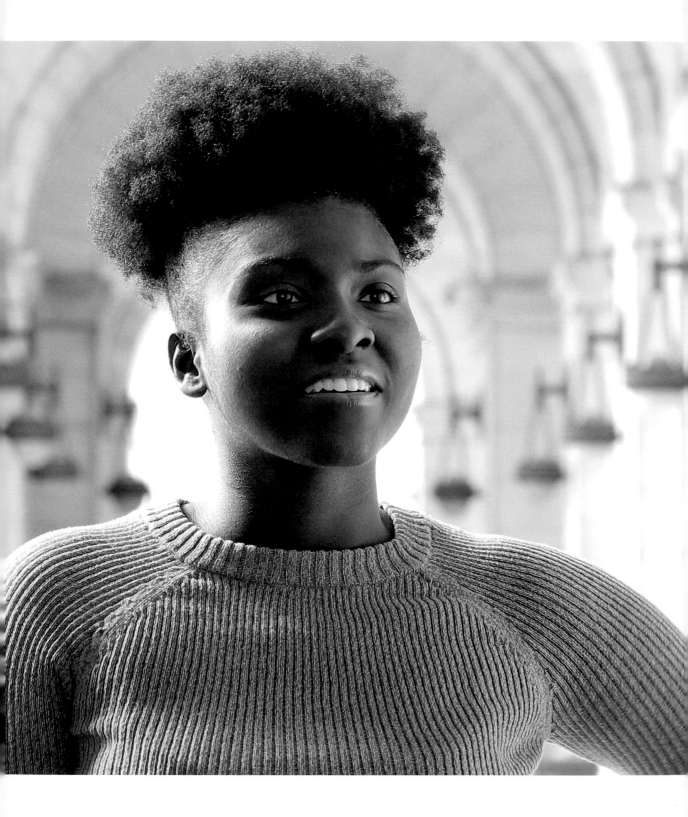

People used to say, "Oh, you're pretty for a dark-skinned girl." When I was in ninth grade, this guy in my class told me, "I don't like girls of your skin color." I was like, "Ain't nobody asked you. Ain't nobody care."

And it goes deeper than just skin color. I had been so caught up on skin color for so many years that I hadn't even *noticed* that my hair was also something that people weren't feeling. I knew that people would talk about my skin color, but I wasn't really putting it together that it was more of a package deal: They don't like my skin *or* my hair. I started listening a little closer to what people were saying, and I thought, *Jeez, y'all just don't like us* at all. *Y'all are really packing it on just to tear us down*. And now I see the connection. Because, you know, if you have my skin color, you usually have my type of hair.

But guess what? Now I like my skin like this! And guess what else? I like my hair like this too! And it's really nice to *like* myself. It feels good. Nobody can tear me down with their foolishness. Malcolm X said, "The most disrespected person in America is the Black woman." And it's like some Black women have internalized that hatred. I see videos of Black women saying, "I hate my natural hair!" This one Black woman said in her video, "My hair just will not do what I want it to do. And I'm using all these products . . ." And I look at the products she's using, and there's a white lady on the box with straight hair. I'm just like, *Well, maybe it's because we keep trying to change our hair into something that it's not. And then that's why we keep having issues*. I'm not saying every Black woman should be natural, but I do think **every Black woman should give her natural hair a chance**.

BRIANA WALKER

I'd always embraced my natural hair, and I'd always wanted to lock it. But when I went into the military in the '70s, I couldn't lock my hair. I couldn't braid it or cornrow it either. So when I got out in '90, I said, "I'm gonna start my locs." And people were like, "No, you're going into the corporate world; you can't get into the corporate world with dreads." So once I got into the corporate world, I started locking. I later cut them off, but then in December of '98, my children lost their dad tragically. And he was Rasta. So in January of '99, I restarted my locs. And here we are today. There are times that I wanna cut them—just for a cleansing—but I'm not gonna. I love them too much. They're a part of me. My daughter clipped them once, and I swear I could *feel* that part of my locs being cut off, like I felt it in my soul. So here I am: almost sixty, still rocking the locs. And my nickname is Soul Sista.

MICHELE EDWARDS

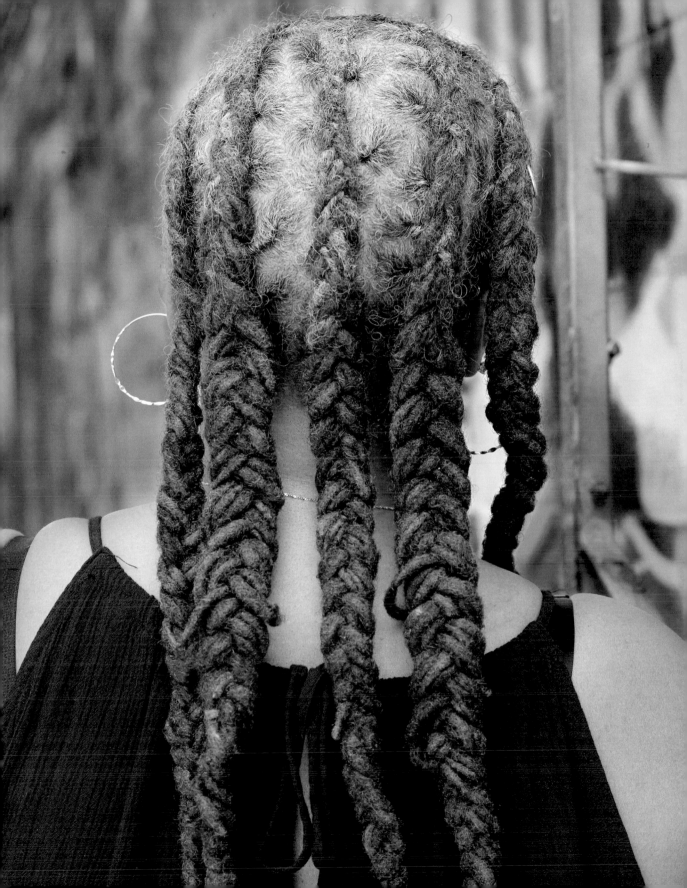

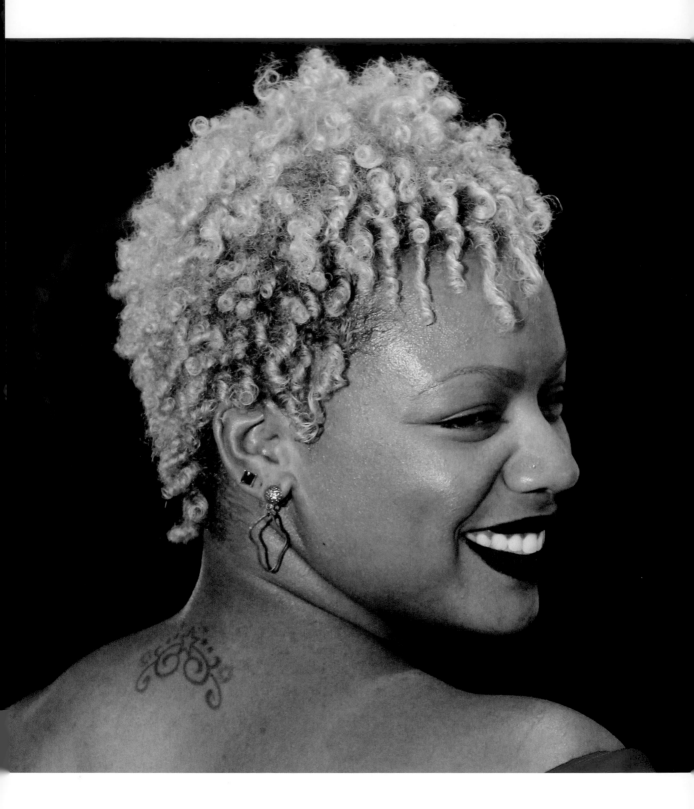

When I was a kid, my mom would hot-comb my hair. You know, she'd put the comb on the stove and then through my hair. And I *hated* the hot comb: the sizzle, the smell, the burning. I still remember it burning my ears and my forehead and the back of my neck. I saw locs as the only way out. So I had locs for several years, and then I cut them off. But I felt good about helping to change the narrative in terms of locs being "clean" and "professional."

Now we're seeing a lot more women with natural hair. But the stereotypes are still there. Even my grandmother—who's kind of old-fashioned—uses the term *pickaninny* and calls my curly hair "unkempt." But it's not unkempt. This is how my hair is. This is how it *should* be. And I'm no longer interested in straightening it or changing it and damaging it just to be accepted by others. Your hair is your crown. **Black hair defies gravity**. It's diverse. It's versatile. It's beautiful. And it protects you. I mean, if you think about it, it protects us—people with melanin—when we're in a hotter climate. So even the chemistry behind our hair is amazing. You can't make this stuff up. We're superheroes.

You know what's funny? I didn't even think about this until now, but I'd gone between pressing out my hair and wearing weaves since I first cut my locs all the way up until last year, when I did an ancestry test and my DNA results showed that I'm 64 percent Nigerian and Ghanaian. After that, I went natural again. I've been more in touch with that part of me, and I seek to learn more about it. Because now I know for sure what I am, you know? I even got my tattoo of Africa to pay homage to my ancestors.

KENDRA WOOLRIDGE

I'd left Boston on a really bad note with my family and friends, and I just wanted to get out. So I spent a year in Brazil, and that's where I finally accepted myself in my skin color and, in full effect, blossoming, my hair. It was before the trend of natural hair and 'fros, so natural hair was still uncommon. Even though not many people in Brazil had natural hair, they fully embraced those who did as being powerful. **In Brazil, natural hair shows power within yourself**. So a really major part of me accepting me, completely, was the effect of being in a whole other world—another country, yes, but also a whole other world for me, because I wasn't in the US, and no one knew me, and I didn't have any people judging me, and everyone just gave me so much love. People there *showered* me with love and made me realize how much love I have for myself, so I learned self-love through accepting myself one hundred percent, flaws and all. And I learned how much love I can share with my family too.

ALBAMARINA NAHAR

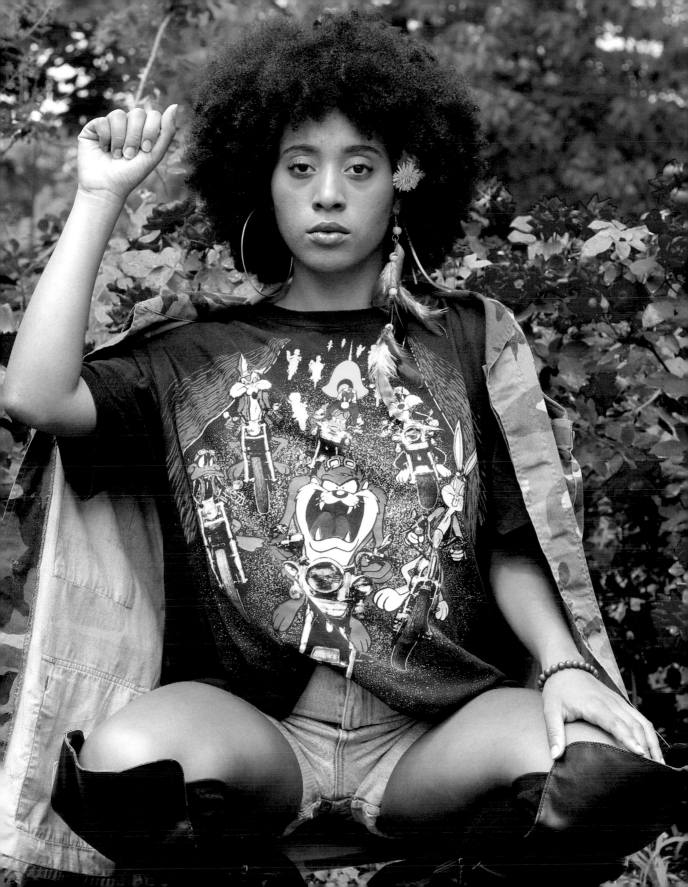

Hair as

Identity

"When you wear an afro, you don't have to say much else about your identity. You've already established that you're proud. You've already established that you've found beauty in power."

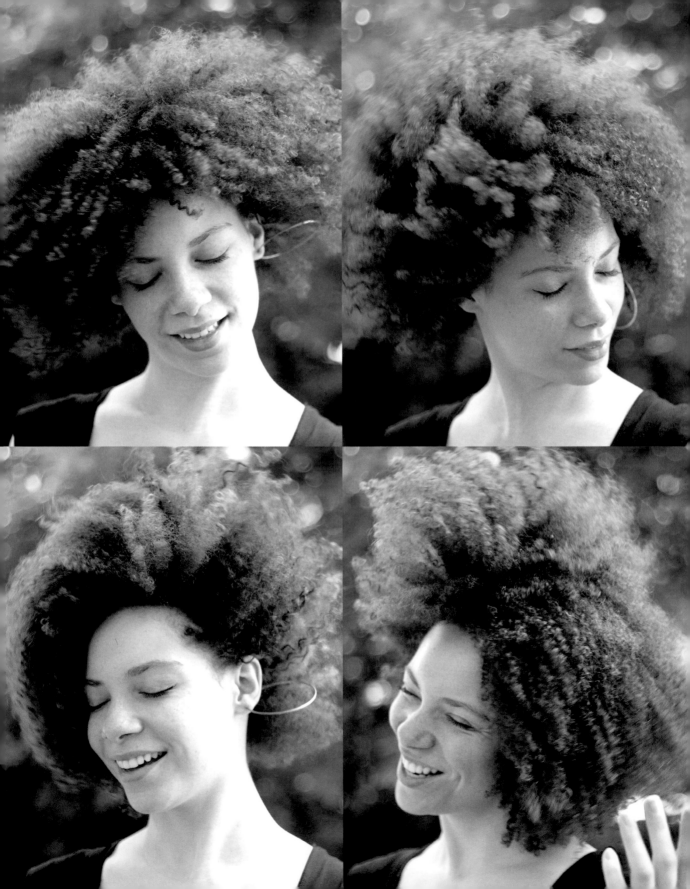

The afro adds this wonderful aesthetic quality, but it can also be political, which can be dangerous. Because then Black rights become political, and the Black body becomes political. And what are the implications of that? That the human being is naturally a political object? People have politicized our bodies to the point where it becomes controversial to say, "Can we please have the police stop killing us?" How did we get to that point where the declaration of the value of a human life is political?

On the other hand, while we can push against the politicization of our hair, I think that the history's there. There was a shift in the '60s for Black people to reclaim their hair. It was definitely a hairstyle of the radical, and it was directly linked to the Black power movement. But first of all, it doesn't speak to the aesthetic power of the afro, necessarily, if it's directly a political movement. And second of all, people can oppose political movements vocally and easily. It's harder when you say, "My afro is an assertion of my humanity." When you wear an afro, you don't have to say much else about your identity. You've already established that you're proud. **You've already established that you've found beauty in power**.

There were fewer afros on the street when I was a kid. My hair has always been natural, but I always contained my hair: I wore it up or in little pigtails or braids. And there was always pain associated with my hair. In the seventh grade, I decided to wear my hair in an afro and everybody laughed at me. And I think that if you're an aware woman of color in this world, that's kind of your thing, whether you like it or not: You go through this world making people react or making them think or provoking them. Even if you're not doing anything. Even if you're just breathing. Which can be great. It can also be an incredible burden. But since when has being Black in America not been a burden?

BRIGID CARMICHAEL

My hair was always such a big part of everything; it determined what I *could* do and what I *couldn't* do. I couldn't play outside when it was raining. I couldn't go to the pool with my friends. I couldn't wear hats. And if little me didn't care one day and broke any of these rules, my mom would get *very* upset, and the next day would be *such* a big hair day of getting burned with curling irons and whatnot. So I'd just always notice little white girls' hair and think, *If I had their hair, I could do whatever I want.*

I don't blame myself for internalizing these negative thoughts about my hair. I mean, I don't blame anyone for feeling these feelings. But I'm *so* happy I'm over it. 'Cause man, what a time. My family is like, "It's hard to believe you've ever straightened your hair; we feel like you've had this hairstyle your whole life." This hairstyle is just a perfect fit for me. It matches my vibe. It fits my face perfectly, it feels nice, it feels good, it feels right.

There's just been so much in my life—and I'm sure in other people's lives, as well—that's up in the air, so much that's unknown. But I like when I can depend on something. And my locs have given me that security I was looking for. Because for the past six years, I've woken up and they've been here with me. I don't even think of my hair in a way that's separate from me now like I used to; it's really just an extension of myself. **Each strand is so important to me**.

My hair is my identity. And I'm super proud of it. We break stereotypes together. People often ask me what type of artist I am, and I'm like, "Actually, I'm a data analyst." And I still always notice people's hair, but the *way* I notice it has changed. As much as I focused on white people's hair as a kid, I now focus that much on Black women's natural hair. If I see a woman with a big ol' healthy 'fro, I'm like, "Wow, you're so powerful. You've probably been growing that for so long. And I'm proud of you." So the focus is still on the hair, but the feelings around it are all so positive now. I can play outside when it's raining. I can go to the pool with my friends. And I can wear hats.

ELANA NELSON

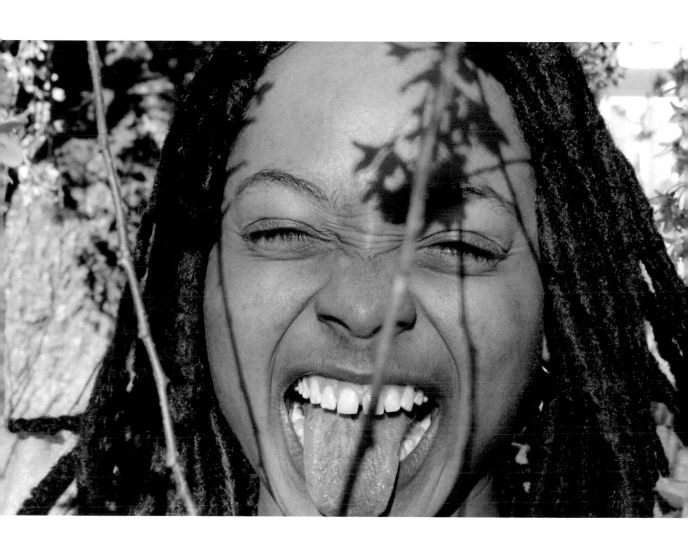

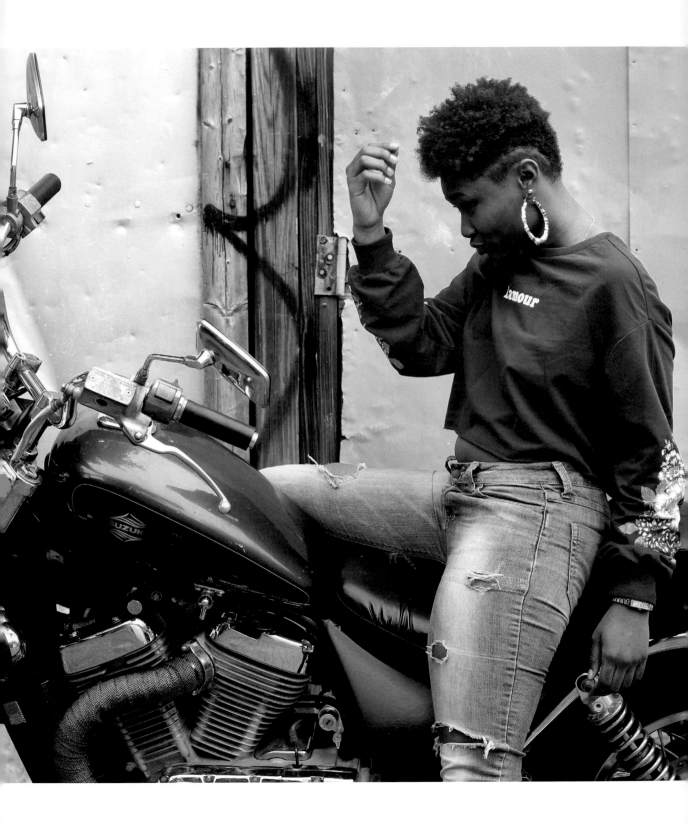

I would say my hair is a part of my culture. It was fun going to the salon when I was a kid because I got to see everybody. And actually I had a hair salon right down the street from where I lived; there was this one girl who would do hair specials for all the little girls when it was time for us to go back to school. She'd do our hair outside so that we could still be with our friends while we were getting our hair braided and cornrowed. And I loved having my braids and cornrows with my colorful beads on the ends and everything. I loved my colorful bows and barrettes—everything. So maybe that's where my love of colorful hair comes from.

But my mom would never let me color it when I was younger, so once I got the door open enough to get my color, I was like, *Oh, I'mma run with this.* I couldn't wait to go to school and be like, "Hey, y'all! Y'all like my new hair color? You know, it was brown last week, but now I got blonde." I was also straightening my hair then, but now I love my vibrant colors and my natural hair texture. **It's just how I express myself**, really. It's a part of my personality. I'm not good with color in clothes, but you'll find some nice colors in my hair. It makes me pop, and I like to pop. I like when people stop and be like, "Oh my gosh, your hair is so pretty! How did you get that color? You're so bold, I would never do that with my hair." And I love seeing other women with short haircuts now too; I feel like it's sort of a power move.

DAJAE SCOTT

Growing up, my hair was my biggest insecurity.
I wanted to look like the girls at my predominantly
white middle school, so I straightened my hair
to try to fit in. I went through a lot of depression
because of it. But now my hair is **an automatic
confidence booster**. When I walk into a room,
I stand out because of my hair. And if I'm having
a bad day, somebody's probably gonna compliment
me, and it's gonna make me feel better. Or even
if I'm not in the mood to talk, somebody's gonna
come up to me and talk to me about my hair.
And I really like that.

KENNEDY JENNINGS

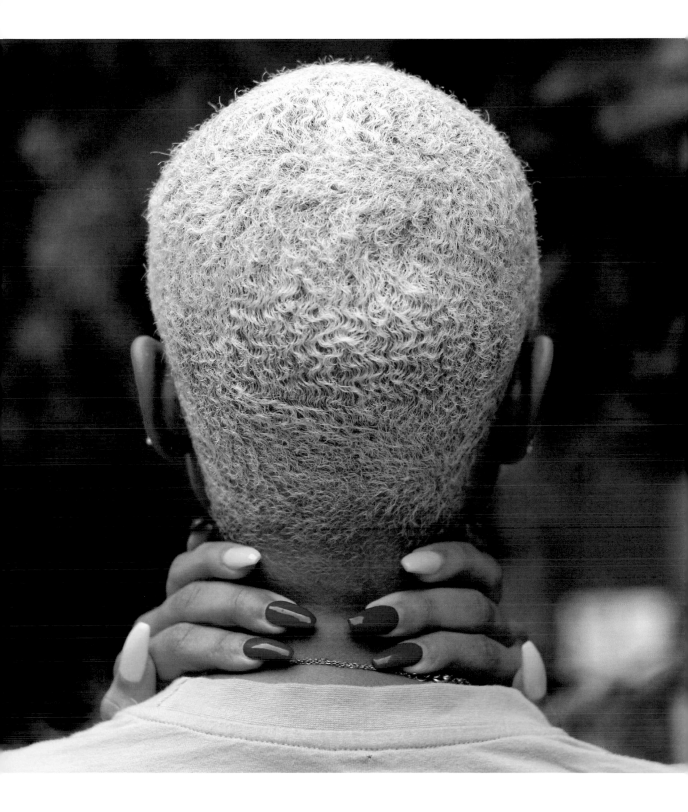

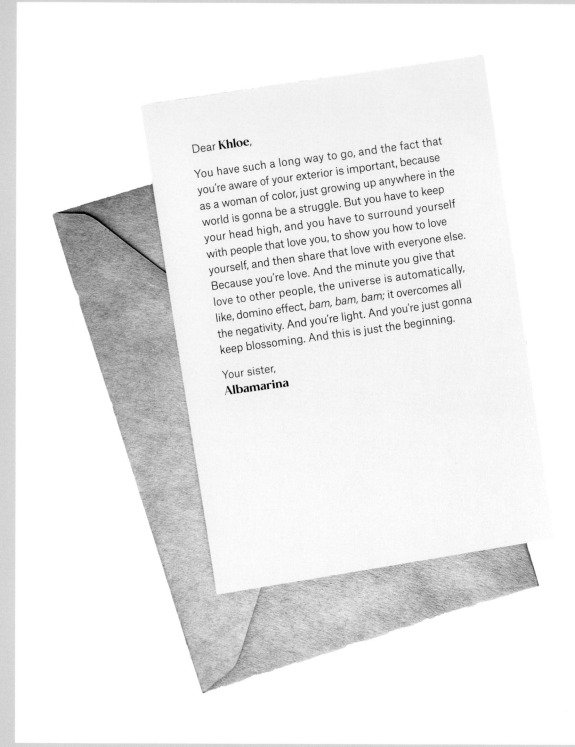

Dear **Khloe**,

You have such a long way to go, and the fact that you're aware of your exterior is important, because as a woman of color, just growing up anywhere in the world is gonna be a struggle. But you have to keep your head high, and you have to surround yourself with people that love you, to show you how to love yourself, and then share that love with everyone else. Because you're love. And the minute you give that love to other people, the universe is automatically, like, domino effect, *bam, bam, bam*; it overcomes all the negativity. And you're light. And you're just gonna keep blossoming. And this is just the beginning.

Your sister,
Albamarina

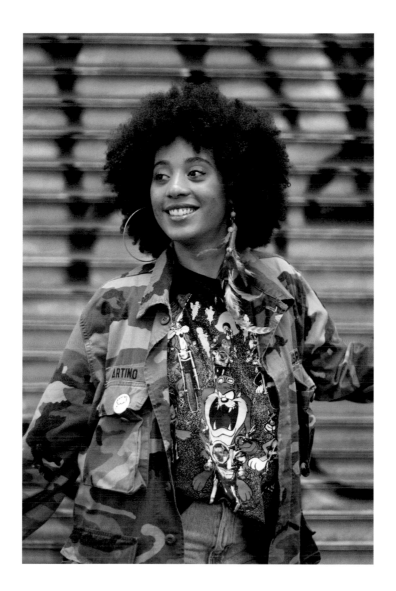

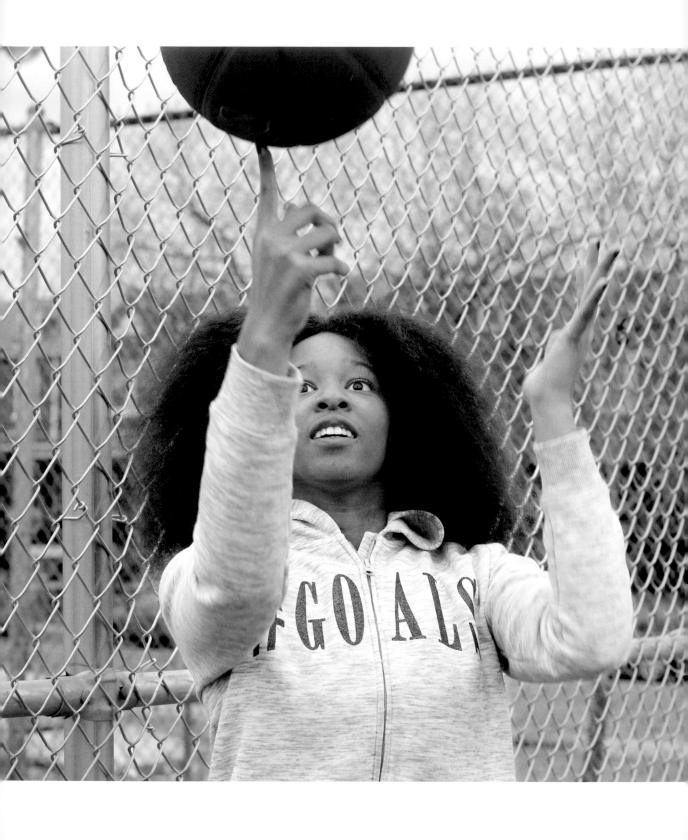

I do remember this time when my mom brought me to this hair salon, and I do remember the pain that I had to go through in there, because it was just . . . I was pretty young, like maybe seven. And there were a lot of irons. Like, just a bunch of irons and a bunch of heat. And I remember it just overwhelmed me. I remember crying, and it was really scary for me. And so after that, I just had a fear of hair salons. After that, I was just like, *OK, forget it. I'm not doing that ever again. I'm just sticking with my fluff.*

My fluff is me. My fluff is my bud. I'm twelve, so I don't know how to say this in like, um, an adult-ish way, but I like my fluff because when people see me with my fluff, they're like, "She's rambunctious. She's all out there. She's wild. **And her mane says it all**."

MAIA SMITH

I didn't feel happy if my hair wasn't straight. I didn't feel like I could go to formal events with my hair curly. I was always trying to tame my hair to fit in. And finally one day I just slowly began learning about my hair and about how beautiful it is. And now I'm here, and I love it. When I enter a room, my hair speaks for itself. It speaks about who I am, about my values, about how I decide to portray myself to the world. And **the bigger my hair gets, the more beautiful I think it is**. So my natural hair journey has been a transformative experience. And it comes down to loving yourself and loving the way that you came out of the womb, right?

DANYELI RODRIGUEZ DEL ORBE

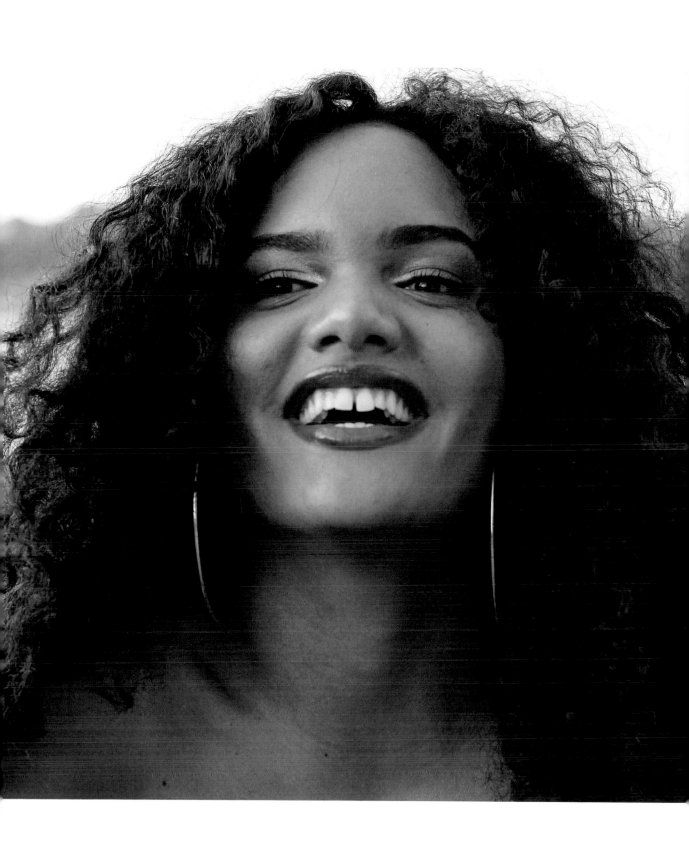

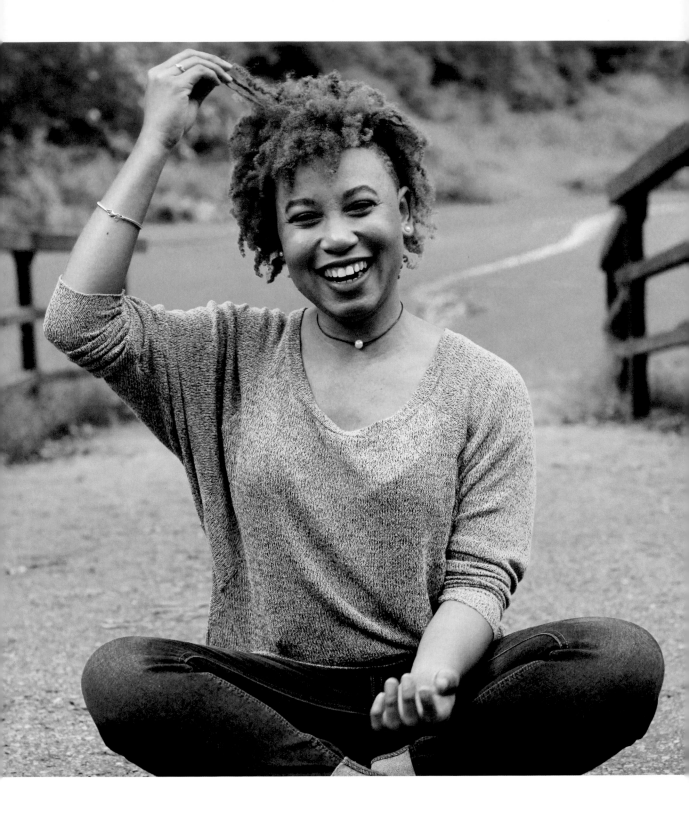

Starting my natural hair journey was a risk. My mom didn't like my natural hair at all, and she made me feel self-conscious about it. So I would wear headbands and hats and wigs to cover my hair. But the more I played with my hair and tried to figure out what to do with her, the more I started to like her. I pay attention to what she likes and doesn't like—and she always lets me know. She doesn't have a name, but I call my hair *her*, and I just let her do her thing. **I let her live. I let her be free**. So we're cool now. We have a good relationship. She fits my personality. She embodies me. I feel the most powerful when my hair is wild and crazy, like she is right now. I look at us in the mirror and think, *We can do this. I don't know what it is, but we can do it.*

TIFFANY WARNER

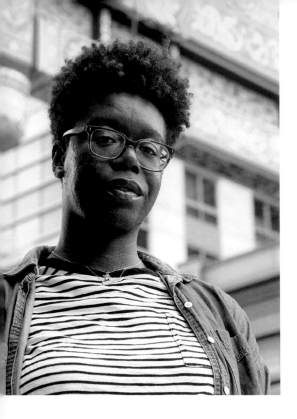

I had a lot of insecurity about myself in middle school, and so there was always insecurity around my hair too. I didn't really start wearing my hair naturally curly until eighth grade. I'd read this blog—I can't remember what it was called—by this woman who was talking about learning to love herself through her hair. And I was like, *OK, let me try this.* So I went natural. And I did learn to love myself, and I loved my afro, and I loved how fast my afro grew; whenever I would get a trim, my afro would just grow even bigger. And people started knowing me for my hair. I became known as "the girl with the big hair." And I loved my hair, but I started realizing that the only compliments that I got were about my hair. And I realized that I was hiding all my insecurities under my hair.

I really had to think about what kind of relationship I had with my hair and whether it was more positive or negative. I had to ask myself, **Am I using my hair as a veil** *to cover up all my flaws?* And I realized that I was. So my aunt was like, "Why don't you just cut it off?" I was like, "Cut it off? What do you mean? This is my hair!" But then I had a gut feeling about it, and that was the final push that I needed. Before the chop, I asked myself, *What would I be without my big afro? What would my identity be?* And then in December 2017, I cut off my hair, even though I had so much love for it and I'd taken care of it so well.

When I saw it fall on the floor, I cried. But I think the best way to explain my haircut was that I literally felt free. I felt like I could focus on something else other than my hair. The veil was lifted. I finally had to deal with the things that my hair was protecting me from, like all my insecurities, and the thoughts of *Will people still compliment me even when I don't have my big hair anymore?* I felt like my relationship with my hair changed because it wasn't big anymore. I learned to love my hair again from a different perspective, like not using it as a veil, but instead using it as a crown. I was no longer using it to hide other parts of me, but rather to enhance and embrace these other parts.

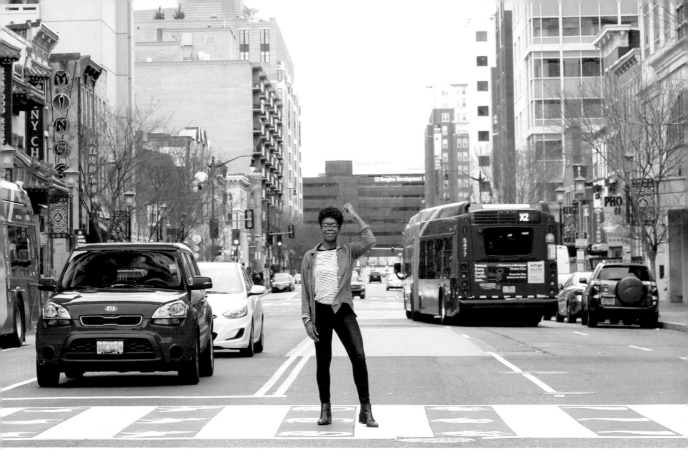

I think it's OK to have a changing relationship with your hair. I think it's important to be aware of how it affects you; it's an ode to self-awareness and consciousness. And hair is also a source of bonding and community. When I was younger, my cousin Brittany would braid my hair, and that's when we started bonding as cousins. And now my twin brother comes to me for hair advice; yesterday, I taught him how to keep his hair moisturized. So I see hair as a concept because there's so much emotion attached to it; people laugh over it, they cry over it, they bond over it. It's a beautiful thing. It really is.

MICAILAH GUTHRIE

When I choose to wear my hair in an afro, I get a lot of compliments—especially when I really comb it all out and everything. People say, "Whoa, it's so big!" It adds a certain aesthetic. I haven't gotten a perm since my freshman year of high school. The tips of my hair are still light brown from when I dyed my hair, but I've been trimming them regularly because I just want my hair to be its natural color again. My natural hair is so versatile without changing the color or the texture. **It's special, it's great, it's beautiful.** And it's become a part of my identity.

BETHANN MWOMBELA

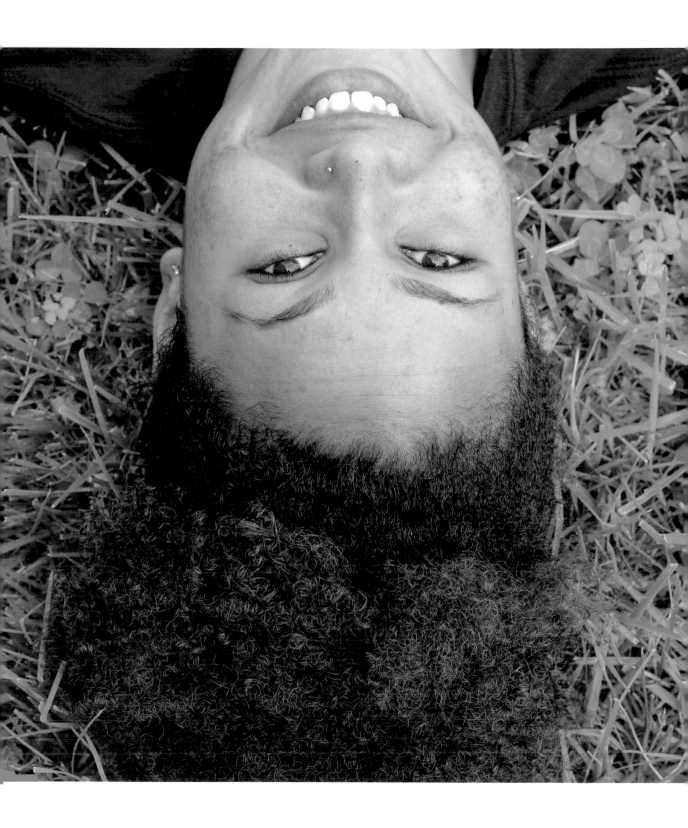

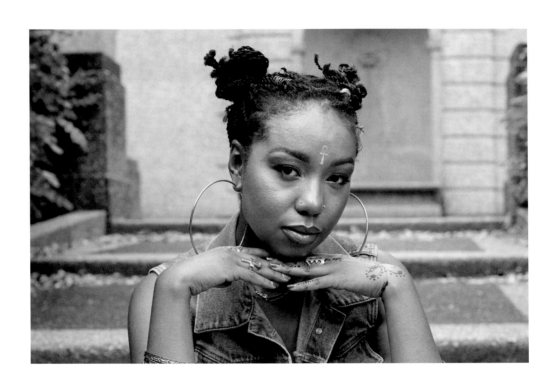

Dear **Khloe**,

I've been in your shoes. Even though I was raised to love my kinky hair and my Afrocentric features, what I was seeing in the media and at school still influenced me, and I believed that my hair had to look more Eurocentric in order for it to be considered "good hair." Thank God I'm out of that phase now, though. I'm praying for you and all the young girls who are where I was when I was growing up. Khloe, you are so freaking cute! I hope to meet you one day. But I want to let you know your hair is absolutely gorgeous the way it is. It's already blossoming and flourishing; just know that your hair is beautiful, and it's exactly what it's supposed to look like. And just like a tree, your hair needs to be watered and hugged and nurtured in order for it to flourish. So speak life into it. Your natural hair is God's cotton.

Your sister,
Asha

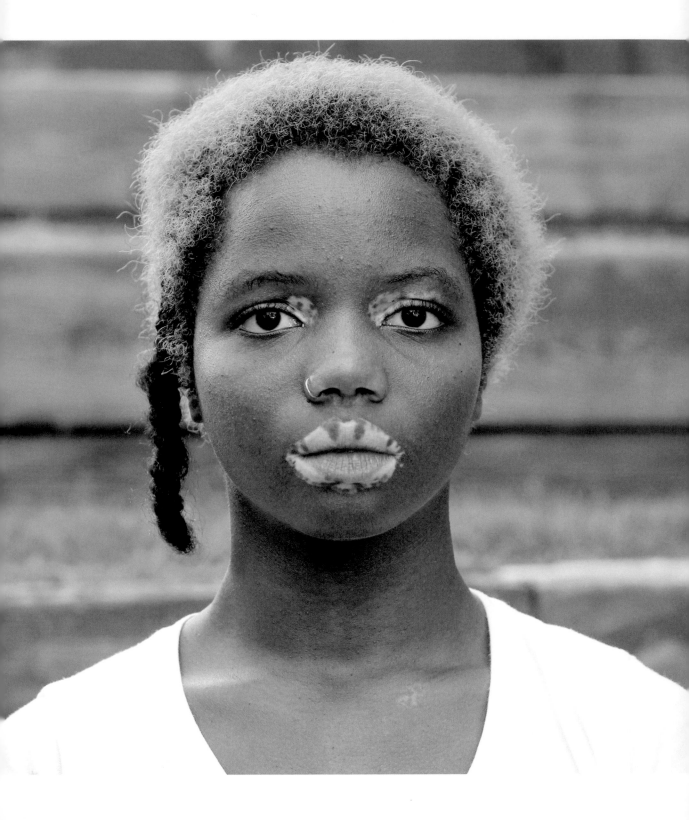

I like that my hair is short. I like that my hair is blue. But my favorite thing about my hair is my braid. It's next to the feminine part of the brain—the temple. So I keep it long and untouched by color in order to pay homage to all of the females who came before me, and it's **braided like the mitochondrial DNA**, which is the only DNA that's passed from woman to woman. So I feel like it's only right to not touch it.

NIN MALUKA JACKSON

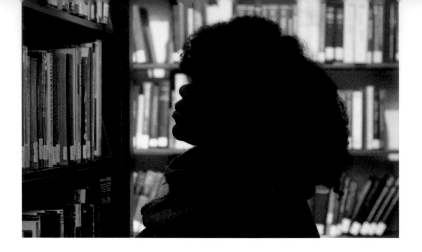

I was in second or third grade when my mom started perming my hair. When I got older, I asked my mom, "Ma, why didn't you *ask* me if I wanted to perm my hair?" She was like, "I don't know, I just didn't know what to do with it." But you know, you live and you learn. And now she knows better; she's even natural herself. Because perms damage your hair and cause breakage. And depending on the type of chemicals in the perm, they can even leave a green film underneath your scalp. So going natural—grabbing a pair of scissors and cutting off all my permed hair the day before my twenty-first birthday—was the best decision I've ever made.

You should never look at somebody else's hair and wish that it was yours. And your hair can take you places if you allow it to. People of African descent, we have a unique type of hair; it's been said that our hair connects us to the universe because **our curls contain the golden ratio**. I don't know the exact science behind all of this, but I know it's been said that the universe has a divine number, and the divine number is represented by different swirls found in nature. For example, if you look at a seashell, you'll see a coil pattern. If you look at a hurricane, there's a coil pattern there. Even galaxies have a coil pattern. And our hair mimics that same pattern and helps us receive positive energy from the universe. So I think it's pretty special.

VERICA WILLIAMS

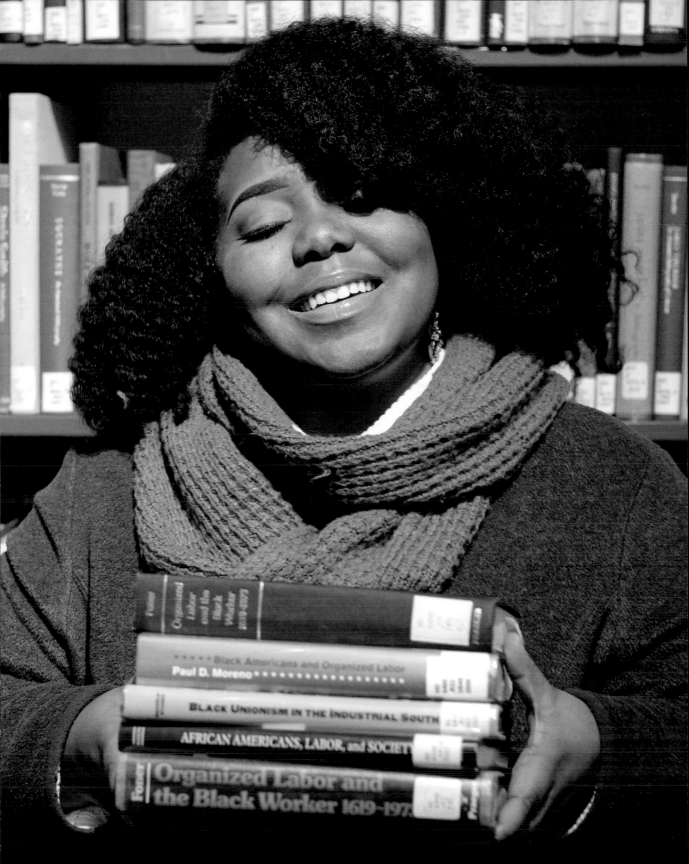

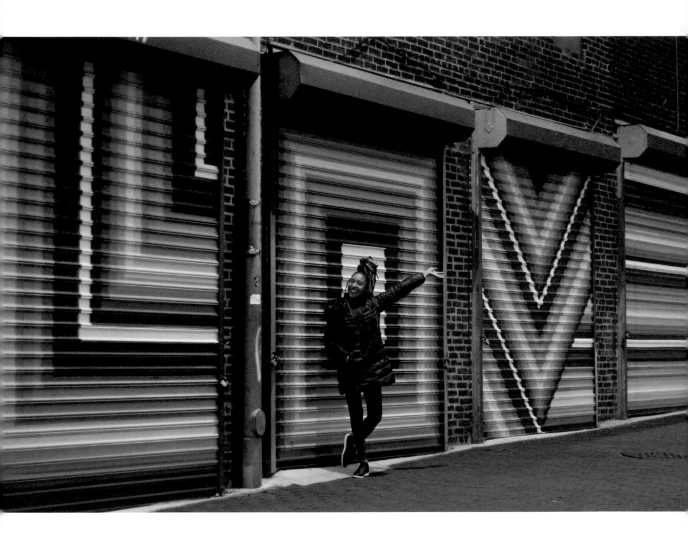

I wasn't too worried about the stigma around locs; I felt like if people were gonna judge me, then I would deal with that when the time came. I just didn't really have a lot of time or energy to spend on my hair anymore, and I'd been thinking about doing it for a while. So one day I asked my mom to twist my hair—just to do two-strand twists—but I don't think she really knew that she was starting my locs. I left my hair in those twists, and yeah, that's how my locs formed. Do I have a special connection with my locs? I mean, my hair *is* a part of my body. **It holds energy**. It's been through a lot of experiences with me.

NADIA HARPER

Self–Love
Self–

/Discovery

"When you see a woman with a big afro, you know:
This woman loves herself."

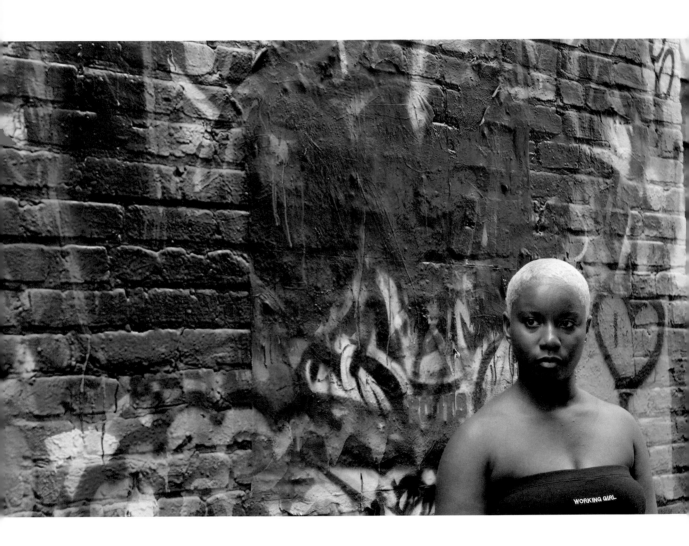

It's been two years now. I cut my hair sophomore year of college due to damage. I wasn't taking care of it, so I went natural. I was really scared. I was insecure. I was like, *No one's gonna like me; I'm gonna look like a little boy.* But that's not what happened. **I fell in love with myself all over again**, and I gained confidence. Now I feel like I can go outside without needing makeup or anything and just be myself. I can now accept myself for me. I think I gained more confidence because I realized that I didn't need to hide behind weaves and braids and all that stuff. It felt really free.

MARIAME FOFANA

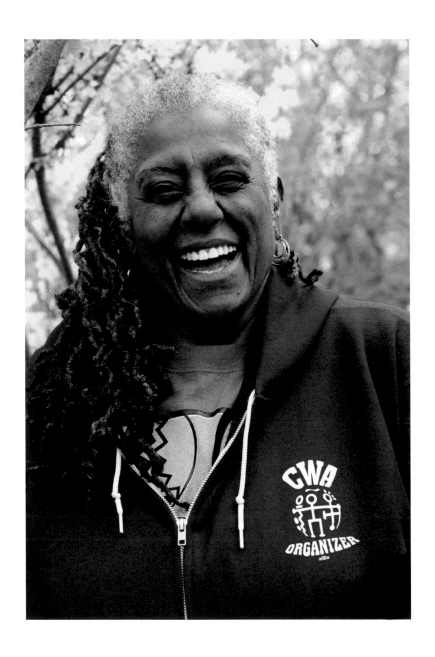

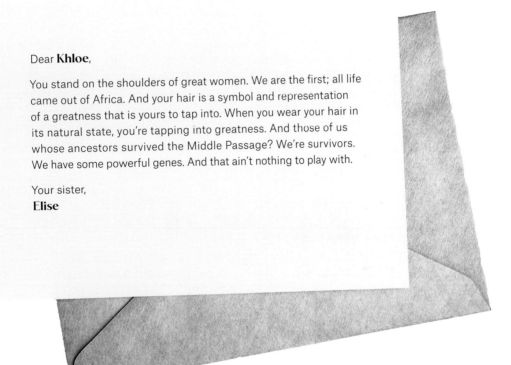

Dear **Khloe**,

You stand on the shoulders of great women. We are the first; all life came out of Africa. And your hair is a symbol and representation of a greatness that is yours to tap into. When you wear your hair in its natural state, you're tapping into greatness. And those of us whose ancestors survived the Middle Passage? We're survivors. We have some powerful genes. And that ain't nothing to play with.

Your sister,
Elise

It was easy for me to hide behind my weave—and to be accepted by society with my long hair—but now I'm allowing myself to go through the process of becoming more self-aware as a Black woman. I always want people to understand that you can't love another person if you haven't learned to properly love yourself.

My hair has taught me self-beauty. No matter what you look like, no matter what size you are, no matter how old you get, no matter how many times you change your hair, no matter if you chop it off or grow it long . . . beauty starts with *you*. It's OK to have moments where you don't feel beautiful. But you don't stay in those places. You pick yourself up, you put your head back on your shoulders, and you **wear your crown as proudly as you can**.

MAYA GARNETT

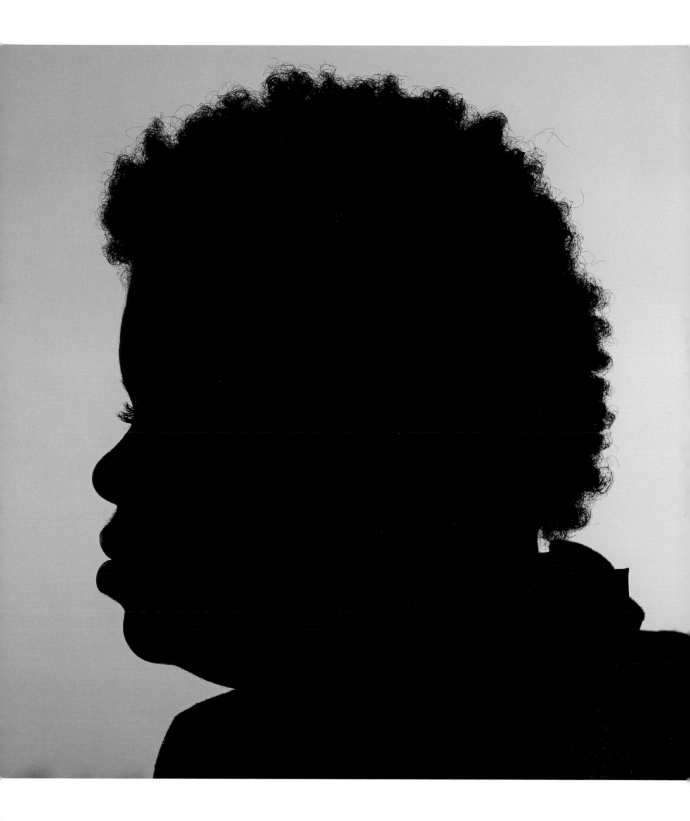

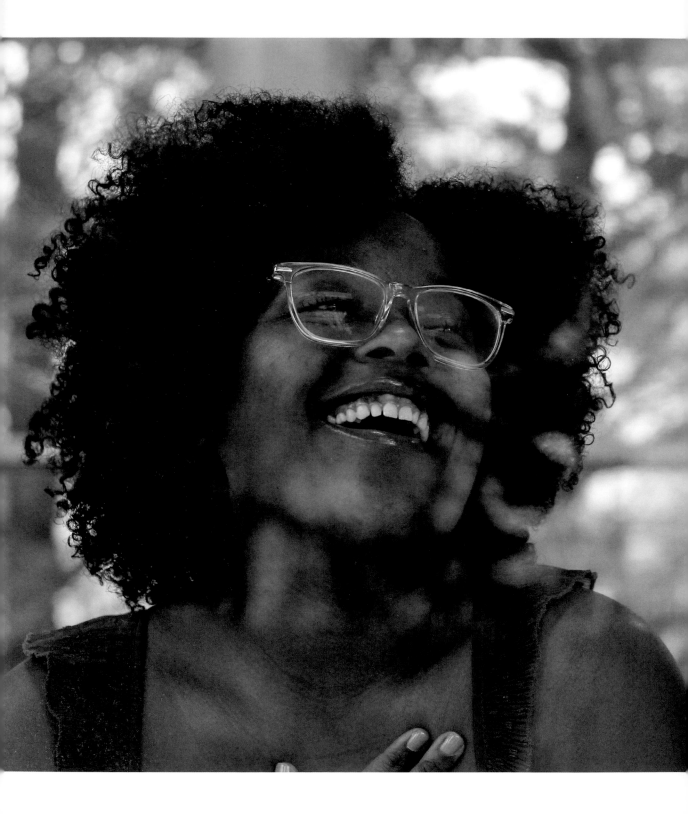

I was in high school and I'd just started leaving my hair natural instead of straightening it. One of my white friends was like, "Yeah, I think you look better with straight hair." And that really stung. She was a straightforward person so it probably didn't seem like a big deal to her, but it was to me. I kept wearing my hair natural anyways though. And I'm not trying to pull guys into this, but whenever I did twist outs, guys would always tell me, "Your hair is so beautiful!" But whenever I'd do a wash-and-go, I didn't get as much attention from guys. And so I told myself, *OK, well I guess I'm not gonna do wash-and-gos anymore.* And I didn't start doing wash-and-gos again until this year; it took me three years. But I don't need validation from men—or from anyone—anymore. And I've learned that **you need to love yourself and your body before you can truly accept love from someone else**.

JOSIE JACKSON

I had a cousin who told me that I could wear my hair out curly if I just put conditioner in, and that was revolutionary to me. I went to my eighth-grade dance with my hair curly, and everyone just crowded around me. They said, "Oh my God, your hair looks so good!" I was really proud of my hair at that point, but it was only when I wet my hair and when my curls were defined that I was *really* excited about my hair. So that was sort of like Hair Consciousness 1.0.

Hair Consciousness 2.0 came after I graduated college. I got a texturizer, which makes your curls looser. It felt like a toxic shampoo. The hairdresser left the texturizer in a little bit longer than I would've liked her to. It left my hair feeling numb and limp. I took photos during the process, and my face is progressively sadder throughout. It was really shocking, and I cried a lot afterward. I realized that I actually had a really personal relationship with my hair; it wasn't just stuff growing out of my head. It was a relationship *I* wanted to figure out, and I didn't want anyone to get in the way of that. So that brings me up to present, I guess, and it's still an ongoing process. I wish I cared less about the frizzy hair, the flyaways and stuff, because curly hair is so dynamic. But I definitely don't stress as much about what my hair looks like now—especially in the work environment.

There's a lot to unpack. The idea that straight hair is "normal" is just a construct, really. Textured hair exists everywhere. There's a whole spectrum that exists that we can embrace; we just need to expand our idea of what we can live around. White people shouldn't look at someone's afro and say, "Oh my God, this person didn't comb their hair." This person *did* comb their hair; this is just how it dries. And there's a term for that: *cultural relativism*— when you analyze someone else based on your own parameters. And that's so illogical, you know? So many people are striving toward a straight-haired, "presentable" image, and it's kind of cool that our curls naturally bounce away from that. If you wet our hair, it just resists straightness. And I think **that's sort of a revolutionary thing: that each curl is different** on each part of our head.

ZAHRA AHMED

Do you want me to just list all the things I love about my hair? **I love that it's black, I love that it's curly, I love that it's strong, I love that it's growing, I love that it's free**, you know? The image of Black hair has not been portrayed well in the media over the years, so unfortunately it was hard growing up and feeling different, you know? You get bullied, teased, made fun of because you're different, and you're taught from a very young age to not understand your difference, so to love yourself is actually a fight. It shouldn't have to be that way. And hair is a big player in that arena. So I guess for me, I'm just at the point where I embrace who I am, and I respect who I am, and therefore I respect all things about me.

SARA PRENDERGAST

I used to get texturizers, but I stopped because I don't like the chemicals. I cut off all my hair and rocked a really short hairstyle, and then I let it grow back. My hair was really big and full in my early twenties. And I loved the bigness and the fullness of it. But then I started dyeing it a lot, and dye changed the texture of my hair. It wouldn't curl up at all, and it was just very flat. Even now, it's still not as big as it used to be. So I've had to fall back in love with my hair as I'm trying to really restore balance to it. And I'm not letting society tell me that there's something wrong with my hair, and I'm trying to be OK with every curl and kink. It's a struggle, **but it's a beautiful struggle**.

KRISHAUN SMITH

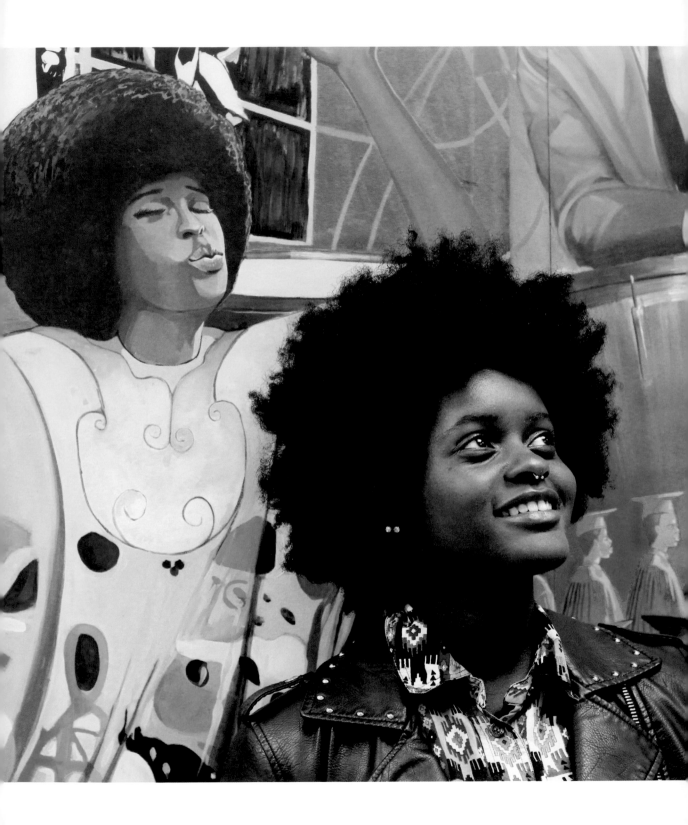

Your hair is a part of your body. And you wouldn't want to harm any other part of your body, so why would you harm your hair? I'm not saying that you shouldn't experiment with your hair, but just be cognizant of how you treat it and keep in mind that whatever you do has side effects. Your hair—just like any other part of your body—is fragile and **should be treasured**.

DAI PARKER

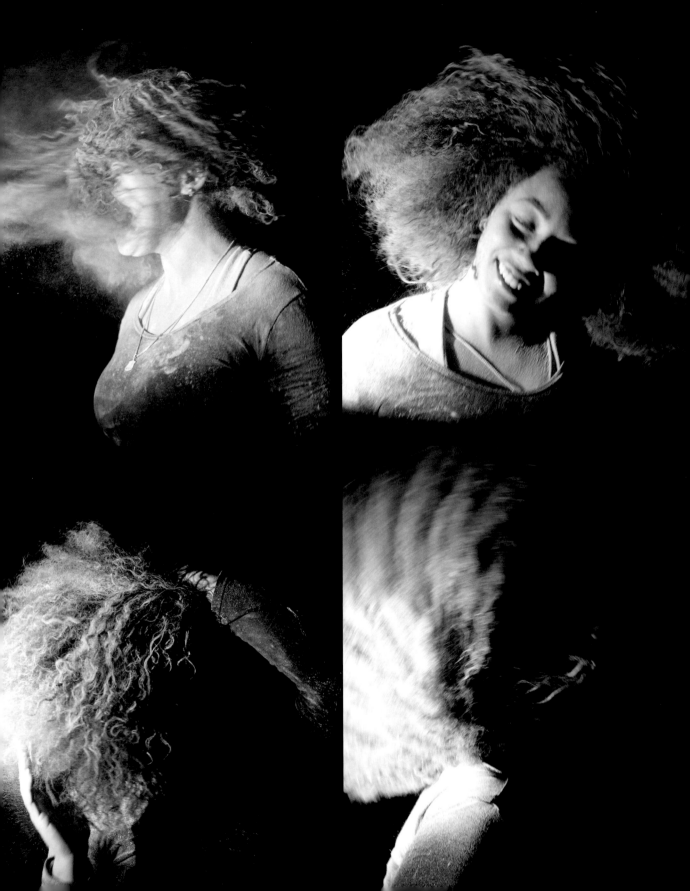

Growing up, I always had my hair blown out. So I'm getting used to my curly hair now. I'm still not completely comfortable with it. I have moments where I'm like, *You know what? I'm just gonna do my thing and wear my hair curly.* But then if I hear any type of comment, I get put off balance. Like this past summer I was wearing my hair curly a lot, and my coworker at my real estate job was like, "Curly hair just seems so immature to me." And then as days went by, I started thinking, *Hmm, maybe straight hair does look more mature.* Isn't that crazy? I guess I just feel like I don't have enough strength sometimes, and so I keep bouncing back and forth. Sometimes I still want to straighten my hair, even though it's damaging.

My foundation for loving my natural hair isn't really solid; I'm still building it. So I guess my advice for others would be the same advice I have for myself: Don't think about what everyone else says. Just do you. Wear your hair how it's supposed to be: naturally. And **begin building your foundation as soon as possible**. Put in the work now to love yourself so that things will be easier later on.

ANALEE JIMENEZ

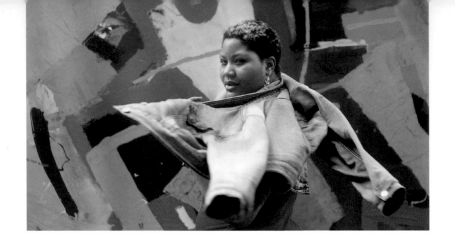

My hair was breaking off. It was really thin. It felt like plastic. And it was just lifeless. So I grew out my relaxed hair and cut it all off. Now I love my short hair. I've gotten over the stigma of "You need long hair to be beautiful." And I rock this short cut everywhere I go. Because when your hair is short, you're basically showing yourself; there's nothing to hide behind. So it's just like, here: here are my cheekbones, this is my face, and this is who I am. And it just basically screams confidence. Because it's been centuries of women being told that longer hair is beautiful, and so for a woman to basically buzz off her hair to what some would say would be a man's haircut is amazing. That's a confident woman. **You can't tell her nothing**. As a woman, you need to be confident in everything that you do, and so from this day forward, your main words when you wake up are, "I am confident and I am who I am." And I wish you the best in life, and I know that you're gonna be a beautiful woman.

IMAHIA STANFORD

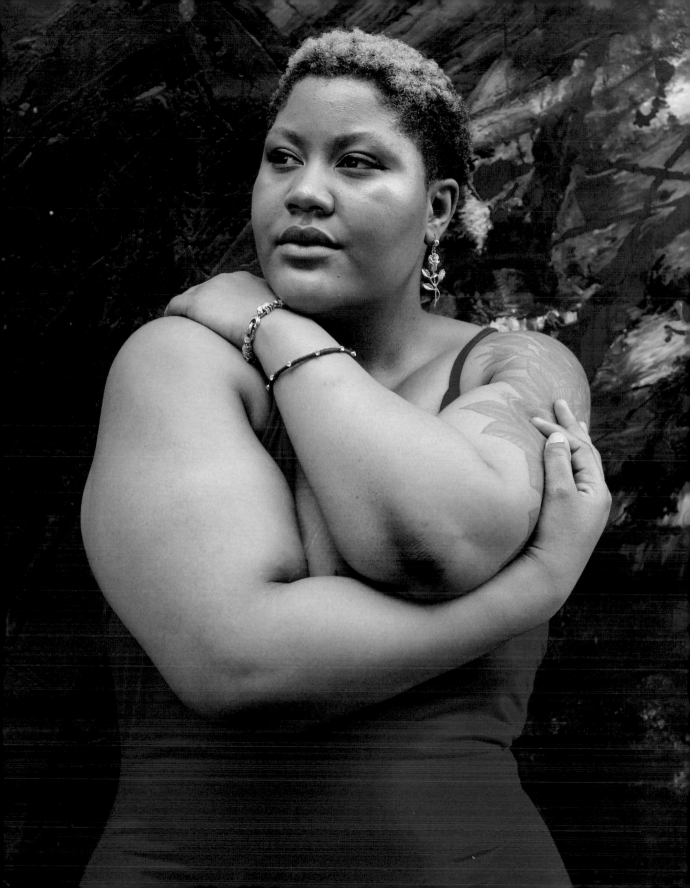

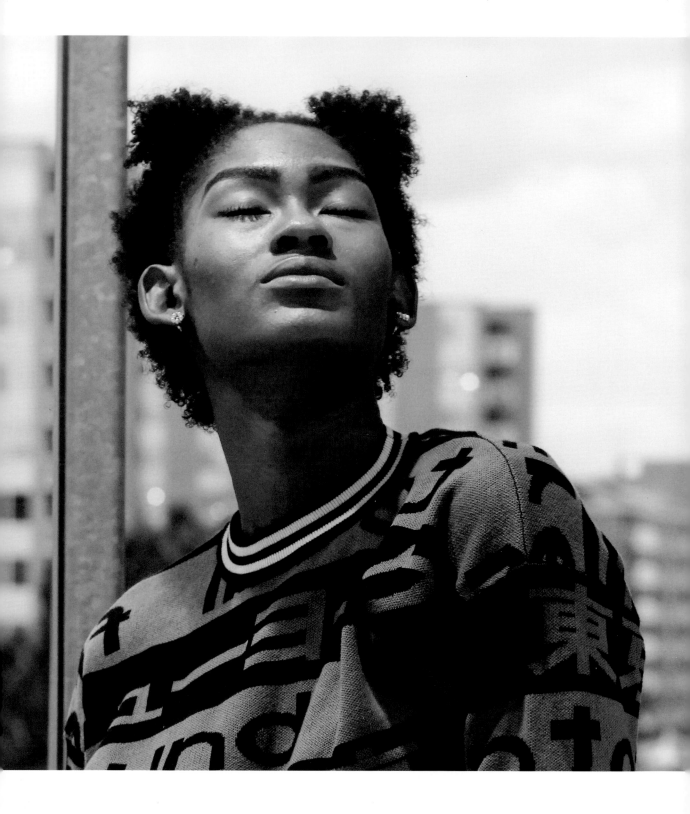

Your hair holds so much power within yourself. Your hair explains you. When you see a woman with a big afro, you know: This woman loves herself. She doesn't care what anyone thinks because she knows she's beautiful. She doesn't have to press her hair, put a weave in her hair, or do anything to be considered beautiful. Society has told her, "You should do this or that with your hair," and she's told society, "No. I like myself the way that I am. If you don't like my hair, then keep it moving." And my confidence has grown so much since I went natural. **It's just so free to have your own hair**.

PATRICIA ALBERT

Dear **Khloe**,

Everybody says this, but it's true: We always want what
we can't have—including hair texture. But in reality, we
should just feel so lucky to have whatever hair we were
born with. Because whatever hair we're born with
is just so naturally beautiful. So I really hope that after
seeing this book, you realize that you're not alone.
There are so many women who have hair just like yours,
and that makes you part of a beautiful community.
And never be afraid to speak your mind—we need the
insights that kids have to offer.

Your sister,
Ellin

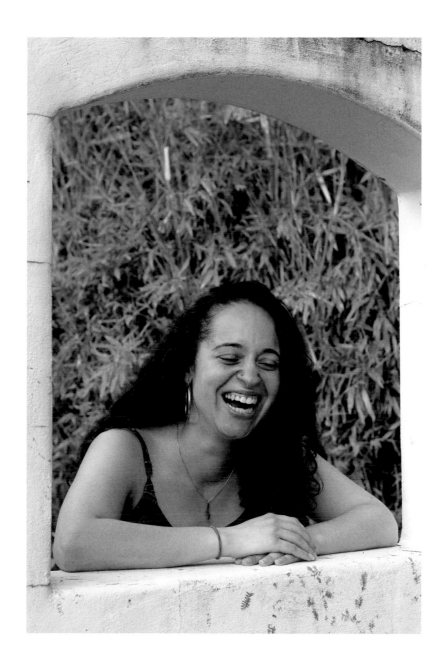

I used to get confused when people asked me how I learned to love my natural hair because I've been natural my whole life. I've always felt like my hair is so cool. I love its texture, I love its versatility. My mom had to explain to me that some people don't love their natural hair. And sometimes it makes me feel sad that the fact that I love my natural hair makes me rare.

But I've been modeling since I was five, and as I've gotten older I have noticed that when I'm on set, some stylists aren't knowledgeable about how to do natural hair. And sometimes I feel like, because of that, I'm not gonna get booked again. So I feel like it's unfair because that's probably why I don't see a lot of other girls who look like me on TV and in ads. But I will always stay loving my natural hair. And the more the modeling industry wants me to straighten my hair, and when they get an attitude about it—just for that, I'm not doing it. The more the industry kind of pushes back against kinky hair, the more adamant I become about keeping my hair natural. **It's not me that needs to change— it's society**.

CELAI WEST

Sister

hood

"It's my responsibility to step up on my sister's behalf when people hit her with rude comments about her hair."

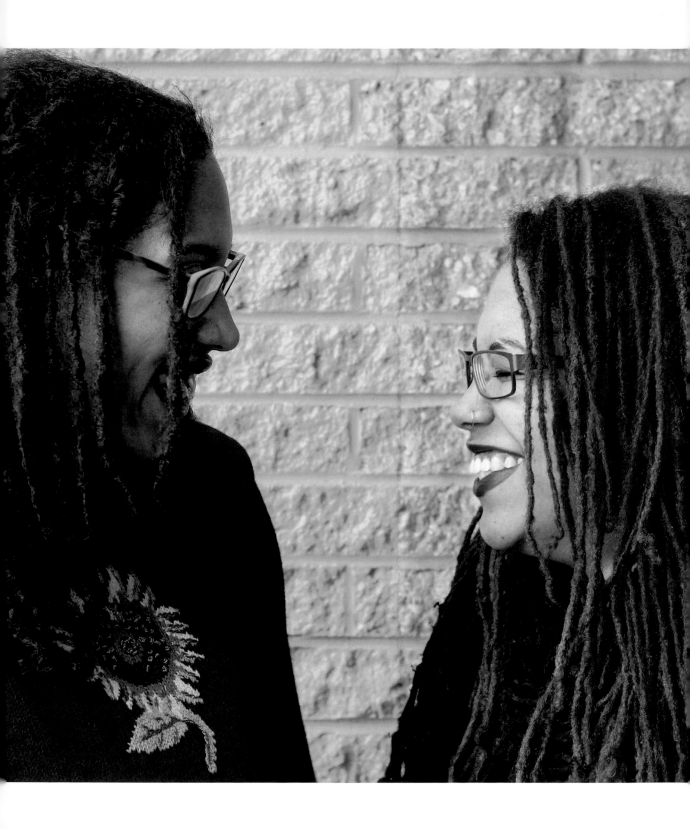

So, let's see. My natural hair journey started when I was thirteen and I decided I didn't want perms anymore. I cut my own hair off in the bathroom. **Just chopped it all off.** And then at eighteen, I decided I wanted locs. But my mom said I couldn't lock my hair until after I finished high school, so a week after graduation I started the locking process.

REBECCA FUNDERBURK

(Right)

It wasn't until my sister started locking her own hair that I really saw the possibilities of my hair. I don't know if you remember this, Rebecca, but I was flat-ironing my hair one time and you told me, "You're just adhering to Eurocentric beauty standards. **You need to liberate yourself**." And you were right; I've felt liberated ever since I went natural and locked my hair. I never wanna cut off my locs. I'm gonna be in the grave with these locs. I just love them.

LAURA FUNDERBURK

(Left)

OK, so I don't particularly remember *telling* you that you needed to "liberate yourself," but I do remember feeling as though you were trying to adhere to a specific standard, and that's why you kept flat-ironing your hair. And I felt like that was a problem.

REBECCA

Yeah, you were right. It was a problem.

LAURA

I went to school for sociology, and the one thing I learned is that there are certain things society has taught us, without us even knowing it. So some people have been taught to think, "Oh, you're light-skinned, so you're automatically gorgeous." And because I'm light-skinned, people often think I'm another ethnicity. I think I played into that by straightening my hair. But when my little sister went natural, I realized that **melanin is beautiful**, and everything that comes with it is amazing.

AVANT GRIFFITH

(Blue dress)

Some people say, "Oh, what if you're trying to get a job or start school?" But I never think about that. I've always liked the texture of my hair. I don't do much to it. I feel like the laziest naturalist, but I'm still a naturalist. **Every curl and coil has a place in this world**, and you don't need to conform to society and change your appearance. It's about self-love.

AFRA M. ABDULLAH

(Red dress)

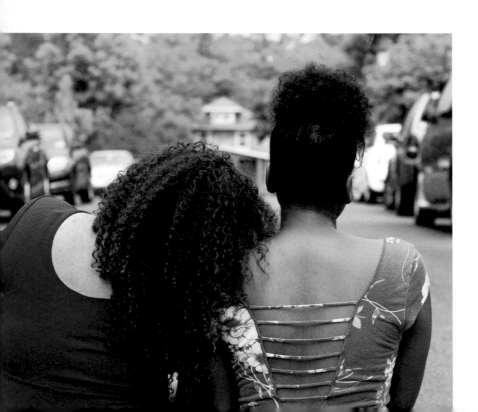

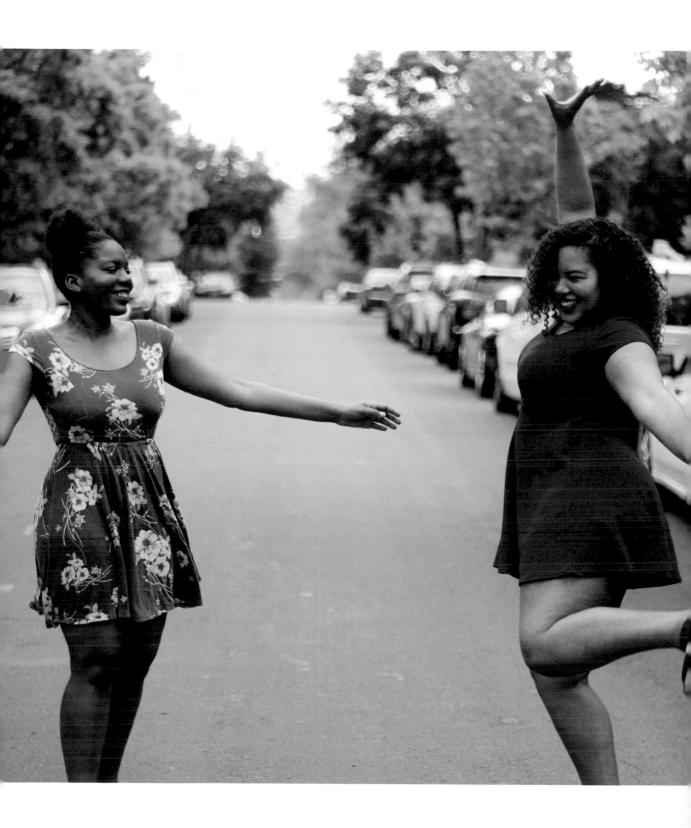

My elementary school was predominantly Black, and everybody there straightened their hair. I was always looking at how everybody else had their hair, and that's probably why I put mine up in a bun: that way, nobody could really see that it was curly. And then I went from one extreme to another when I got to my majority white high school. I didn't have many Black female teachers there, but the ones I *did* have relaxed their hair, and so did the other Black female students.

I've never thought about this before, but I guess my school environment did have a big influence on how I wore my hair. Maybe it had to do with wearing a uniform my whole life, you know? I was so used to looking like everyone else: same clothes, same shoes, same bookbag. I guess I wanted to have the same hair too.

When I got to college, the natural hair movement started growing, which helped me embrace my natural hair and wear it out more. Then I cut all my hair off before starting the Peace Corps in Malawi, and that was really empowering. So many women there had short hair too. And I loved having short hair; it was so much curlier. I love having long hair too though. And now that I'm a teacher, I like talking with my coworkers about our natural hair journeys; **it's big for students to see their teachers wearing their hair naturally**. Because I never really saw that when I was in school.

ELLIN PHIRI

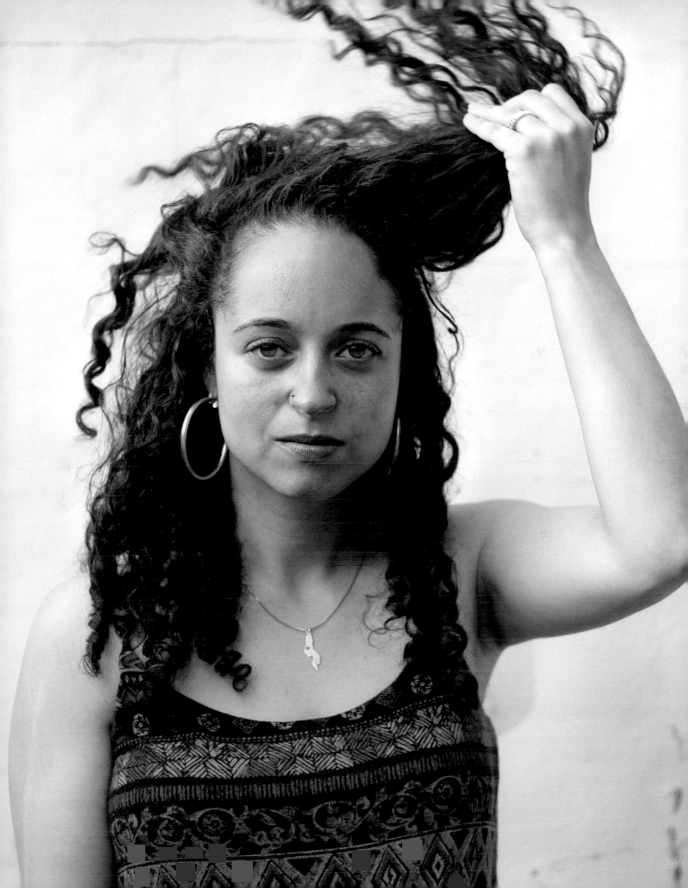

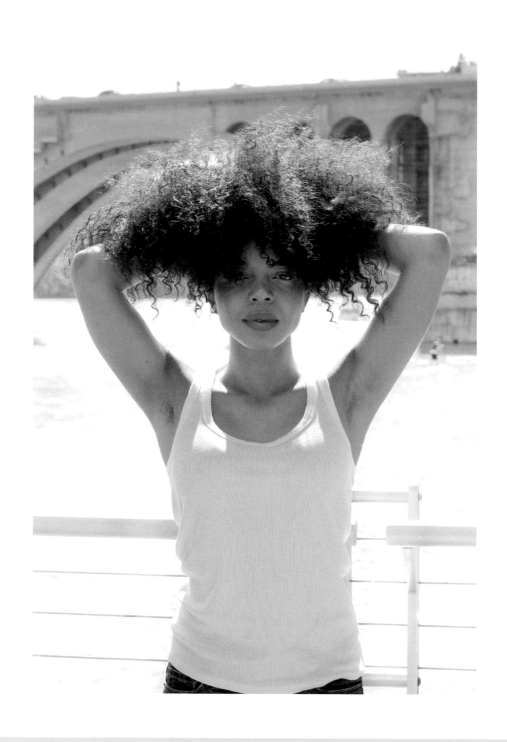

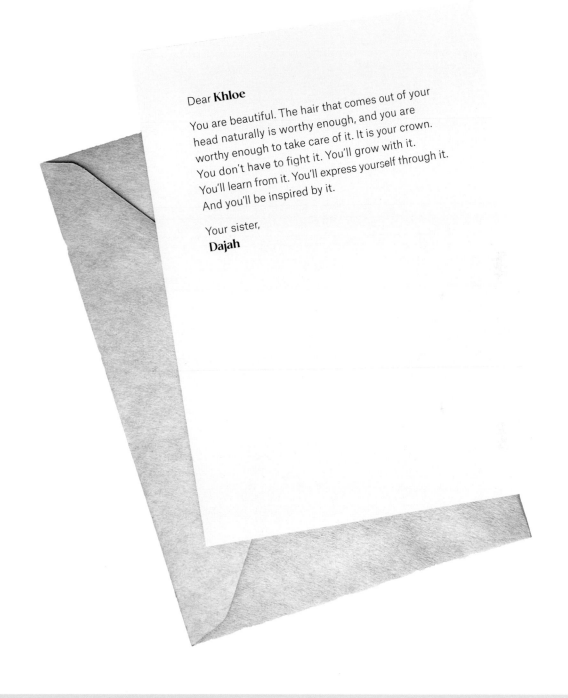

Dear **Khloe**

You are beautiful. The hair that comes out of your head naturally is worthy enough, and you are worthy enough to take care of it. It is your crown. You don't have to fight it. You'll grow with it. You'll learn from it. You'll express yourself through it. And you'll be inspired by it.

Your sister,
Dajah

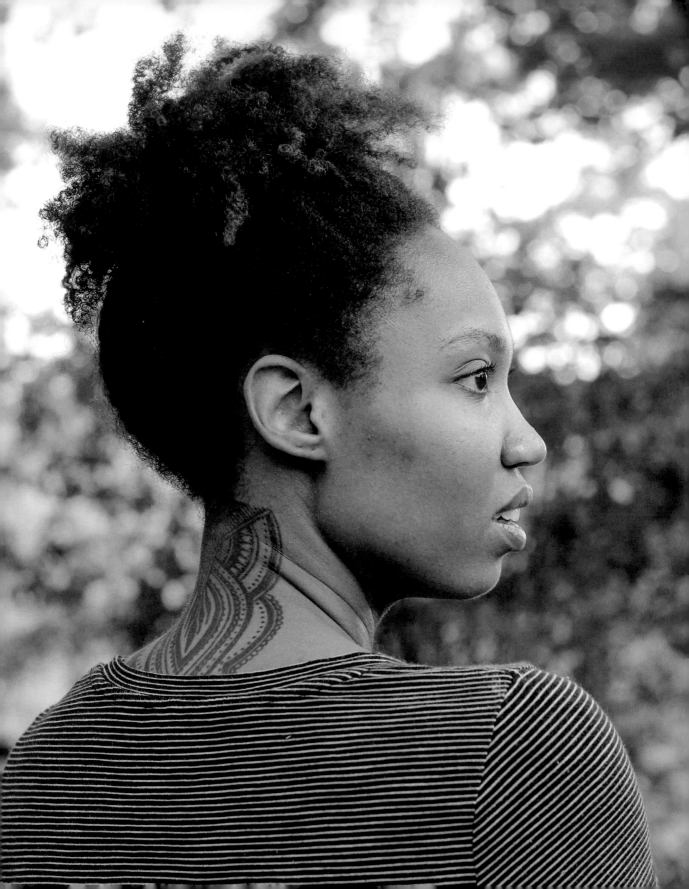

I definitely had to reprogram myself. I would go on Tumblr, and I would look at pictures of afros all day long, just constantly. And then after about a year, that's when I kind of started to see my natural hair as beautiful. Because up until then, I thought that straight hair was the best—and only—way to be beautiful. I cut all my hair off and started again. I had a little teeny tiny afro, and then I grew it out. Both my parents didn't care. My grandmother though, every time I see her, she's like, "What is wrong with your hair? Why is your hair like that? Why isn't it straight?" But all my cousins are also natural, so we're just kind of like, "Whatever." All of the older generation in my family, they hate it. They're used to the wigs or perms or whatever. But now the whole perm thing is, like, not a thing anymore, at least with the next generation, so that's nice. Sales are down for perms and chemicals. So yeah, **it's really powerful**.

TIA JOHNSON

My mom has been blow-drying my hair a lot, which causes heat damage and takes away my curls. So I basically have a little bit of curly hair, but not that much. Every time I wet my hair and let it dry for a little bit, it looks really heat damaged. One time I went to the salon to cut off the damaged ends, and my mom got mad. She thinks my hair is gonna turn out to be really bad, like she thinks it's gonna turn "nappy." She just likes it straight. But I hate blow-drying my hair. **And it hurts**. The heat, it really hurts. Embrace your natural hair. Show it off. Don't do anything to change it.

LEEANN JIMENEZ

(Pictured with her older sister, Analee)

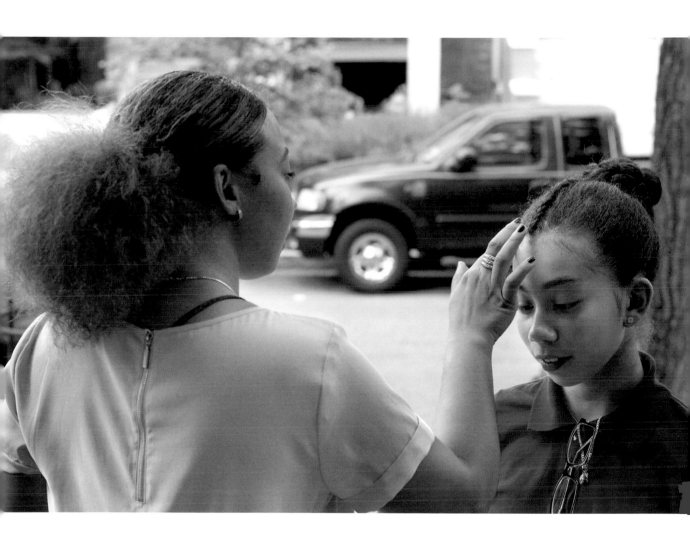

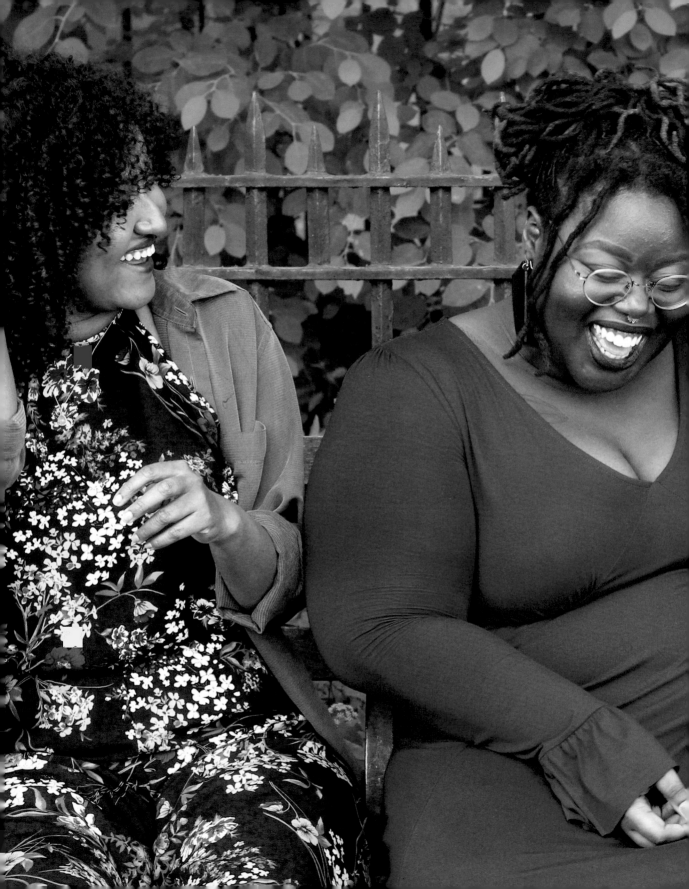

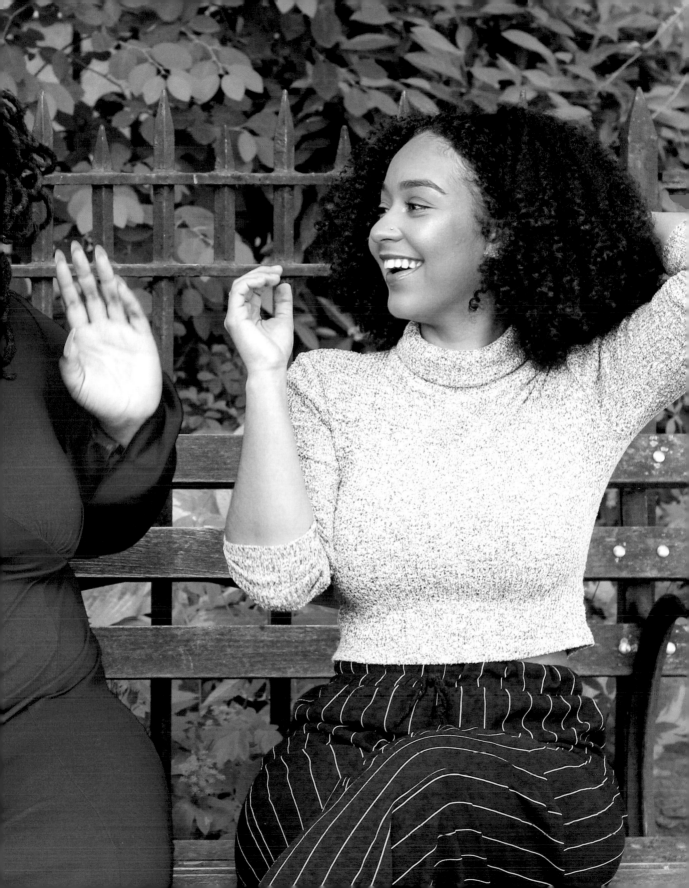

My dad's from Ghana, and my mom is Mexican. But she's like a white Mexican, almost, and her hair is really straight, so she had no idea how to do my hair. She'd wash my hair, but then she wouldn't be able to comb it out and it was just like a frizz. Sometimes she'd put my hair in little *trenzas*—braids—and that was my hair for a long, long time. During eighth grade, I started wearing it out a bit; I had the straight bang and curly hair look—that was a thing. But I was the only Black and Hispanic person in my parochial school. Everybody else was non-Black Latino. So sometimes they would throw stuff in my hair. One time, I remember, they had little balls of paper, and little by little they put them in my hair, and I didn't notice till they told me. I turned around and it was all in my hair. I ran out of the classroom and cried and cried and cried and cried.

Fast forward. After middle school, I went to a predominantly white elite school on the Upper East Side of Manhattan. I didn't fit in at all; I felt a lot of insecurities around being Black *and* Hispanic. I was trying to understand what my identity was, and it was all a mess, so I decided to perm my hair. And of course I had it straight for all four years of high school. And then when I got to college, all the girls were like, "No! What are you doing?" and they convinced me to go natural. Now I've learned to love my hair. It's one of the more interesting parts of me. And I would say to my younger self that I think **some of the things that you find to be the most annoying or ugly parts of you, when you grow up, you find to be the most beautiful and the parts that you cherish the most.** Don't get discouraged. Just keep on keepin' on. That's my thing.

LESLY AFRANIE

(Left)

My mom started relaxing my hair probably when I was like three. I used to have kiddie perms, so I spent the majority of my childhood with relaxed hair. Looking back on the damage to my hair, I get so stressed. When I got into high school I started thinking more critically about my Blackness, about beauty, and I just got really fed up and took some scissors and cut off all my hair. I remember the day before coming to school with my little afro and just being nervous. I look back on it and I'm like, *That's so wild, that my hair growing out of my head the way that it naturally grows was so nerve-racking for me.*

The summer after my first year of college, I locked my hair. So now here I am. I love having locked hair, and honestly, this is the healthiest it's been in my entire life, and it's just doing its own thing, so I'mma let it do its thing. So yeah, that's my journey.

And any words I have to say to Black girls? You are beautiful, you are *seen*. Whatever negative comments anyone has to say, just know that you're gonna grow into a beautiful, intelligent, smart woman, and they're gonna be looking at you like, *Wow, I feel so ashamed that I teased this person whose beauty is so unique.* Because there's so much beauty in Blackness, and that deserves to be celebrated. I know it's hard, but don't give up. **Loving yourself is a process; if you fail one day, there's always tomorrow.** You'll get there.

MAYA FINOH

(Middle)

Growing up, my hair was always curly, but like a lot of little Dominican girls, I always had a bunch of braids—anywhere between three to eight braids, whatever my mother was feeling. And I started getting perms at around five years old. They blew out my hair at the salon, and I felt like I was on top of the world; couldn't no one tell me anything.

But many Dominican salons care about how straight your hair is, not how healthy it is. And with that came a lot of breakage, and my hair never grew past a certain point. When I got into college, I started my natural hair journey. And that kinda kick-started me analyzing my identity, my Blackness, these negative stereotypes I had about Blackness, and all these toxic, self-hating thoughts that I was just beginning to work through. I wanted to finally see what my natural curly hair looked like. So I transitioned for nineteen months, and in those nineteen months, I really unpacked what it is to be Dominican, what Dominican identity is founded on, and why we so badly want to distance ourselves from what makes us, *us.* Our music, our food, our people—it all comes from our African roots. The only things that really came from the Spaniards are our language and our religion.

Growing up, I always saw Black and Brown bodies in the Dominican Republic, and I just don't know how I managed to convince myself that they weren't Black. I've gone to the Dominican Republic every summer and once I got into college it was just, I guess, I don't know, the wool was pulled away from my eyes, and I was like, *Wow, we are Black people. Why did it take this long for me to realize this?* And at first, I didn't like my curly hair, but I pushed through every day, because like Maya (pictured center) says, **self-love is an active work**, something you have to work on every day. I yearned for my straight hair because I felt like it was prettier, but I was really committed to just seeing what would flourish from my head, and I just really wanted to accept what was going on there. And I wouldn't have it any other way. Because your hair makes you unique; no one else is gonna have the same three hundred curl patterns as you. That's all you, something you inherited from your ancestors. It's just something to celebrate.

JASMINE PEREZ

(Right)

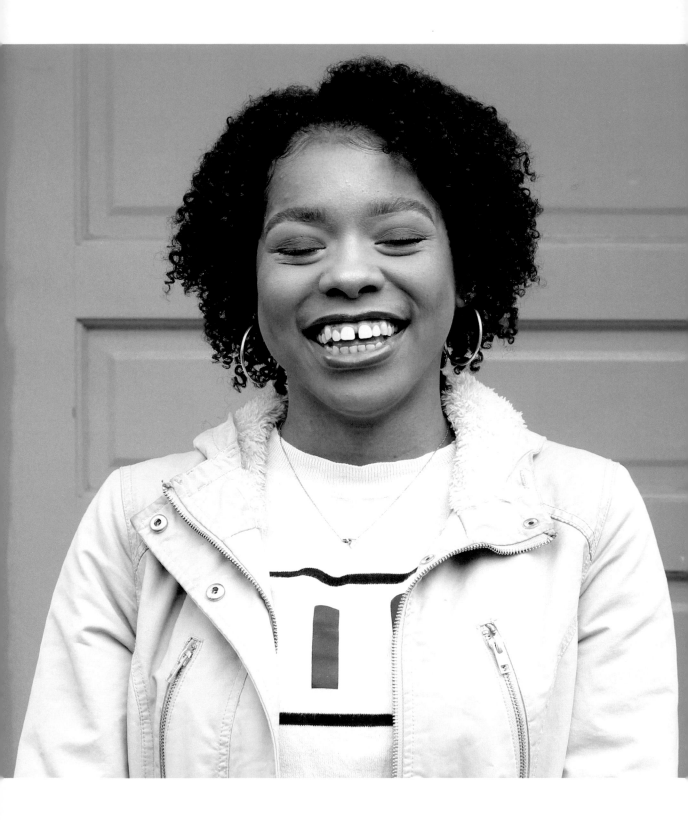

When I look at myself, I realize that this is how I was intended to look by whoever—or whatever—created me. There's nothing wrong with my natural hair, and I wish I'd known that when I was younger. And it's funny because when I first went natural, my mom was like, "Wow, Maya, I didn't know your hair would look the same way it did when you were a kid before you started getting relaxers." But that's the thing: **Your natural hair is just always waiting for you to accept it**. It's always gonna grow back the same way it did when you were a kid, because that's the way it was intended to grow. And my hair was created for me to wear, so when I was finally ready to accept it, it was there waiting for me. But I also don't think we should be judging people who are still deciding to wear weaves and relaxers. It's easy to think, *We've passed that.* But some people haven't, and it's very understandable as to why they haven't; it's hard to go natural when you don't see your hair type being held up as beautiful. Instead, our goal should be to create a society where, at some point, these people would be comfortable enough to go natural.

While we're uplifting natural hair and encouraging everyone to be natural, it's also important to recognize privilege within the natural hair community. My mom's reaction to me going natural was not the same as my mom's reaction to my sister—who has 4C hair—going natural. So when I'm walking up and down the street here at Georgetown University, I don't necessarily have hair privilege. But as soon as I walk through the door at my mom's house, it's a different story; it's my responsibility to step up on my sister's behalf when people hit her with rude comments about her hair. I have to say, "Stop. This is the way my sister's hair was intended to be, and she has the right to wear it the way it grows out of her head." So everyone is privileged in one way or another, and recognizing your own positioning within a space is essential to being a good ally and—in my case—a good sister.

MAYA FLEMING

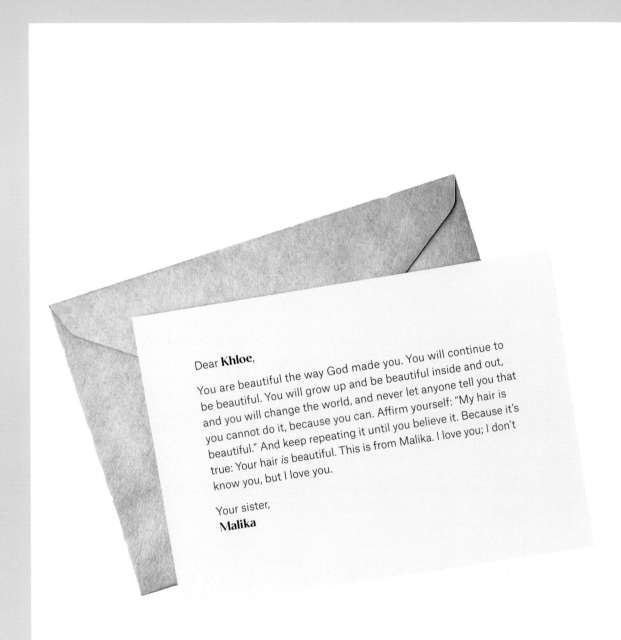

Dear **Khloe**,

You are beautiful the way God made you. You will continue to be beautiful. You will grow up and be beautiful inside and out, and you will change the world, and never let anyone tell you that you cannot do it, because you can. Affirm yourself: "My hair is beautiful." And keep repeating it until you believe it. Because it's true: Your hair *is* beautiful. This is from Malika. I love you; I don't know you, but I love you.

Your sister,
Malika

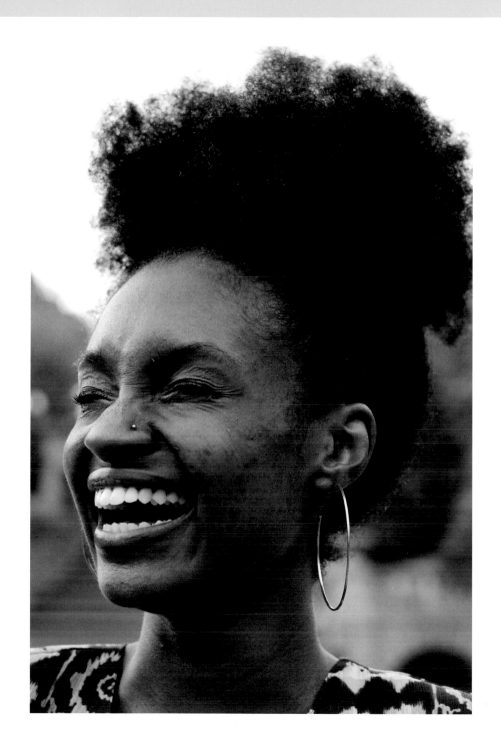

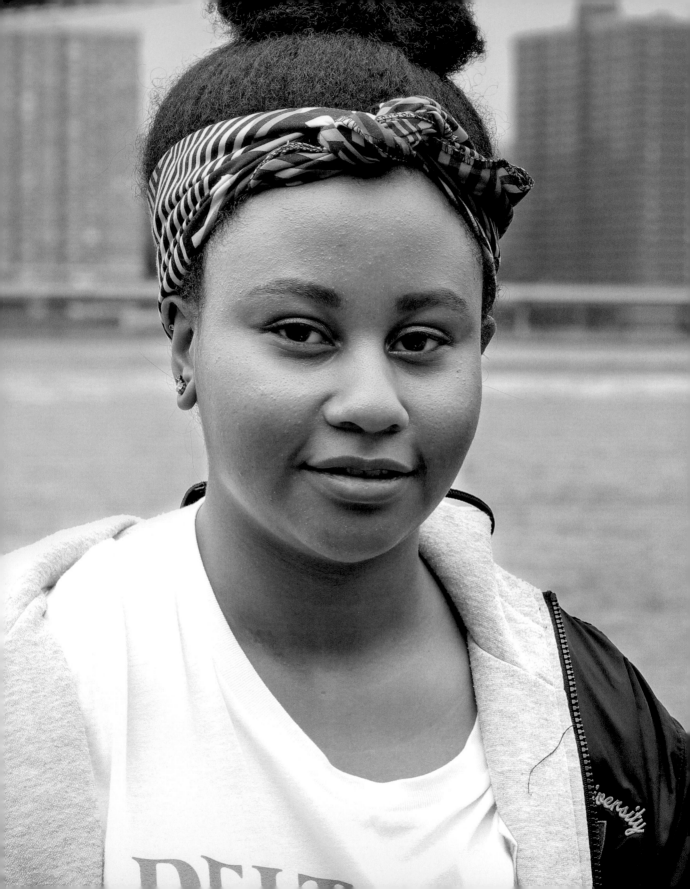

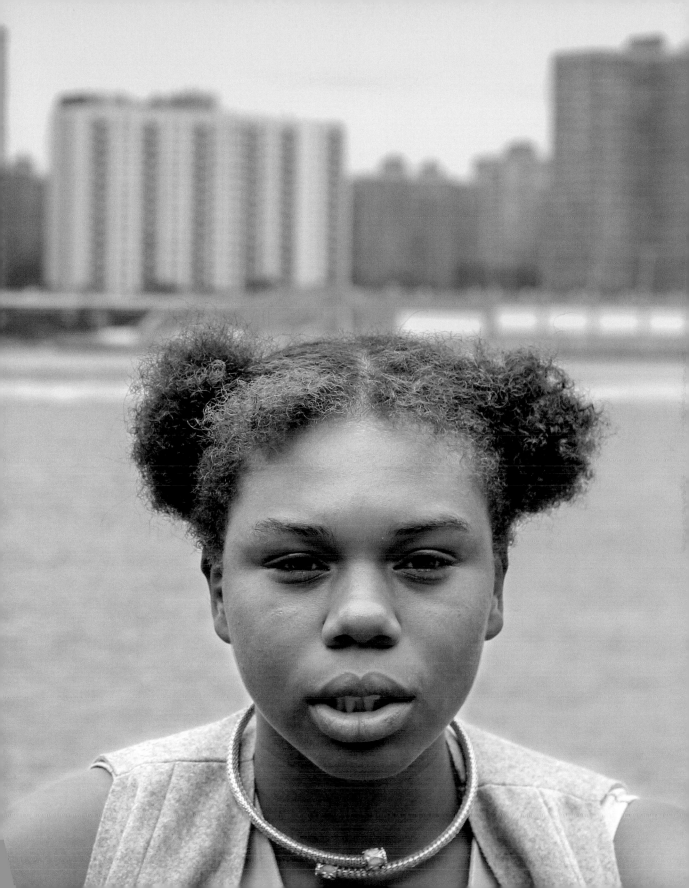

We're taking up space and we're speaking our truths, and it's revolutionary. Of course, it's about criminal justice and racial injustices in policing. But this Black Lives Matter movement has people talking about how racism is ingrained in every facet of society—including our beauty standards.

Black women are the most overlooked and the least heard. Growing up in the white media landscape, a lot of Black girls go through a period of self-hate. We're taught time and time again that there's a certain way you should look, and part of that "look" is straight hair. We're even punished for wearing our natural hair at school and in the workplace. It wasn't until the last year or two that I began loving my natural hair.

When you see all these bad things happening to your people, it's easy to get disillusioned and say, "Oh my gosh, I don't wanna go through this. I wish I was somebody else." But then you look at all the positives of being Black, and you realize, "I can't imagine being anybody or anything else." **I take such great pride in being a Black woman**. We stand at the intersection of misogyny and racism, but we have so much strength. We're becoming more outspoken and taking up space in places that weren't meant for us. And we're inspirational.

There's so much to be proud of: our culture, our swag, our style, the way we speak, the way we care for our homes, the way we uplift our families and our communities . . . I think we have it all. That's why our influence is so widespread. And of course, I take such great pride in our hair. It's so incredible that I get to wear this hair, you know? It's just so majestic and magnificent. It's a blessing. An absolute blessing. And a form of liberation.

KAYLA WHITE
(Left)

166

It wasn't easy for my grandmother to come to America from the countryside of Jamaica in the 1950s and build herself up, but she did it. It wasn't easy for my mom to go to Columbia Law School and gain financial stability for her kids, but she did it. And they've accomplished these things without ever becoming elitist. But what makes me most proud is that they have always embraced their truest, most authentic selves; they haven't tried to change or conform for anyone. And that's how my mom raised me: to be my most natural self. She never shamed me for embracing my natural hair. She was never like, "Oh, it's time to get your hair done 'cause it's looking a little too nappy." And I feel very thankful for that, because **it taught me to live without fear**. So even though I don't wear my hair as a political statement, I'm not afraid of people automatically assuming that I stand with Black lives. Because I do. And I'm not afraid of any judgment that comes with that. As Nina Simone said, "I'll tell you what freedom means to me: no fear."

A lot of Black women are afraid of being reprimanded or fired for how they look. That's understandable, and I would never knock any Black women for wearing wigs and weaves or for straightening their hair. I've worked on a lot of television shows as a background actor, and oftentimes they make me sit in a chair for an hour as they straighten my hair. Or sometimes they tell me to come to set with my hair already straightened or "tamed." There's this Netflix show I worked on that was set in the '70s, when natural hair was a big thing, so all they did to my hair was pick it out. So I really had no fear on that set.

Now I see myself as a resource, as a link, as someone who can guide younger Black women and girls through the acting industry without compromising their values or being put into a box. When I was a little girl, I didn't see myself represented anywhere: magazines, television, movies, or billboards. And if Black girls saw themselves represented, they might not have to go through that self-hatred phase. Casting directors act as gatekeepers, so if I get the chance to be a casting director—and especially if I'm the only Black voice in the room—I want my voice to be heard and respected and used to make sure Black women of all different hair types and skin tones are represented, just like my mom taught me.

ALEXIS PALMER

(Right)

Our hair is love. Our hair is life. And at the end of the day, people will love and accept you as long as you love and accept yourself.

GERMANIA MARTINEZ

(left)

We need to love the skin we're in and love our hair. Because **we have bomb hair**.

EMANI HILL

(right)

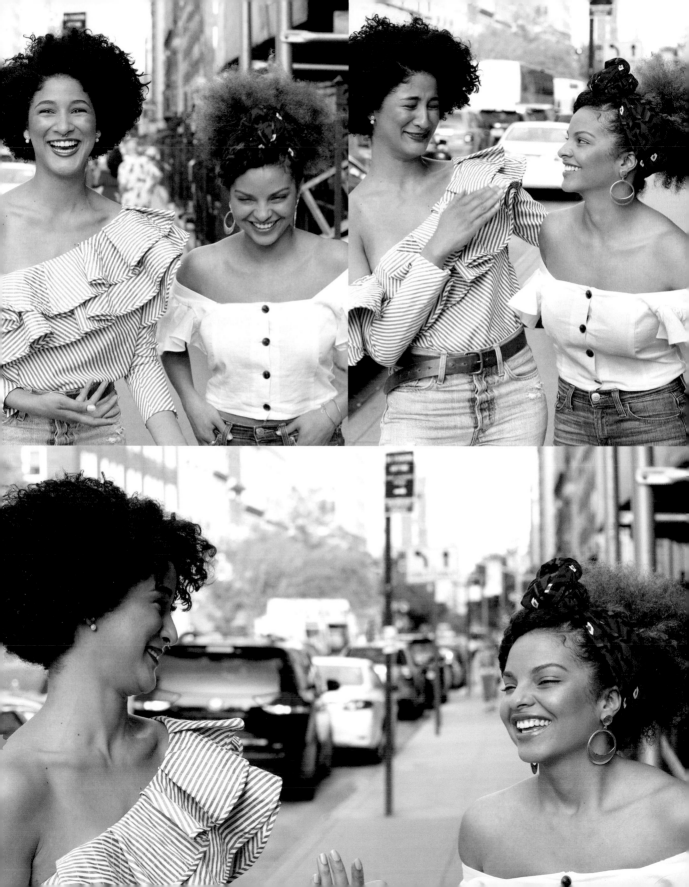

Mothers
Daugh

and
ters

"What I see when I see my daughter with her locs is confidence . . ."

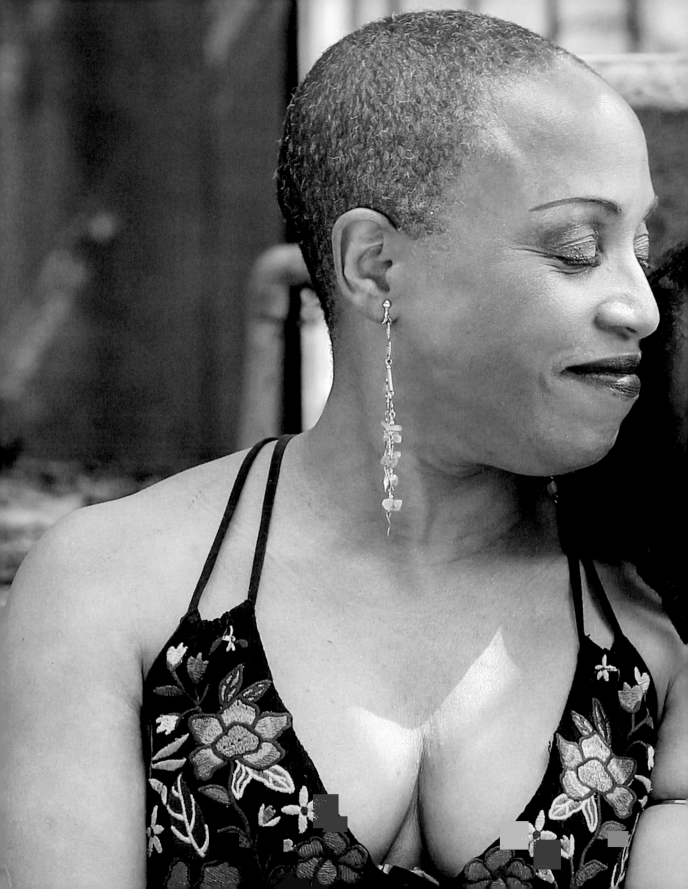

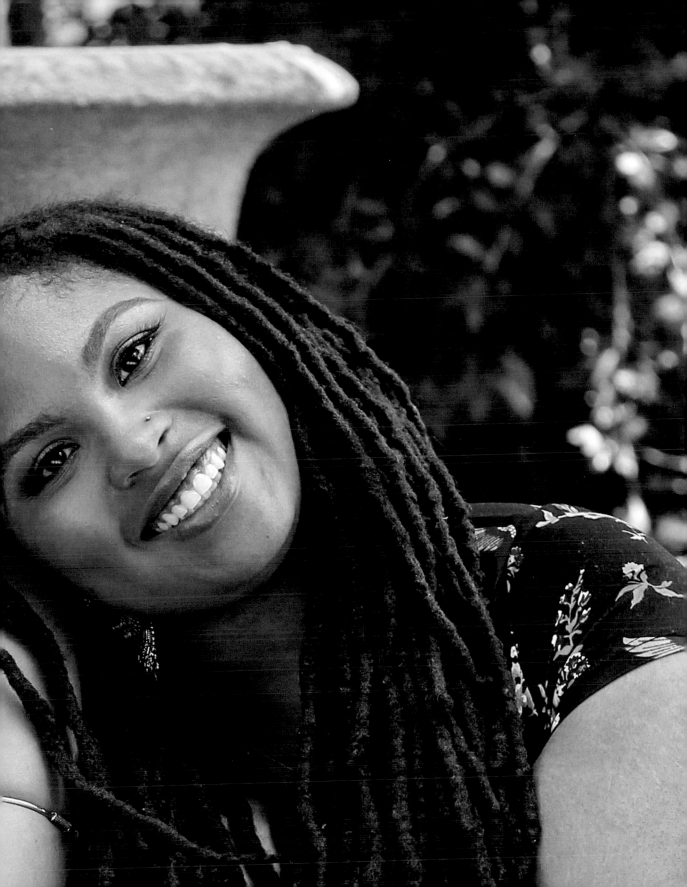

That's just what you did back then; relaxing your kids' hair was the norm. So when I was seven, my mother put a relaxer in my hair. We had a standing hair appointment every other week. We were always the first ones there. Then in my early thirties, my hair was breaking off because it was over-relaxed, and I had a big bald spot. The guy I was dating went to the barbershop, and I happened to go with him. I remember thinking, *I'm gonna cut my hair. I'm gonna cut it until I can love it the way it grows out of my head.* And I hopped up in the chair and said, "Just cut it all off!" I went home, covered all my mirrors, cried for three days, and then started going out again. People even started asking me to model.

When Siobhan was born, *I knew*: I wanted her to have natural hair. Because when I had a relaxer, I couldn't go swimming, I tried not to sweat, I was always paranoid when it rained. **I always call it the prison of our hair**, and I didn't want my daughter to be imprisoned the way I was; I didn't want her to have that life. I wanted her to be free. And it makes me cry because I just think of all the strife my hair caused me when it was relaxed, and I wonder, *What would my life have been like at twenty if I had just loved my hair?* I *fought* with my hair, so to see Siobhan happy with her hair—to know that she feels pretty with her natural hair— that's my dream.

KARYN-SIOBHAN ROBINSON

(Mother)

I'll forever be grateful that my mom never let me get a relaxer. That choice was kind of taken away from me, and so I've never had to go through the big chop with my hair being stringy and falling out. Every time I took a bath, my mom would rinse my hair and she'd say, "You have the most beautiful hair I've ever seen." Like, every time. And then when I was ten, I got my hair blown out and flat-ironed, and I asked my mom, "Mommy, why don't you tell me my hair is pretty like this?" And she said, "Siobhan, the rest of the world is gonna tell you your hair is pretty like this. **I'mma tell you your hair is pretty when it's natural, because I know the truth and I know the history behind our hair.**"

A year later, my mom dragged me to see an advanced screening of Chris Rock's documentary *Good Hair*. I really did not want to go, but that movie changed my life. Watching the scene of a chemist putting a soft drink can in relaxer and seeing it completely disintegrate made me decide *I want no part of this. I'd rather just love my natural hair*. Then the following year I turned twelve and I got locs, and that's one of the greatest decisions I've ever made. So if anything, I wish I would've started locking my hair when I was even younger. My locs are a big point of pride for me, and I love that they stand in defiance to Eurocentric beauty standards. After all, it wasn't that long ago that Zendaya wore faux locs to the Oscars and was told she probably smelled like patchouli oil and weed.

SIOBHAN ROBINSON–MARSHALL

(Daughter)

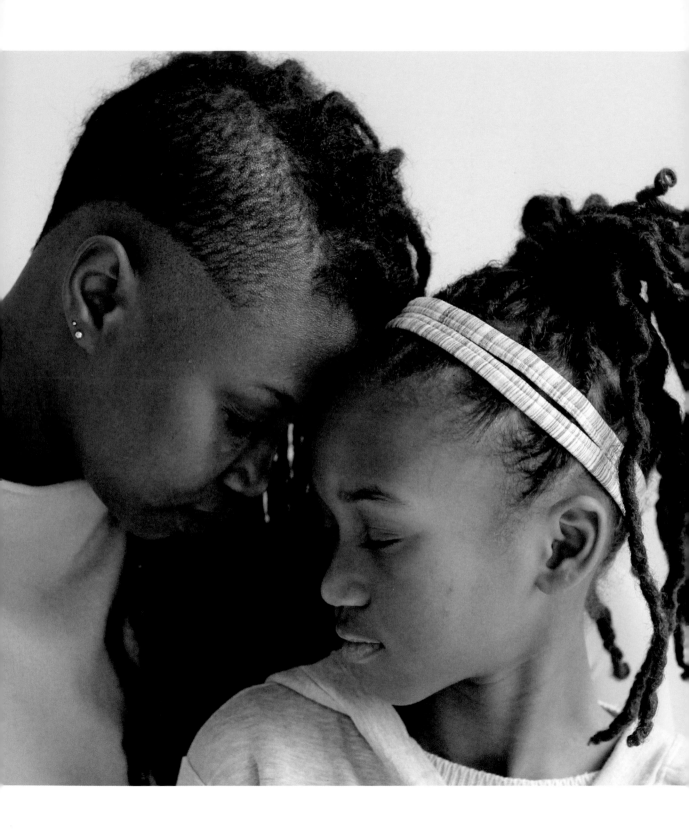

Yazi was *sure* that she wanted to have locs by five years old. She's had them for about four years now, and what I see when I see my daughter with her locs is confidence, a strong sense of self, a creative, and **somebody who is unique in their expression**. I'm so glad that she decided to choose a natural and protective style for herself, and to really honor African American—or African, rather—standards of beauty, as opposed to European standards of beauty. What do you think, Yazi? What do you wanna say to any Brown girls who are sad about their hair? What would you say to make them feel good about their natural hair?

SIHNUU HETEP

(Mother)

I wanna say that God gave you the hair that you need. The hair that you need is beautiful. And **if you're born with that hair, that means you're beautiful with that hair**.

YAZI BERG

(Daughter)

Anything else you wanna say?
What do you think about being Black?
I love being Black.

SIHNUU

Same.

YAZI

Same? Cool. We love being Black. All good.

SIHNUU

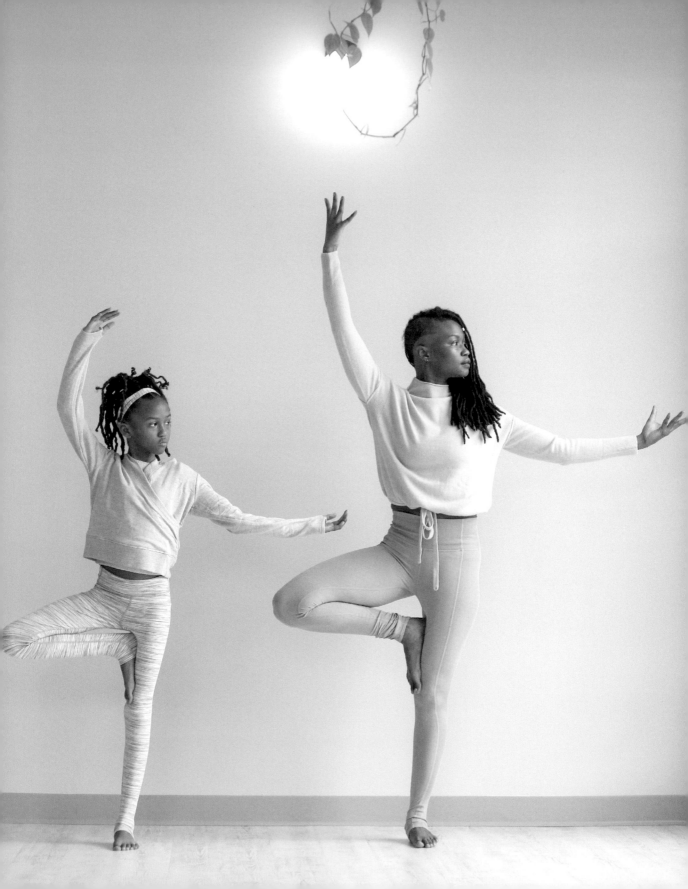

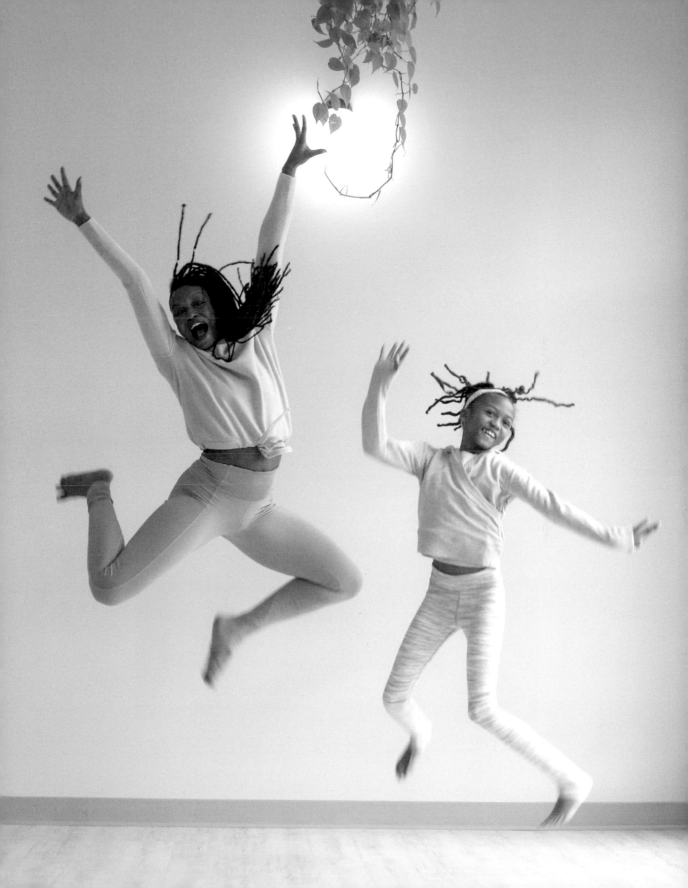

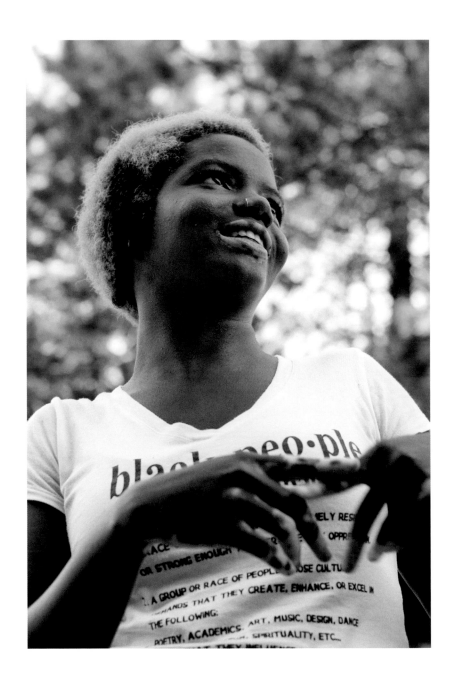

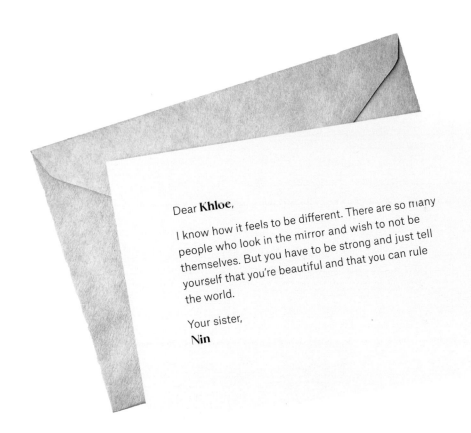

Dear **Khloe**,

I know how it feels to be different. There are so many people who look in the mirror and wish to not be themselves. But you have to be strong and just tell yourself that you're beautiful and that you can rule the world.

Your sister,
Nin

When I was younger, I had a friend named Daniela. She had beautiful dirty blond straight hair. And one day I asked her, "How do you get your hair like that?" She said, "I just washed it." So I went home that day and asked my mom, "Mommy, can you please wash my hair the way Daniela's mom washes her hair so that my hair can be straight like hers?" And that really hurt my mom because it made her aware that I didn't love my hair. So she stopped straightening her own hair, and she started wearing her hair curly all the time. Because she knows how beautiful I think she is, so she was like, "You think *I'm* beautiful? Well this is me, and this is my natural hair. And you look like me." And now I have four younger sisters who all have very different types of curly hair. They've gotten made fun of for their hair, so I'm always telling them that they have to **be the sunshine in all the darkness**. Because being the oldest, I have to make sure they know they're beautiful, and that nobody else's opinion matters. That's what we need to teach the younger generation, and I'm so happy to be a part of this project because everyone deserves to feel beautiful.

BRIANA VELAZQUEZ

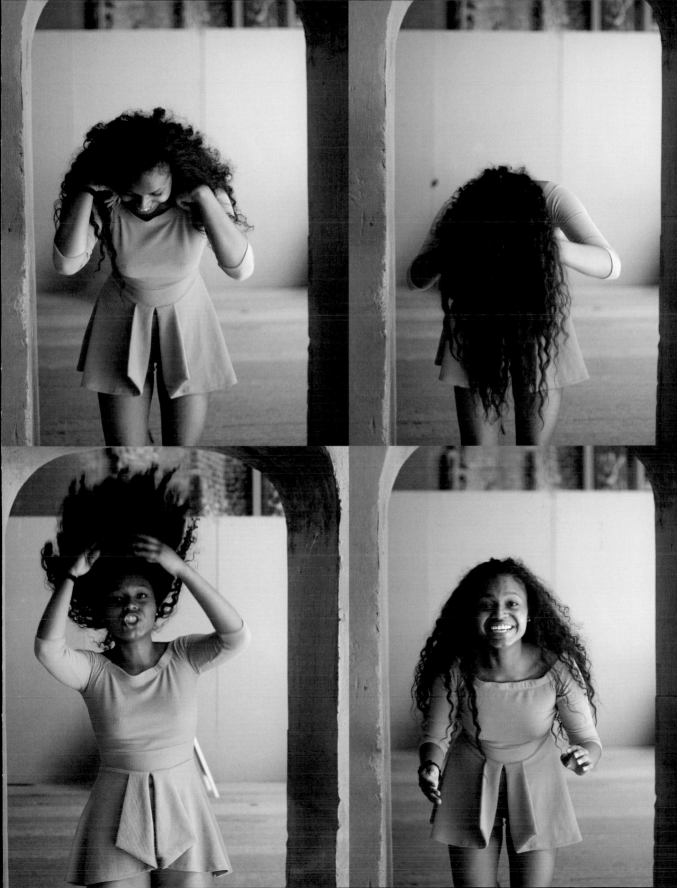

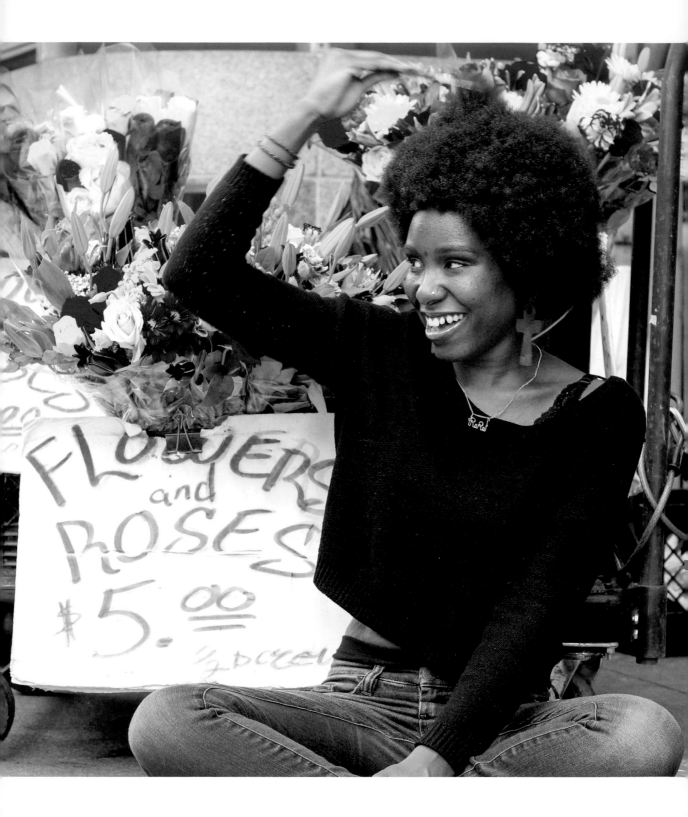

When I was growing up, my mom would put little ponytails and twists in my hair. But I always wanted to wear my hair out in an afro. So one day, I was like, "Oh OK! I'm going to school with my hair in an afro!" I was full of confidence, but then everybody laughed at me, like, "Girl, what are you doing? Why is your hair out like that?" They told me I looked like a tree, and they started calling me "tree girl" and "branchy girl." But you gotta take care of yourself, and I realized that my hair looked like a tree because it was so full— always *full*. I had to encourage myself, like, *Look, I'm beautiful.*

Now I can wear my hair any kind of way I want to, and I don't care what anyone has to say about it. Every day I wake up and I go outside with my afro, **peacefully and gracefully**. I've been teaching my fifteen-month-old daughter how to love her hair too because she needs to be around positivity at all times. So when I pick out my hair, she watches me. She gets my pick and she picks out her hair too.

RASHIDA HOLT

I've always admired my mom, and I've always wanted to be like her. She actually went natural before I did. She had been going through a rough patch, so she decided to cut all her hair off and go natural. Watching both her personal growth and her natural hair growth was beautiful and empowering, and I said to myself, *Wow, I want that joy and that confidence I see in her now. So I went natural too. And I think when women take the time to wash their hair and to do their hair themselves, that's a form of self-care. Because you get to unplug from the world and plug into yourself.*

MICHELLE MUTISYA

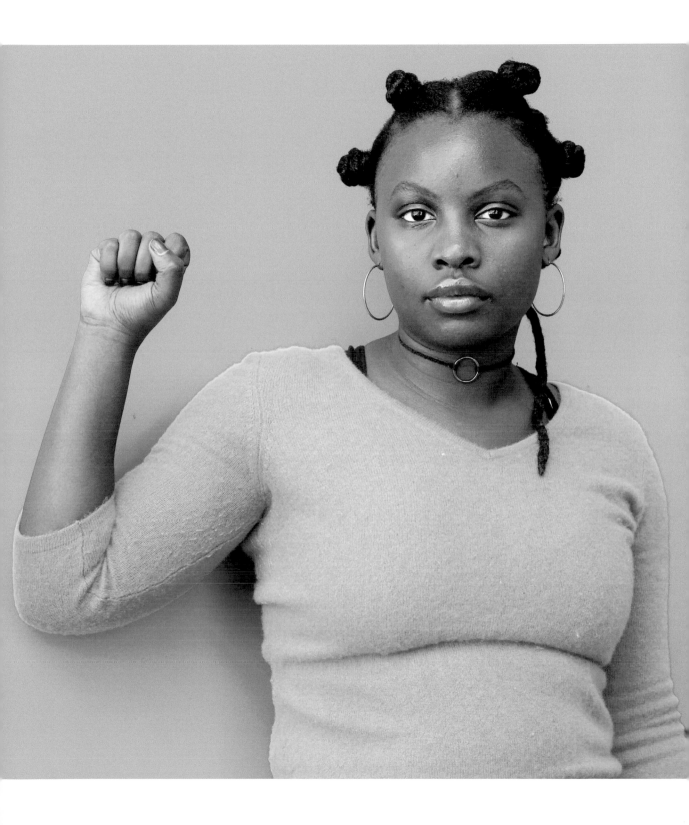

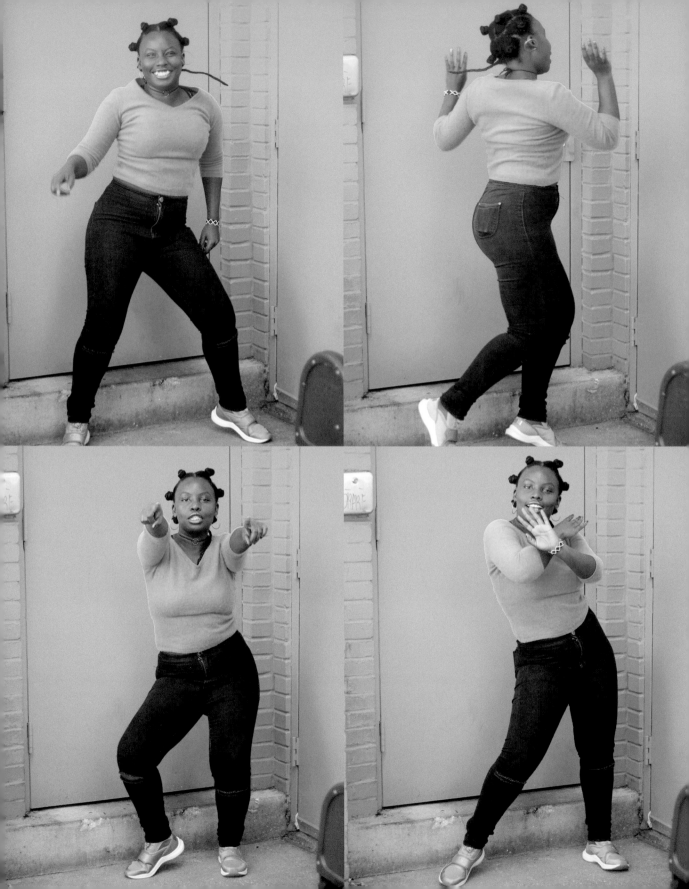

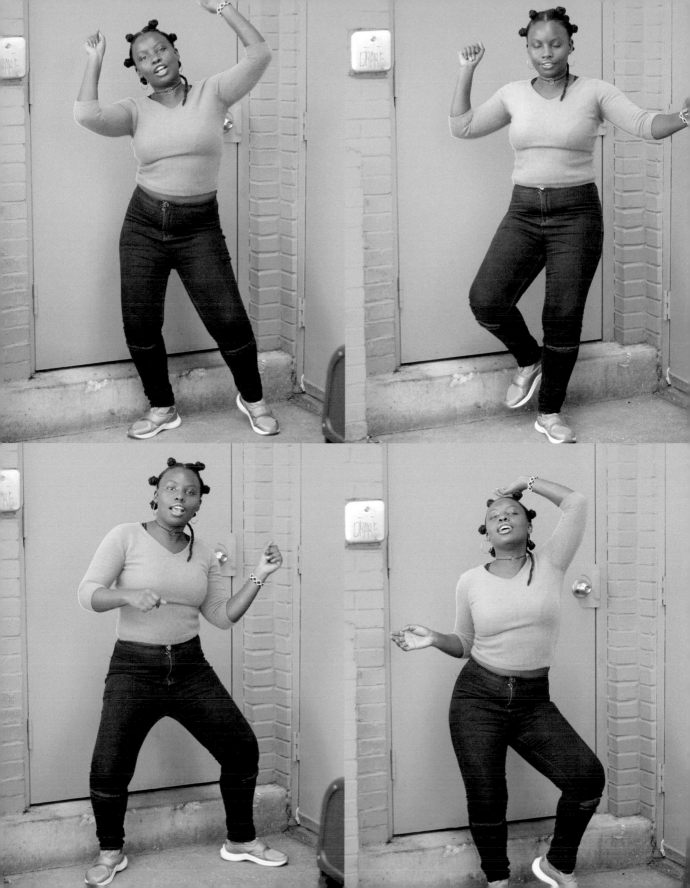

My favorite part about my hair is the curl pattern.
I am *in love* with my curl pattern. Naomi, what do
you like best about your hair?

SABRINA PRATHER

(Mother)

That you can style it *aaaaany* style!

NAOMI PRATHER

(Daughter)

It's really versatile, right?

SABRINA

Yeah. Right now my hair has twists
and gold clips.

NAOMI

I did it because it's Afrocentric.
It's really quite a fashion state-
ment. **And I like that we get
to talk about things and bond
whenever I sit down and do her
hair**. Have you always loved your
hair, Naomi?

SABRINA

Yeah, it's pretty cool.

NAOMI

Do little kids at school
tell you to change it?

SABRINA

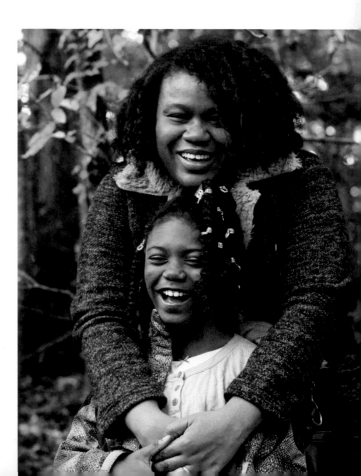

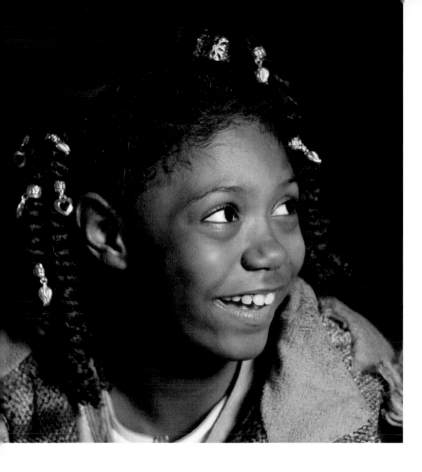

One time, a girl did that. But I didn't listen to her.

NAOMI

Yeah, because you like your hair.

SABRINA

Yeah. I said, "No, my hair's fine!"

NAOMI

That's a great response.

SABRINA

Yeah. It's about knowing who you are.

NAOMI

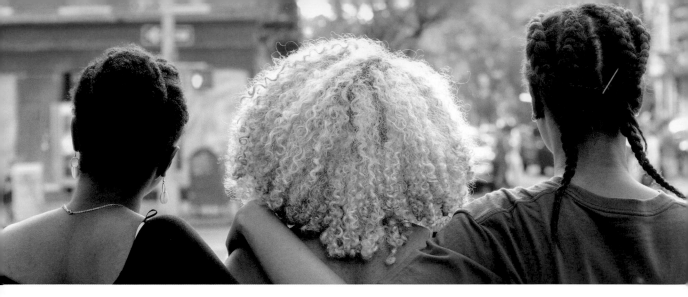

My mom's been perming her hair since forever. When I was little, our mommy-daughter ritual was her and I going to the salon on Saturday mornings so she could get her hair re-permed or touched up or whatever. I thought it was very innocent when I was younger, and I remember wondering, **What's this strange process my mom does to her hair every week?** And I used to love going to the salon because other women would come in, and sometimes they'd bring their kids, and it'd turn into this whole thing of all these beautiful Black women sharing all these stories and pouring themselves into each other. So that's why I thought the salon was a very magical place, in a sense: Because women got to show who they really were before going back out into the world. But it was also the place where a lot of women came to change themselves and hide themselves.

ALENA BLAISE

(Right, pictured with braids)

I wonder how many hair secrets were lost during slavery. Because when we came over here—when they *brought* us over here as slaves— they stripped us of everything. They stripped us of our culture, and that included our hair. I've been reading that many of our ancestors in Africa—women *and* men—would come together and braid each other's hair. It kept the families together, it kept the tribes together. It was communal. We're rediscovering these hair secrets now, which is great.

My mom had her hair permed from a young age; she didn't really have a choice. But about five years before I was born, she cut her hair and went natural. She knew the best way to convince her child that natural hair is something to be loved is to *show* it—to have it yourself. So she's been training me since I was little to love my natural hair. And I wanna do what my mom did when I have children; even if I have boys, I think it's important for boys to know that their hair— or their mother's hair, or whoever's hair—is to be loved.

AMANDA BARCLAY

(Left, pictured with bun)

192

I'm half Black, half Japanese. My Japanese mom has straight hair, and growing up I felt insecure with my hair because her hair was straight and wavy, and my hair was always curly. And I hated that a lot as a kid because I wanted to have straight hair, because if my mom was the definition of beauty, and I didn't look anything like her, then how could I be considered beautiful, right? And I went to a predominantly Asian and white high school, so the standard of beauty was extremely different from what I saw when I looked in the mirror.

I just wanted to be accepted so badly, but the need to be accepted is really overpowering and the root of a lot of self-hate. It gets to the point where you become like a beggar saying, "Please, just give me some acceptance. I'll do anything." And it makes a lot of us want to tone down our Black-ness. It's what made me keep my hair in a bun for the first three years of high school. My mom was really supportive though, and eventually I started enlightening myself and reading books about the Black side of my culture. That's when I realized that **there was actually nothing wrong with me**.

KILALA VINCENT

(Middle)

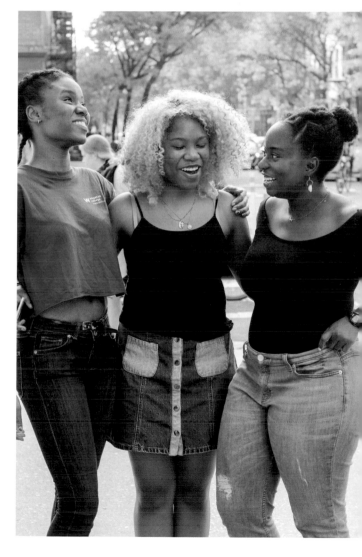

Three years ago, no one could've convinced me to stop going to the salon. One of the things that I actively thought was, *Oh my God, when I'm pregnant in the future, do I have to stop relaxing my hair? Am I gonna have horrible hair throughout my pregnancy?* And I also thought about my future kids; I wanted them to be born with my husband's hair, because he has the "good hair" and I have the "bad hair." And that's just how I grew up: Between my brother, sister, and me, I was the one with the bad hair because it was the curliest. But the second time I went to Ecuador with my husband, I knew they wouldn't know how to straighten my hair properly at the salon, so I was like, *You know what? I'm just gonna wet my hair and rock it.* And I was actually pretty surprised. My hair had a little curl to it, and I was like, *Well, hello there, curls.*

I did go back to my salon when I came back to the US, but then my friend who lives in the Dominican Republic did the big chop, and I thought that was so brave of her. So I was like, *You know what? I'm gonna do it too.* I actually video-called my mom and filmed her reaction with another phone as I did my own big chop. It was hilarious. She thought I was going through some sort of phase and that I would eventually go back to getting my hair straightened. Every so often, she'd ask, "When are you gonna go back to the salon?" To this day, she still tells me, "You messed up your hair. Your hair was so nice before." And I say, "No, no, no, **I didn't mess up my hair. This is how my hair is**. This is what it's gonna be from now on."

SALLY VENTURA

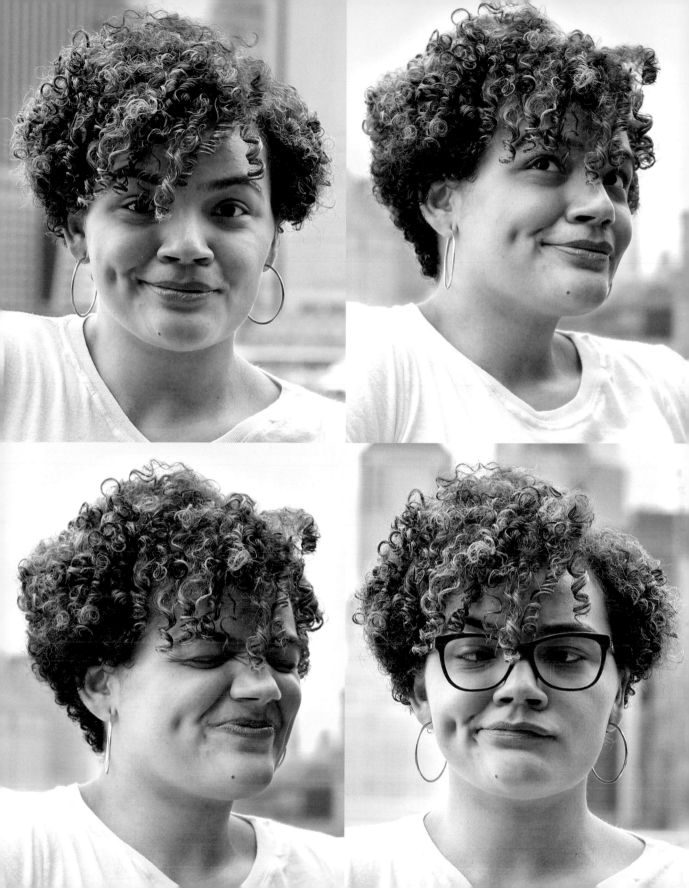

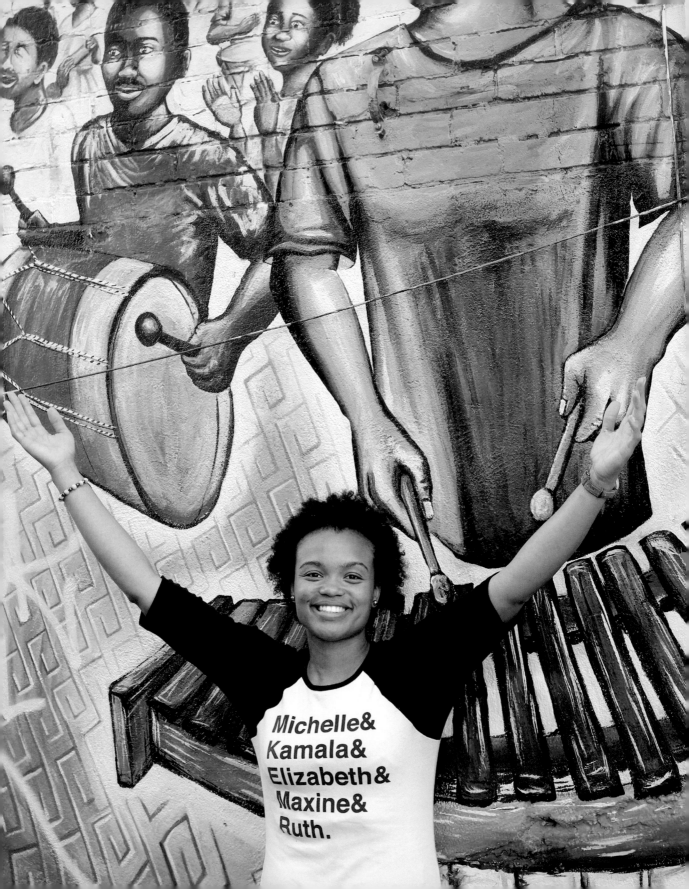

In high school, a lot of my friends started rocking an afro; they stopped straightening their hair and started embracing their curls. And in the back of my head, I was like, *Well, you know, maybe one day I also would like to stop using chemicals to straighten my hair.* Then when I was sixteen, I told my mom, "I don't wanna do this anymore. I don't want to have my hair straight; I just want to see how it really looks." My mom said, "You don't know how your hair looks; it's not gonna be a texture that you think is pretty, it's not gonna be manageable." And then I remember she pulled me on the floor and forcibly placed the relaxing cream onto my scalp and onto my hair. I felt powerless. I felt that I didn't even have control over my body, my hair, and part of my identity.

We often only see the effects of colonization, of so many hundreds of years of these settlers coming and imposing their traditions and ways. Sometimes we feel so disconnected from where our ancestors came from because it's been so long, and we just don't know the history of our ancestors prior to being in the Americas. **So how do you unlearn hundreds of years of colonialism? It takes a long time, but I think it's possible** by reclaiming the hair that we were born with and embracing the features that our ancestors had. I see a lot of power in taking ownership and making my own decisions in terms of my hair.

And now I try to help my mom with her hair too. And within the past couple months, she's been going to work with her hair curly. Now she's also getting braids and cornrows. So I'm happy that she's taking that ownership of her own hair without worrying about what other people have to say. Because you're always going to be reminded of your roots, no matter how much you try to cover them up; you can't just wash away—you can't just straighten away—the essence of your identity.

JOHANNA FIGUEROA

Dear **Khloe**,

You are beautiful the way you are, the way God made you,
naturally. Embrace your hair. It is your crown; wear it
with pride. It's beautiful. Don't let anyone tell you anything
differently. Love it, and love yourself. That's what I tell
my grandkids too. You know, it's *you*. It's a part of your
heritage. So Khloe, stay natural, baby. Trust me, you're
gonna love it.

Your sister,
Michele

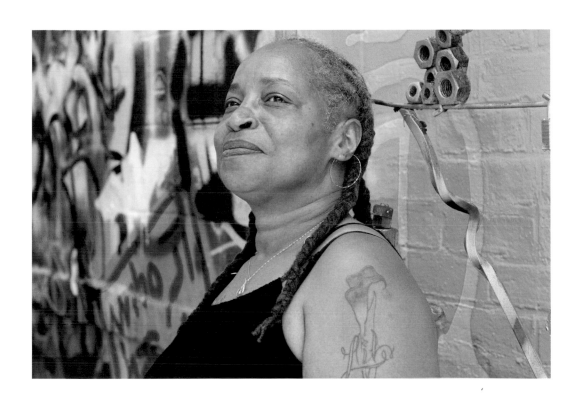

My white mom would say things like, "I just don't know what to do with your hair," or, "How do I work with this?" It wasn't her intention, but I really internalized what she said. I grew up not liking the kind of hair that grew out of my head, and really aspiring for the straight, sleek look. And that was something I really didn't get over until I locked my hair. I feel like the time that I locked my hair was a really rebellious time in my life, and so taking something that people kept telling me was "unmanageable" or "not great" and then turning it into something else—**something that I felt was beautiful**—was symbolic for me in a lot of ways.

But also, your hair doesn't always have to "look done." I think that took me a really long time to learn. As Black women, we're put to this high standard of having to look "put together" all the time, and we're subject to so much more criticism. And I think that's kind of dumb. If your hair is messy one day, who cares? I mean, I do twist my hair up a little bit in the morning, but it comes out all the time. I don't get my locs professionally retwisted, so it's inevitable that my hair's gonna be loose at the top. So that's something else I've had to unlearn: It doesn't matter if my hair doesn't look "nicely done." I still look good.

BREANNA BRUMMETT-SWAYZE

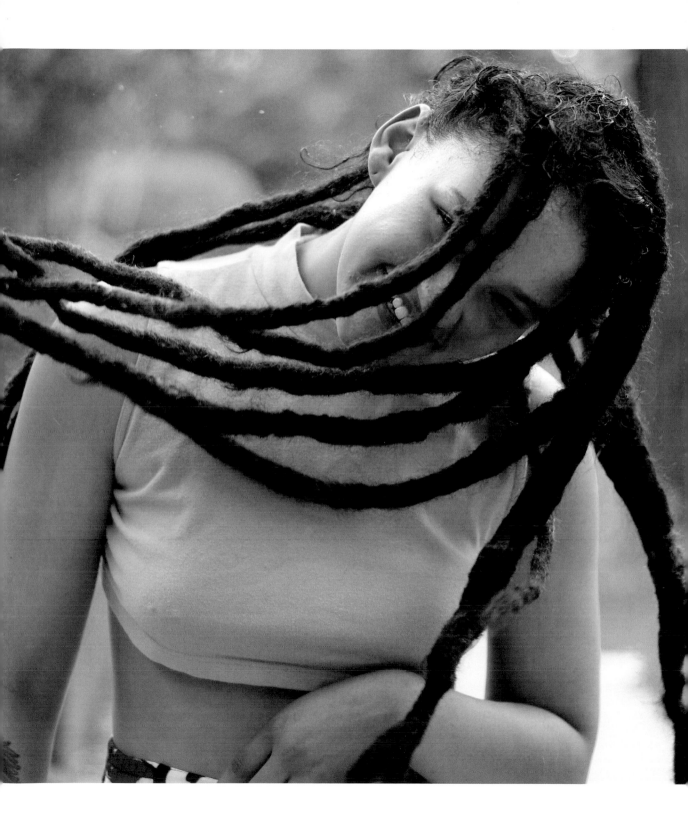

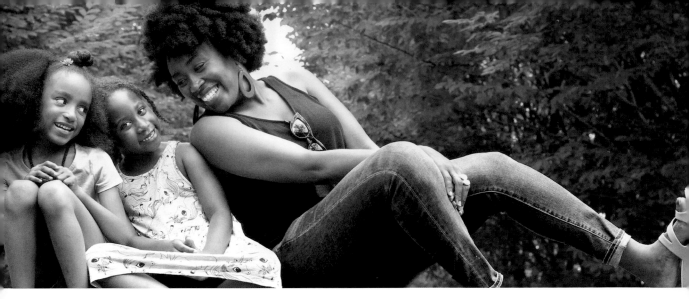

I like that my hair is really fluffy and it can do a lot of things. I can put it in puffs and braids, and sometimes it can just stay really curly. It's really cool. And I think Khloe should like her hair just the way it is. She doesn't need to change it, **'cause I think it's beautiful to have hair like this**.

KAELYN STEWART (Left)

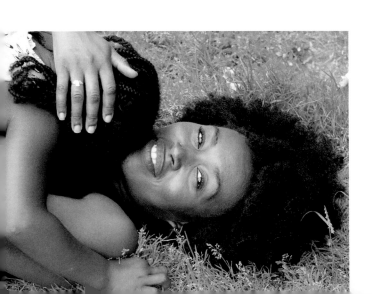

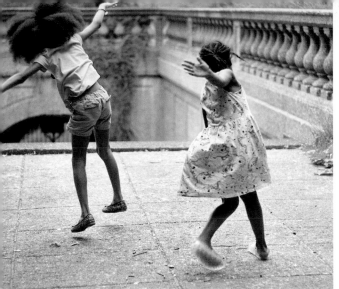
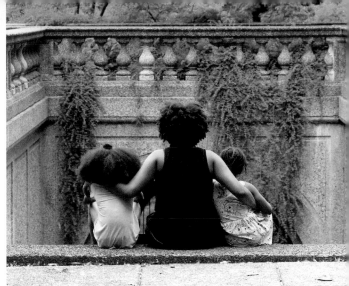

What I like about my hair is that it's very soft. And a lot of people, when I'm out, they say, "I love your hair!" and I appreciate it. I would tell other Black girls: Don't worry about your hair, because I was the same way when I first saw my hair, and I was like, *I really want straight hair.* **But now I feel great about my hair**.

RUTH BENSON (Middle)

I feel great about your hair too. I love our hair texture: the softness, the versatility, **and the way that it kind of curls into itself**.

ROCHELLE RICE
(Ruth's Mother)

White

Spaces

"But also, tell people not to touch your hair."

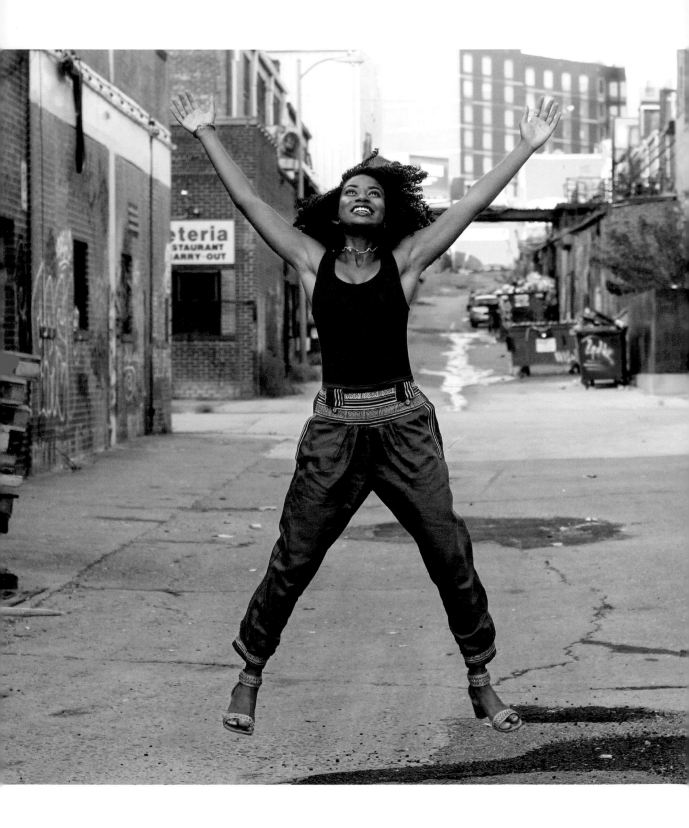

When you're young and you're in a white prep school, you just hate the parts of yourself that are different. I was uncomfortable with Blackness when I was at my really elite, predominantly white prep school, and so I straightened my hair all the time. I remember I used to hate my natural hair, and I used to feel like the only time I liked it was right after I took a shower or bath, and I combed it, and it was really long and flowy. You know what I mean? And I would just feel like, *Oh, I wish I could freeze my hair like this and have it stay like this!* And then, you know, as it dried and got bigger and crazier and wilder, I always just felt like, *This is not how it should be. This is not how it should look.* And then even when I first started wearing my hair curly, it was curly with a ton of product, curly with a ton of gel, curly but brushed back, curly but made to be smaller. I just felt the need to tame it. But not anymore.

Of course, there are still times when I think about how people perceive me. I've been interviewing for medical school, and I feel like I need to put it up or wear it half up or do something with it to make it look "professional." And my job is pretty casual, but I still think there's just an idea of what's "done," like when our hair is "done" and when it's "not done." I feel like my white coworkers can go a couple days without doing their hair and just throw their hair up in a messy bun and that's fine, but I would just never do that. I don't know if that's a me-thing, but I don't think it is; I think it's a Black woman thing. And I feel like people would sort of look at me differently if I let my hair sit for a couple days and then just threw it up.

But for the most part, I feel free now. I don't feel the need to be boxed in by a white European ideal of beauty. And my feelings toward my hair have evolved **along with my feelings toward my racial identity**. For a lot of women, hair is representative of their femininity, and so when they cut it, they feel really liberated and they feel like they're sort of shedding what society has put on them. But for me, my hair has always more so represented my racial identity because I'm half Indian and half Haitian.

NIMESHA GERLUS

My hair was definitely looking like kind of a hot mess for a while. It was half permed and damaged and half natural and healthy. I didn't do the whole big chop thing; I did the whole transitioning thing. And at this point YouTube wasn't a huge thing for natural hair videos, so I didn't really know what to do. My mom was like, "You need to do something with this. Why don't you go get your hair straightened?" But I majored in chemistry, so I was like, *Hm, I'm learning about all these chemicals, and I know how bad they are for you, so why would I keep putting them on my head?* So I stuck with it, and right after graduating, I cut out the last damaged part. And I've realized that **your hair will love you if you love it**. But I didn't always love my hair.

I grew up in a mostly African and Dominican neighborhood, so people were never like, "Oh my God, your hair!" And then I went away to college in Westchester, and I was surrounded by so many people who didn't look like me. I would take out my hair and they would ask, "Can I touch it?" Or they'd just start touching it before they even asked. But here in DC, people aren't like, "Oh my gosh, this is so abnormal. I've never seen this before." They bring up my hair, but only to tell me that they like my hairstyle or to exchange hairstyling tips. It doesn't feel like I'm being looked at like I'm exotic. So I feel less like an outsider here. And I'd tell any Black girl who goes to a majority white school, that people might ask questions about your hair because they're curious and they haven't been exposed to it. So try not to take offense to it, and take that as an opportunity to help them understand something that they've never seen before. But also, tell people not to touch your hair.

DZIFA J. AVALIME

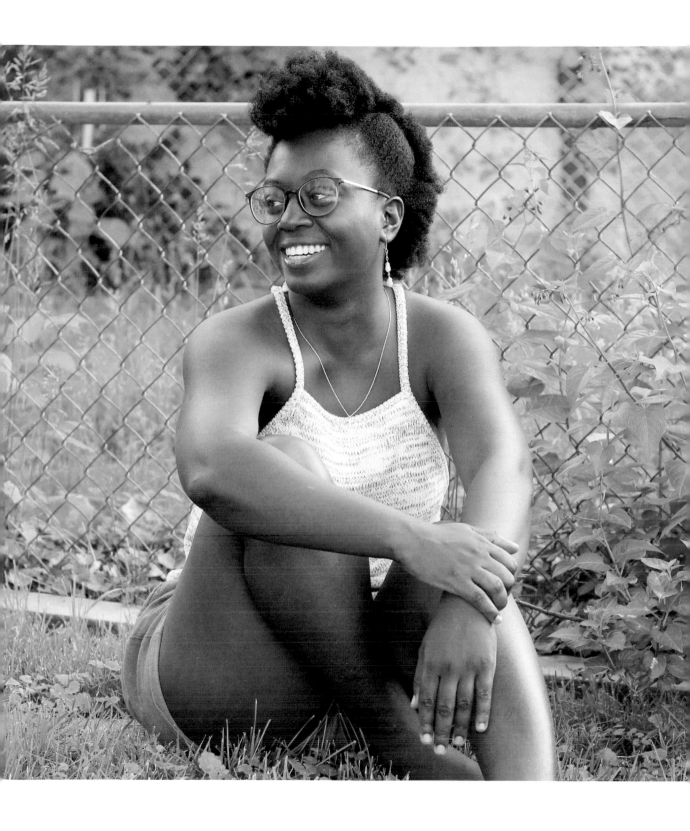

I had just started attending a new private Christian school that was predominantly white, and I joined the swim team so I was getting my hair wet every day. I was the only person of color in my grade, and I wanted to fit in so I straightened my hair every day before school. Then one morning I was running late and I couldn't get my hair straight the way I wanted it to be, and my mom was already tired of me straightening my hair all the time, so she said, "Go stick your head under the faucet. You're not gonna be happy with it all day, and you're gonna get it wet this evening at swim practice anyways, so just get it wet now and wear it curly." So I did, and I went to school with my hair curly and I was really nervous about it. I got into my first period about fifteen minutes late that morning, and there was a commotion because my white classmates had never seen hair like this. They couldn't focus on anything except for my hair; they thought it was funny to throw paper balls in my hair and see if they would stick.

I finished first period, went to second period, and then on my way to third period, the headmaster stopped me in the hallway. He was with the principal and the dean of discipline. He told me, "I'm glad you're adjusting well here. I really like your fluff today. But I've just gotten emails today from your teachers about your hair." Apparently, teachers were writing in because my hair was an "unnatural hairstyle" and it had become a distraction to my classmates. "Your hair is actually against dress code," he said. **My natural hair**, according to my white teachers, was an unnatural hairstyle, and therefore it **was against dress code**. At first I thought the headmaster was joking. I laughed and tried to walk away, but he said, "No, really, you can't go to class. I need you to come to the office." They called my mom into the office too. She asked me what I'd done to get in trouble. "I didn't do anything," I said. "I didn't straighten my hair this morning." She started laughing because she thought it was a joke, but my headmaster was serious: I wasn't allowed to go to the rest of my classes that day.

I didn't really start loving my hair until five years ago when I moved to Washington, DC. It has a completely different demographic than other places I've been, and you see women with the biggest hair here. I even saw Angela Davis speak when I was working at Busboys and Poets. So being around other people who look like me has helped a lot.

KAMARAH NOEL

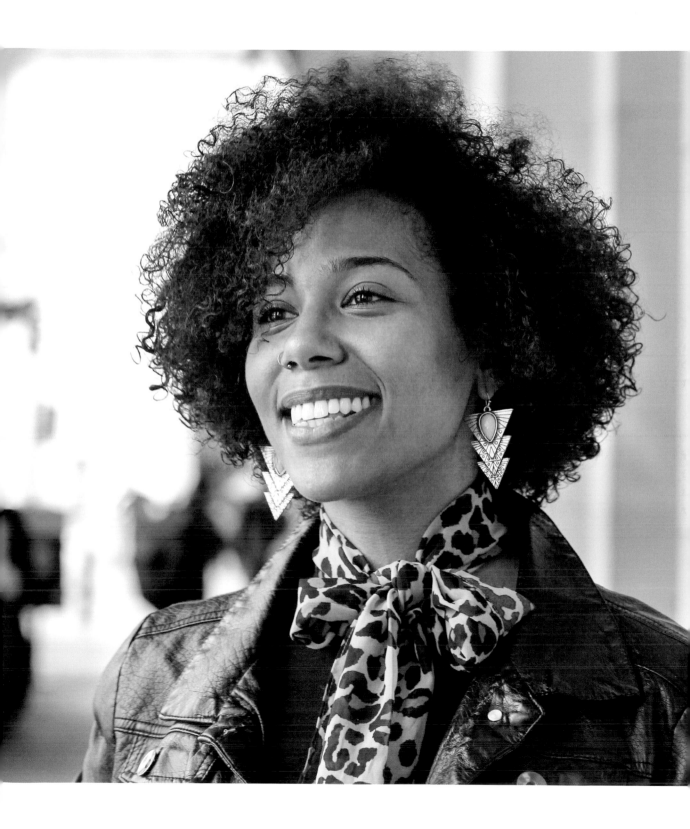

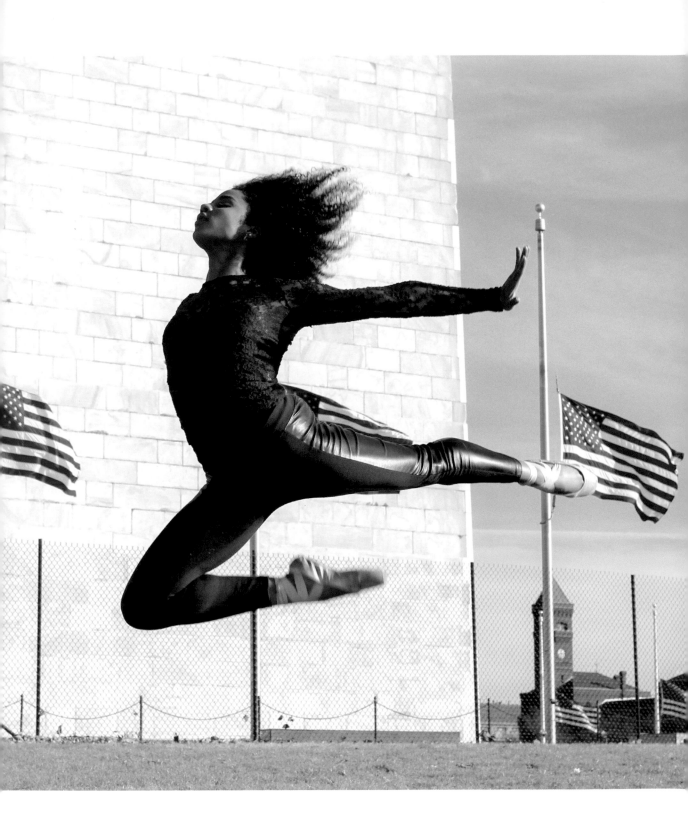

I was born in Puerto Rico, but I grew up in Anderson, Ohio, which is a very white suburb. I was the only Brown kid at school, and I used to get made fun of for having natural hair. **My classmates would rip out my ponytail holder—they would physically take out my hair tie—just to see my hair out and make fun of my "nappy" hair**. They'd also pet it, which felt castrating. So I used to hate my hair. I used to be like, *Oh my God, I'm just gonna shave it all off; I can't deal with the bullying.* I felt really stuck at that school because I didn't connect with those people anyways, and I knew that it wasn't my place.

But I told myself that I wasn't gonna cry and stay upset and care so much about what my classmates thought of me when we clearly just had two different ways of living. You know what I mean? I was an artsy kid, and I was always out doing shows and stuff like that; I never went to the sleepovers or anything like that. So that helped, you know? Ballet was like a little refuge for me. Focusing on what I was passionate about helped me put things into perspective and realize that **I could rise above their bullying and their ignorance**. Because I was doing greater things—things that I felt happy about. I've connected with people from all over the world through dance. And why would I be alive other than to share my life on this earth with others? That's kind of how I look at it: I don't see a purpose in life if you're not doing something passionate that truly empowers you. It's what my soul needs.

HELGA YARÍ PARIS-MORALES

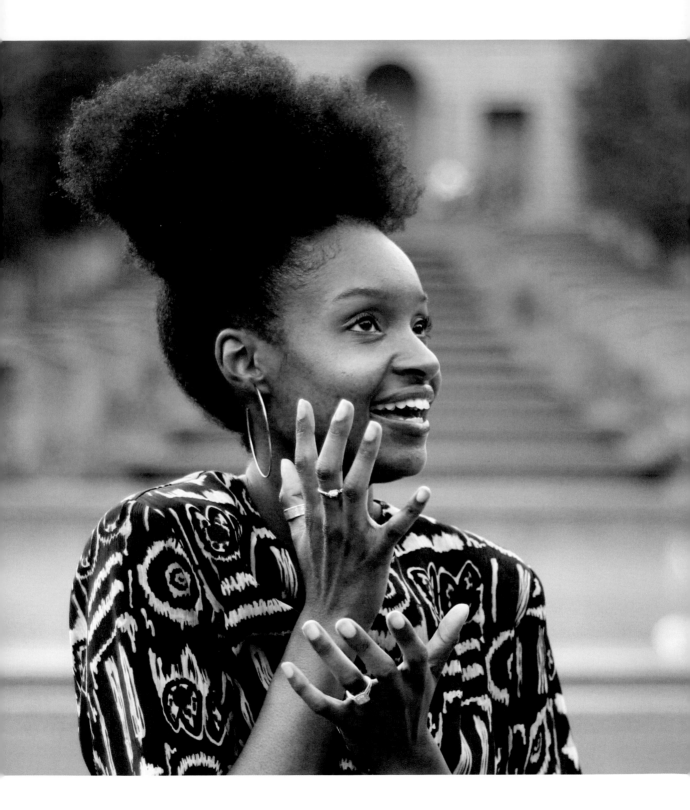

I was obsessed with this L'Oréal commercial for a no tears shampoo. They had these children washing their hair outside on a little slip and slide, and I was like, *I want that shampoo*, because one of the little girls who washed her hair with it had loose curls, and I wanted her hair. So I thought, being only seven or eight, if I bought the shampoo, that my hair would look like that. So I got in the bathtub—which was a big ol' pool to little me—and I was just swimming around. But when I finished washing my hair, it didn't look like the girl's loose curls from the video. I didn't cry, but I was really upset.

And that's just an example of, you know, the media's impact on everyone. It's there, whether we want to see it or not. So whether it's TV or films or social media, really all of the images that we're fed don't look like this— like me, like women with tight curls. And especially when I was younger, if I *did* see someone who looked like me, that person was always cast as a negative person. Somehow that person was wrong. That's definitely a thing: lighter is better. But it's crazy because our culture is exploited all the time. So it takes a lot of un-brainwashing to be like, *The women I see in the media are beautiful, but they don't represent the only form of beauty*. I do believe Black women have it hard, don't get me wrong, but **there's still an avenue to self-love** for us.

MALIKA BENTON

I traveled a lot for gymnastics when I was little, and I only knew how to handle my hair when it was straight, so I'd relax it every month or two. I was the only Black person on my team. Being surrounded by white girls with straight hair made me see straight hair as more "appropriate" in society. But then when I got to college, I cut my hair freshman year—my first big chop. I let it grow for two years, and then I started relaxing it again because I still didn't really know how to handle my natural hair. But then senior year, I cut it again—my second big chop. And this time I stuck with it. I learned how to take care of my hair. And I don't care to straighten it anymore. **I like letting it free and seeing how big I can make it**. Now I feel like my natural hair just better describes who I am.

EBONY WALTERS

216

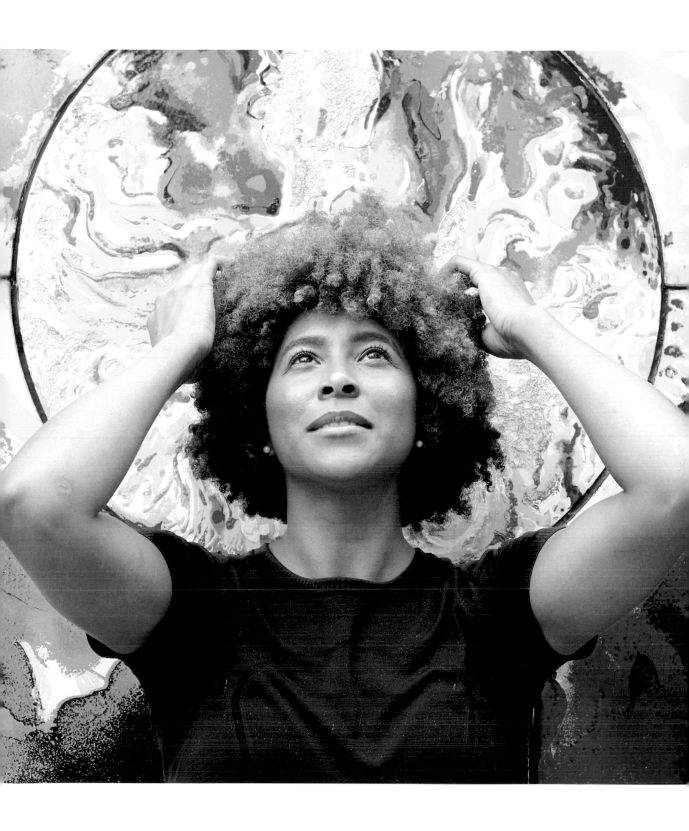

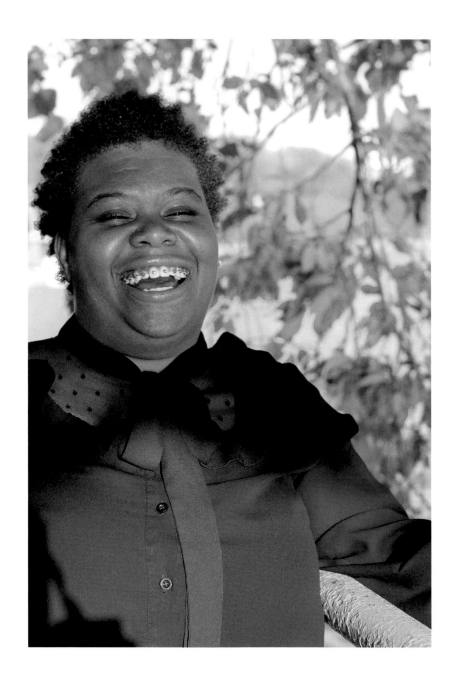

Dear **Khloe**,

Stand on the principle of who you are. If there are people who don't accept you, then that's on them. Their loss. Remember who you are on the inside: a genuine, loving, caring person. And you're capable of doing anything you want. The rest of the world is your masterpiece; all you have to do is paint.

Your sister,
Maya

I was working at a catering job. I knew I had to put my hair back since I was dealing with food, so I had my hair slicked back in a high bun. My supervisor pulled me to the side and said I needed to do something "different" with my hair because it was "untidy." I didn't really know what to say. I didn't like how it felt. I was like, **I don't really need the money that bad if I'm gonna feel this way coming to work**. So I no longer work there.

That was just an on-campus job though. I get nervous about having an office job. If I were to go into an interview with my 'fro, I have to think about how they're gonna perceive me if it's a predominantly white workplace. I don't want them to view me as different because I have a big 'fro, but I also don't want to hide my natural hair. Because it's not "unmanageable," and it *is* professional. And I do want to lead by example and show little girls growing up today that their hair *is* normal and they shouldn't feel forced to straighten it. It's just a lot to think about.

ASHLEY NICHOLSON

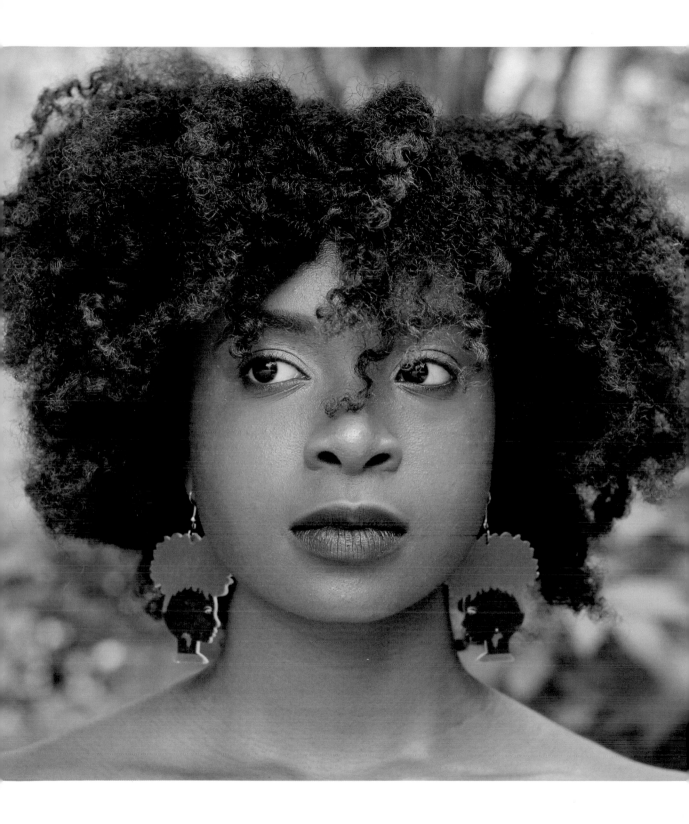

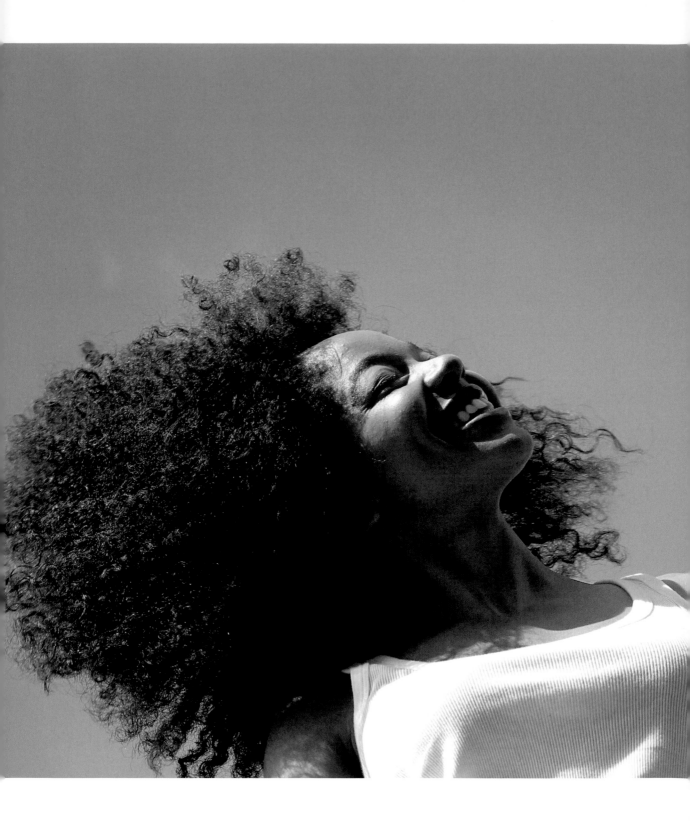

When I cut my hair, a lot of people thought that I was doing the big chop and cutting off damaged hair. But really, I had just cut it so I could donate it. Not a lot of Black women donate their hair. I think a lot of us feel like, *Who would want my hair if I donated it?* But imagine you go to Locks of Love, and you're a little Black girl, and you get a white woman's hair that doesn't fit the hair that you would naturally have. It's important to have the option of curly hair, **and for that option to be seen as beautiful**.

DAJAH MASSEY

Dear **Khloe**,

Being yourself doesn't mean that you're bringing somebody else down. In fact, by you showing who you are, you're actually giving others permission to be themselves too. So let your hair do what it wants. I've been leaving my hair out lately because I realized I was hiding it too much; I wasn't fully embracing the fear of not having a perfect 'fro all the time. But you *can't* have a perfect 'fro; your hair's not supposed to be perfect. You should love it because it's *yours*. Don't try to change it. Like today, I wanted my hair to be big and in a 'fro, but it wanted to be more flat. And you know what? I still love it—because it's *mine*.

Your sister,
Rosa

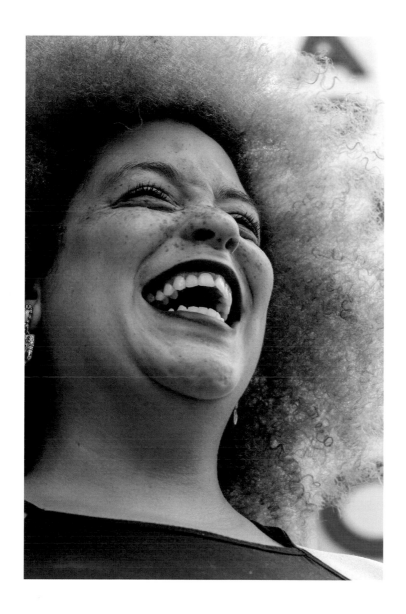

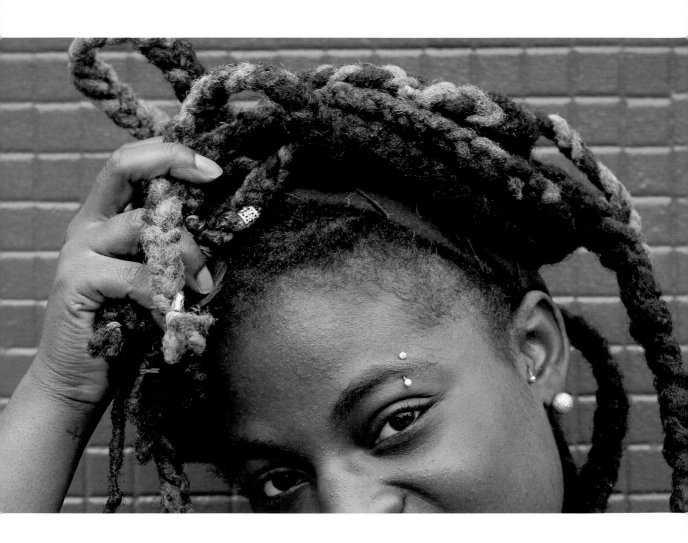

It was an idea from my older brother. He said I should start my locs, so I went with it, and ended up loving them. My locs fit my personality: All I gotta do is get up and shake. Some Black women are worried that they won't get good jobs because of their natural hair, but not me. The only way I'll cut my locs off is if I get a bald spot. [Laughs.] I wanna be an accountant, and if there's no firm that will accept me with dreads, then I'll start my own firm or change careers. **Because no career is worth my hair**.

DE'NEA BARTON

Our moms tend to have a lot of influence on us, and my mom has had her hair relaxed since before I was born; I've never seen her with her natural hair. She's always impressed upon me the need to present myself a certain way. She's a federal government attorney. She yelled at me in elementary school, saying, "Be careful, because you know that teacher is gonna treat you differently than the white kids." And that applied to my hair. Because a white person might see a Black girl with a messy hairstyle and automatically see "unkempt," whereas a white girl with the same messy hairstyle is "chic."

This mentality stuck with me through college. When I transferred from Penn State to Barnard College, I felt like I was in a prestigious place and was surprised to see people in sweats and leggings; I realized that they weren't worried at all about their presentation. They'd feel comfortable walking up to the professor and asking for all sorts of extensions, but I'd be worried that they'd think I was slacking if I asked for extra time. Or whenever I had a presentation in class, even though no one was expecting business casual, I still would never just wear ripped jeans and a T-shirt. **I feel like there are so many extra layers to physical presentation for Black girls, whether that be how you do your hair or how you dress**. And I was always told that I needed to present myself well and behave in a way that would give me the best chance of being treated with equal respect.

Sometimes when I speak out about social justice, my mom's like, "Stop, you're doing too much." But I have to. I keep thinking about all the recent studies that have proven what we already know about the policing of Black bodies and of Black kids in school: that we're punished more often and suspended at higher rates with ridiculous proportions of aggression. We're prone to being sent to the next level of authority. We've seen kids in the news who've gotten in trouble for wearing braids and locs in school. Everything just begins so early, whether it's corporal punishment or administrative punishment in school or just being taught that your body—including your hair—is not OK.

I do still have some of these ideas of what it means to look and act "presentable" or "professional" ingrained in me, but I'm more grounded now. I've unlearned the idea that I have terrible, "unmanageable" hair. In fact, I don't even own a flat iron.

CHRISTIE HOYTE HAYES

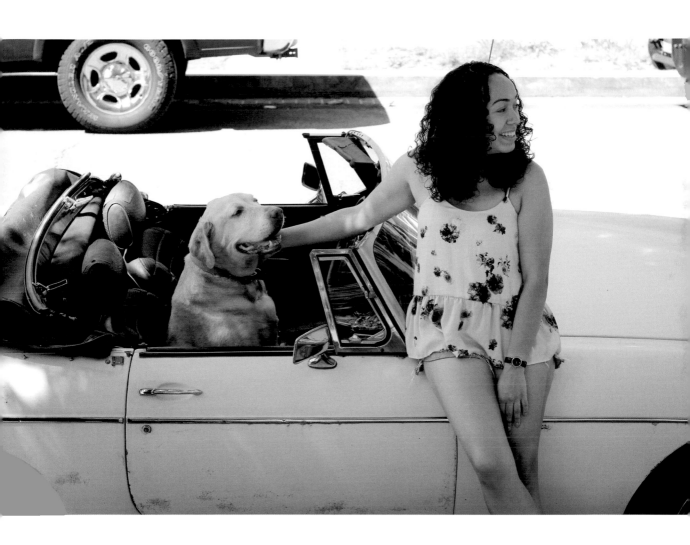

Liber

ation

"I felt restricted when my hair was straight;
I felt like I was a slave to the heat."

I would tell my younger self not to internalize anything negative, and to understand that you are beautiful no matter what anyone says. Every time I go through a challenge in my life—like moving to the United States and not having my mom with me—one of the first things I do to free myself and to release is cut my hair. Because I feel my best self when I'm bald. **I feel indestructible**.

ADEOLA ADEBAMOWO

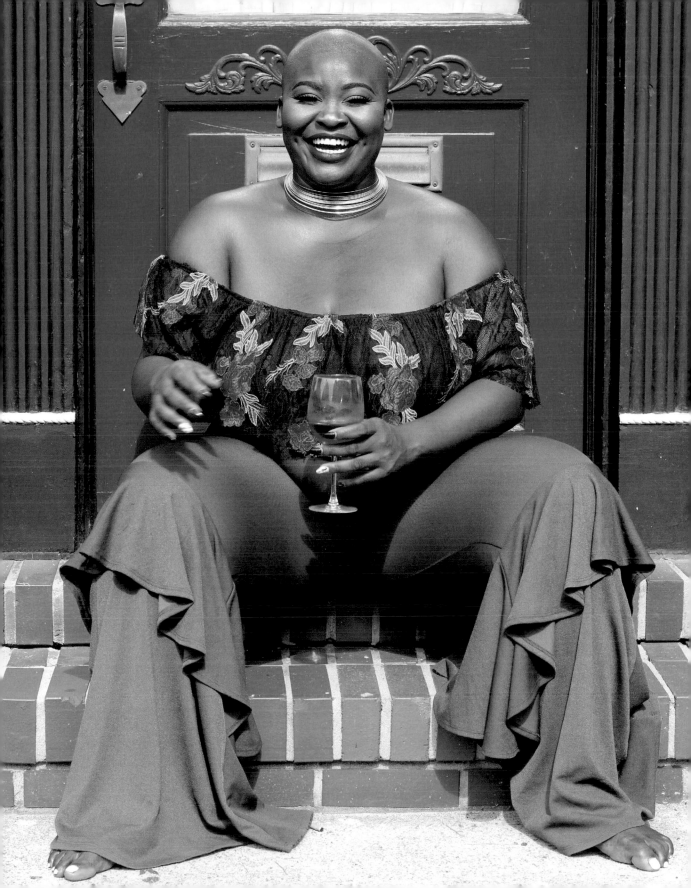

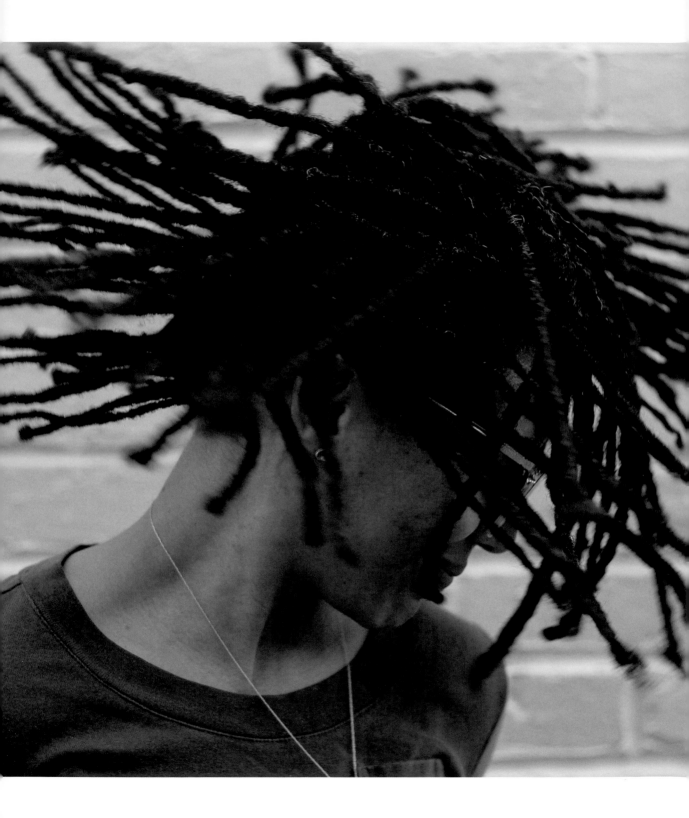

I felt restricted when my hair was straight; I felt like I was a slave to the heat. I was tired of having to do my hair in the morning with a hot iron and a curling iron and I was getting just more unnatural in my health in general, so I wanted to go natural. I also liked the idea of having my hair in one hairstyle and potentially not really having to worry about it every morning, so I chose locs. Then it got to the point where my locs were really long. They were quite heavy, and when I would sleep they would just itch the side of my face sometimes. I was tired of it, and so I decided to shave them off. And then I realized after I shaved my head that I didn't really know what to do once my hair grew back, so I grew my locs back again. But I don't put too much weight into my hair. I think that's why it was so easy for me to shave my hair when it was bothering my face. Some people would think that that's extreme, but I don't necessarily feel like my hair is a huge part of my identity. I think **it's another display of creativity**—like clothes or shoes. And again, if I get tired of it again, I'll probably shave it off or chop the back of it or something. Who knows? I don't know. I just like kind of playing around with it, just like I do with most things in my life. It's an exploration.

CANDY SCHIBLI

We don't want to recognize our tragedies as mistakes. I know there are racial issues everywhere, but I feel like it's different in America because no one likes to talk about it. So when you *do* bring up race, people get uncomfortable. They're like, "Why does everything have to be about race?" It's very frustrating. I'm tired of people getting upset when I bring up race; *I'm* upset about racism. Growing up, I even dealt with colorism from my own family members.

My maternal grandma always put my cousin who's half Indo-Trinidadian, half Black on a pedestal. She'd say things like, "Oh my God, look at that hair!" because my cousin had curly hair—not an afro like me. And then my paternal grandma always seemed to like my cousin who's half Panamanian, half Black better. I didn't care at the time, but now I can't help but think that she treated me differently because I'm darker. Colorism is like a disease, and I don't think it's gonna go away until we get rid of Eurocentric beauty standards. I was also constantly being called "fat" by my family members because I had hypothyroidism and I'd gained a lot of weight in middle school.

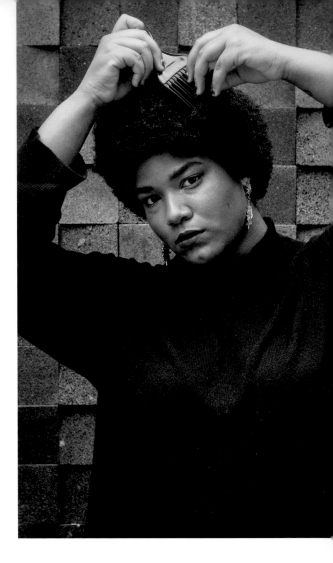

I'd say I really started thriving when I went natural my senior year. The lady at my hair salon wanted me to keep going back to her to get my hair straightened, so she told me that my hair wasn't damaged. But I knew it *was* severely heat damaged, so I did the big chop. It was really liberating. By my junior year of college, my afro was huge. I decided I wanted to try something different, so I dyed

it blonde, and then magenta, and then blue. My hair didn't take the blue well. There were literally clumps of my hair falling out. So I tried to cut it all off myself because it was so damaged, and I had a meltdown afterward; I cried myself to sleep that night.

I ended up getting my hair buzzed professionally, *short*-short—shorter than after my first big chop. It took me a while to get used to, but I *loved* it. I really had to learn to love my face—and the rest of my body—because I no longer had my hair to rely on. And my hair is growing now. It's healthier than it's ever been. It's thicker and it's softer. I'm really proud of my hair. As a substitute teacher at a high school, I feel like my presence is important in the classroom. Because I know that I didn't *have that in high school, and* **I don't want other little Black girls to have self-esteem issues like I did.**

BRANDI CLARKE

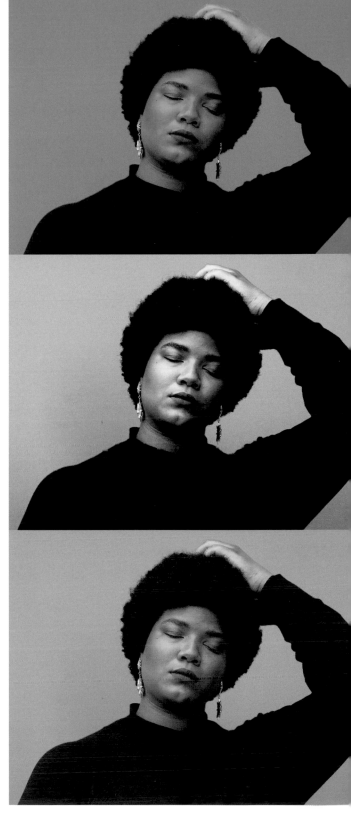

Nowadays, you don't see too many kids going outside and having fun, but that's all I wanted to do when I was a kid. I didn't even *think* about my hair back then. I have three older brothers, and my parents raised me the same way they raised them: watching football, going outside, playing sports . . . I know this might sound crazy, but I used to play in the dirt and make little mud pies and pretend they were actually food. I was a very carefree child; I did not care what my hair looked like, did not care what I looked like. All I cared about was being happy and surrounding myself with loving people. If I was sad, it was because a friend was going home after a playdate, or because it was too dark to play outside—not because of my hair. So **my family never had to remind me to love myself** because I always have.

HANNAH M. CHILDRESS

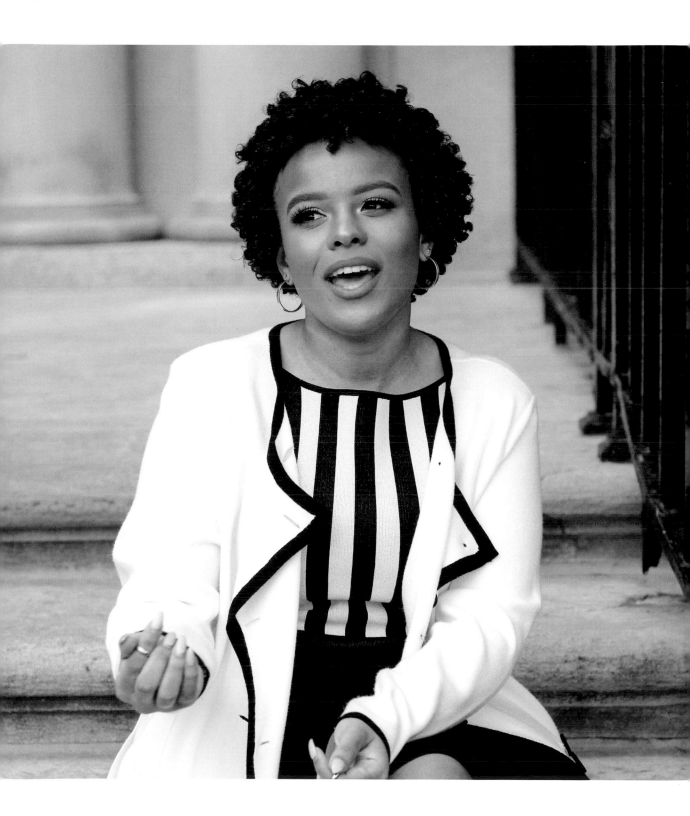

My parents were already in America, but I was still in Gambia. I was four or five—right in that ego stage—when my aunts, unbeknownst to me, started perming my hair. They didn't have bad intentions, but the unfortunate part is that I was too young to make that decision on my own. They conformed *for* me. And this was the time when my mind was developing and I was starting to figure out my identity and hear that little nagging voice in the back of my head telling me, *This is what you need to do to fit in.* But loving yourself and fitting in are two very different things, right?

Learning to love myself was a process. As I grew older, I started stepping back, gaining spiritual awareness, and understanding that I had to push my ego aside and focus on myself. One day, one of my aunts asked, "Do you wanna try bleaching your skin?" I think that did it for me. I was like, *No, I'm never doing that—and now I have to go the extra mile to prove that my natural self is beautiful.*

Because I never had reassurance that I was beautiful as a kid, I know how important it is for kids to be told that they're beautiful—especially Black and Brown kids. As a teacher, I know that children are always watching, so I never want to give off the impression that I'm not happy with myself. It's important to lead by example. And my students have a field day whenever I come in with a new design in my hair. I've had a heart, a lightning bolt, stars, one line, three straight lines—the students had fun practicing their counting with these lines. I just let my hairstylist do whatever she wants to my hair. Because now that I've let go of the ego, **I've let go of fear**.

ADAM MBAI

240

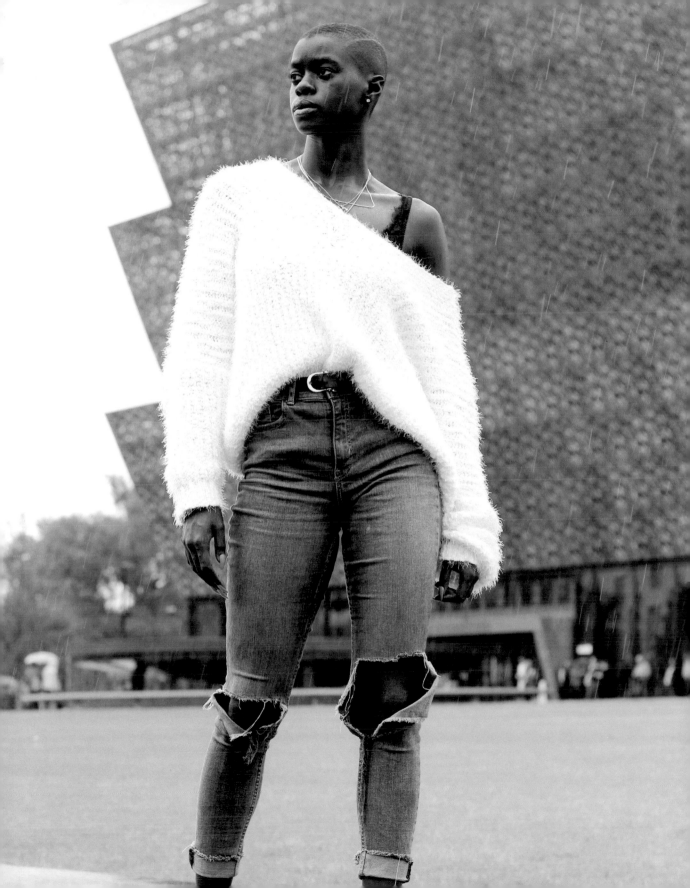

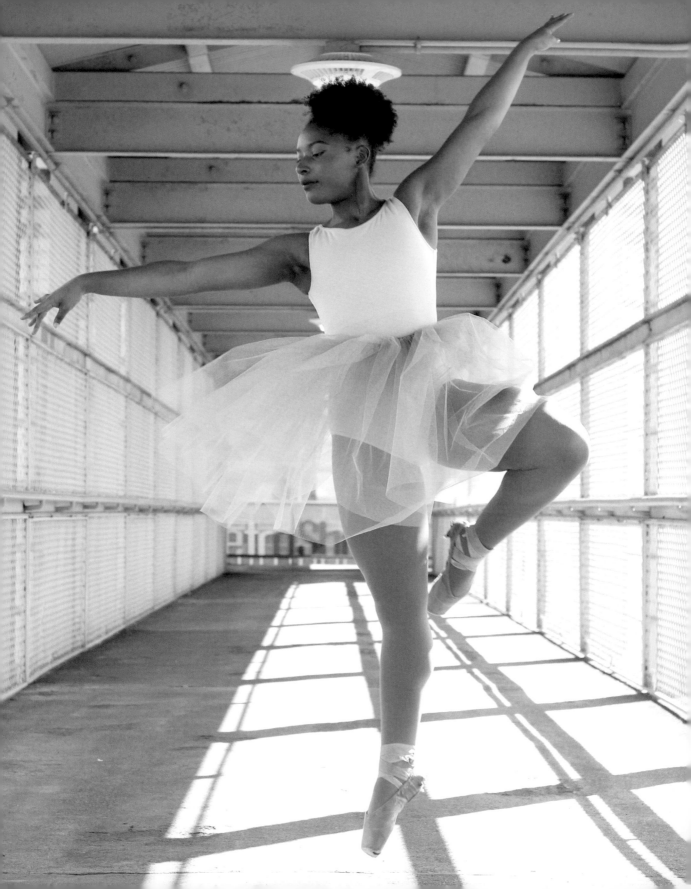

I've always been natural, but I haven't always loved my natural hair. I always wanted my hair to be straight when I was younger so I could pull it back into a bun like other ballerinas. But as I grew older, I've learned that in order for me to move on and become successful, **I have to embrace my beauty**.

SAGE SARAI

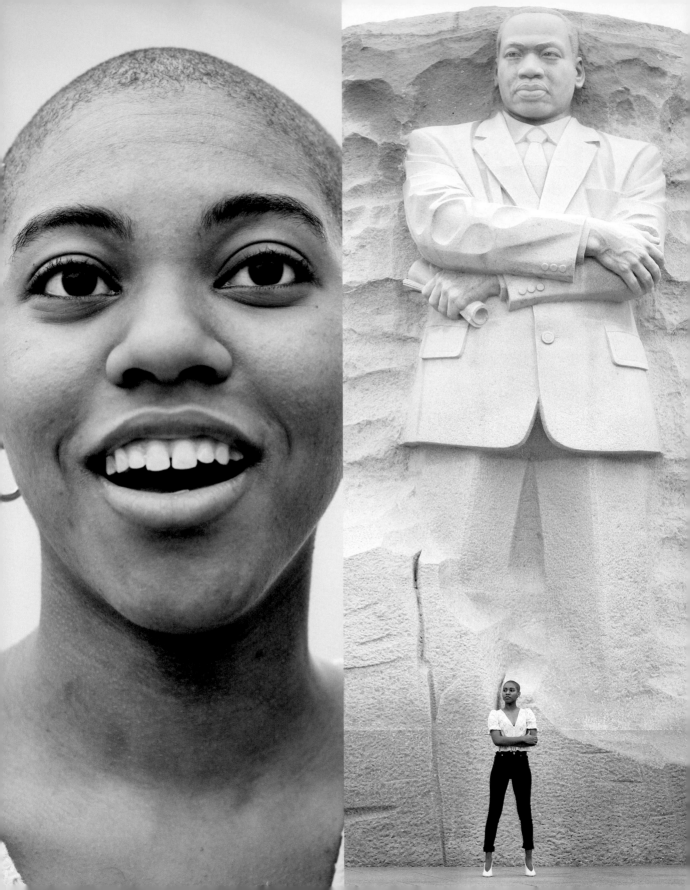

I started my natural hair journey about four years ago. I did the big chop going out of high school and into college, and I let my hair grow freely in its 4C-afro state. But eventually all the stress of going to class, having a job, and being in student government caused me to self-inflict harm; it mainly just had to do with me plucking out my hair. So it's almost like this thing that I loved— or that I was told to be proud of—was what I was ripping away. Or at least that's how I was expressing my anger, frustration, and stress that came with starting college and being on my own.

I ended up enrolling in the St. Baldrick's Foundation, and my mom enrolled with me. Once you join, you vow to shave your head if you raise a certain amount of money for children with pediatric cancer. So I reached my goal, and the day came where we all sat in the field and four barbers came to shave the heads of those of us who'd reached our goals. That day was monumental not only because I shaved my head, but because my mom and I were able to come together to do this one thing for a child in need. My mom wasn't into the idea of shaving her head because of the whole beauty standards thing for women, of course, but she did it anyways to support me; she showed up for me and let me know that I wasn't in this alone, and that brought us so much closer together. So shout-out to my mom, Jacqueline Thompson.

But the stress hasn't stopped. So instead of picking out my afro, I now shave my head once every two weeks. It relieves my stress because it allows me to check in with myself and shed the superficial things. You know? Like yes, we are telling young women of color to love their bodies, love their skin, love their hair. But self-love comes in many shapes and forms. And I think that embracing what you have is important, but also being able to rid yourself of something that's almost held against women by forms of media and by the patriarchy is equally important. And **I feel liberated every time I shave my head**; being constrained to fit into this box that other people tried to choose for me is no longer my life.

ZOEY NEEDHAM

I've been rocking the locs. I had to get rid of them when I joined the military so I combed them out, but now I've gone back to my locs because it's the easiest hairstyle. I like to spend all my time working on my craft, so having my hair in locs just means I have one less thing to worry about. Spending extra time and money on my hair makes me feel less free. So I like the freedom my hair gives me now.

I'm a strong advocate of India Arie's "I Am Not My Hair." You have no control over your hair; it's genetics. If it's gonna be curly, if it's gonna be straight, you don't have a choice. Like a lot of times when I don't wear a scarf at night, my hair gets a little crazy, and it changes my outer appearance, but I notice that my inner appearance never changes with it. So **I'm still me at all times**. And if someone wants to see me a different way, then, you know, it shouldn't affect me, because then that means they never really saw me for who I really am.

EBONY STURDIVANT

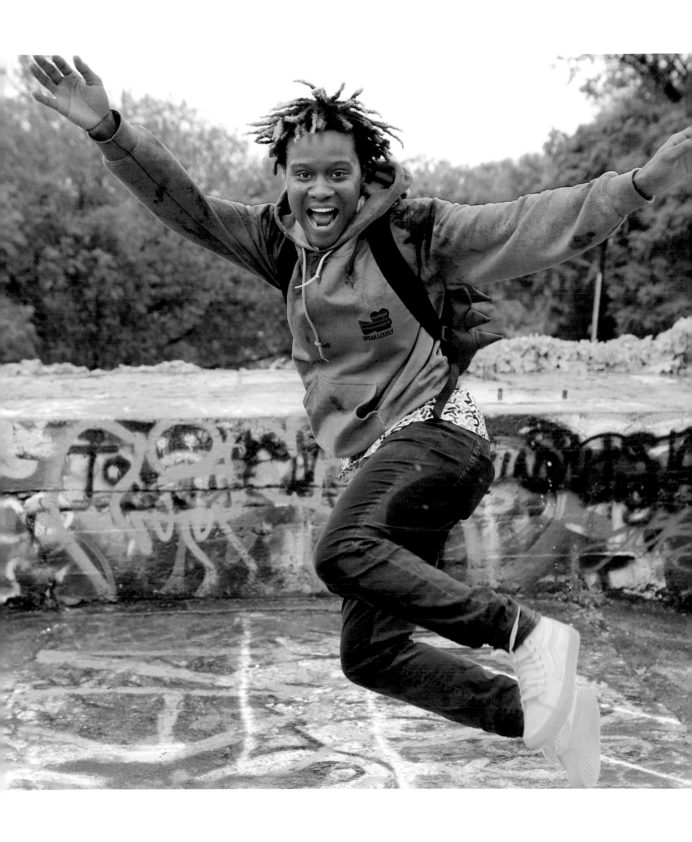

My mother's family—who's fully Salvadorian—never really made me feel any different or any less. They didn't care that my hair was different from theirs, but it was difficult for them to manage and comb my hair when I was little because they weren't used to my hair texture. And then on my father's side, my Dominican grandmother always pushed for me to get perms. So everybody on both sides of my family thought that perming my hair was the best option—including myself. Because everybody on my Salvadorian side has straight hair, and everybody on my Dominican side straightens their hair. So there was a time in my life when I was constantly getting my hair straightened too because **I thought that's what beauty was**; I thought that's what *beautiful* meant.

But as a volunteer in the Peace Corps in Panama, I didn't make enough money to get my hair straightened. And also I was living in a really rural community and the Panamanians where I lived were mostly Indigenous and mestizo and had straight hair, so they didn't know how to treat my hair or blow-dry it or flat-iron it. So I was just natural: no heat for two years. And now with this new natural hair movement that's been on the horizon lately, I feel way more comfortable rocking my curly, bushy, puffy hair. It has a mind of its own, but I love it. I can exercise without caring about the sweat messing up my edges. To this day, my Dominican grandmother still asks me, "When are you gonna go to the salon? You need to look presentable." But in reality, I *am* presentable. And I'm breaking barriers every day.

BIANCA MARTINEZ

248

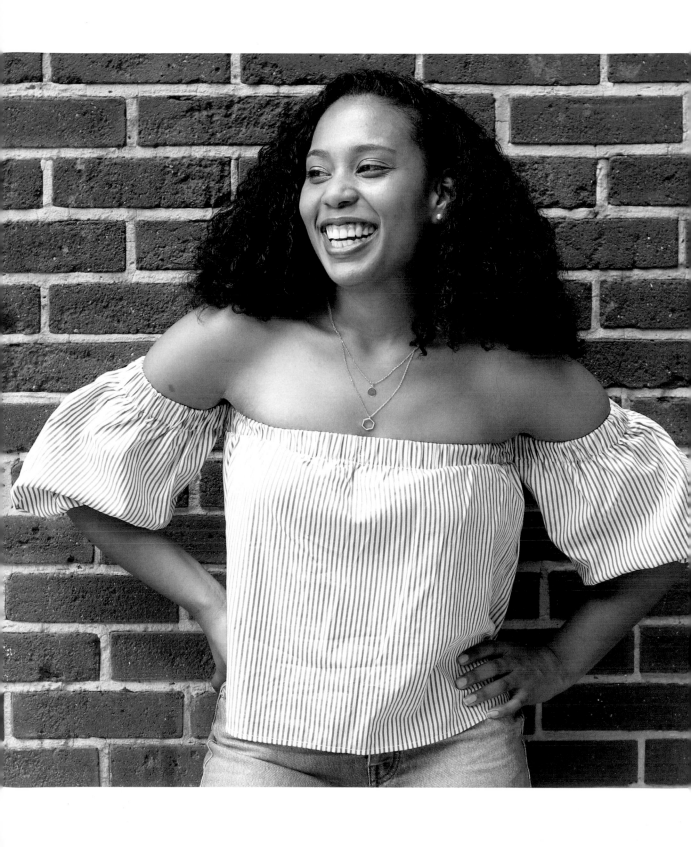

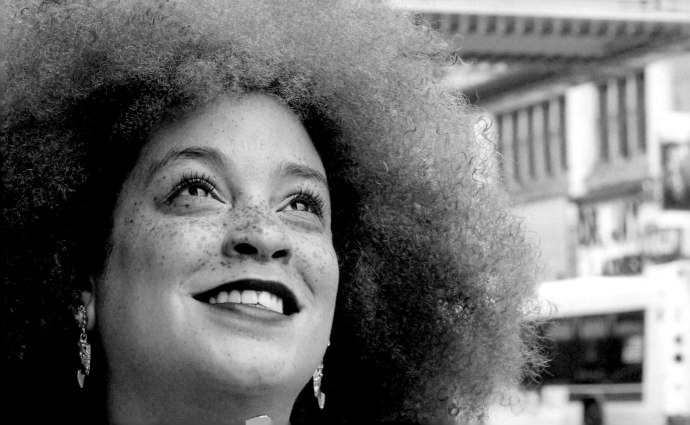

You can't just do it on your own; like everything else in life, you need some-one to guide you—and for me, that was my cousin. She was like, "Why do you keep dyeing and straightening your hair? This doesn't make any sense." So I decided that if I didn't complete this thing I was working on by a certain time, I would shave the side of my head. I didn't complete it on time, so my brother shaved the side of my head. It looked cool, and I loved the half-shaved look—with long, straightened hair. But then as the shaved side started growing back, I decided that I didn't want to relax my hair anymore. A year later, I had transitional curls: My hair was curly at the top, and then the bottom had all these dead, straight ends. But I didn't want to cut off the bottom half because I was so scared of having short hair.

But one day I was taking a bath and remember thinking to myself, *I keep telling people I'm scared to cut my hair. Why am I speaking fear into my life?* So I just got a pair of scissors and cut all the transitioning hair off. As I was cutting it, I started loving it more and more.

My mom would say, "I don't understand what you're doing with your hair this year." But I just ignored it and kinda went my own way. I tell people that I lived for my parents for twenty-five years: I went to school, I got good grades, I got a good job. And then at twenty-six is when I decided to just do me and live my own life. Everybody had been on me about losing weight, but the moment I stopped caring about my weight, I started to embrace myself. **And in that process, I embraced my hair**. And that's when I *really* felt free. Some family members still have issues with my hair at times, and they'll be like, "Oh, what are you gonna do with that pajón?" Like, they say, "That big 'fro, what are you gonna do with it? It gets in the way, it's a mess." And the more they say that, the more I love it. I just make it bigger and bigger every time I go see them.

I like that my hair stands out. People can like it or not. This is who I am.

ROSA BAEZ

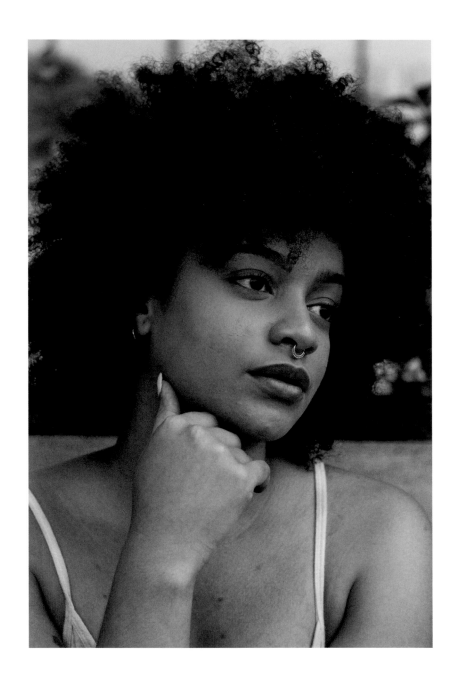

Dear **Khloe**,

I mean, Khloe, I was you once. It was hard to believe myself to be worthy when the people around me convinced me otherwise. But you gotta understand that difference is always going to be frowned upon initially, and you're growing up and you're sprouting and things are gonna change, and your hair's one thing that's always gonna stay with you. That texture, the process—it's all healing. And as you grow up, you're gonna learn to love it. Because everywhere you go, you are going to turn heads. You don't look like everybody else, and you're not *meant* to look like everybody else.

Your hair's a gift.

Your sister,
Keyla

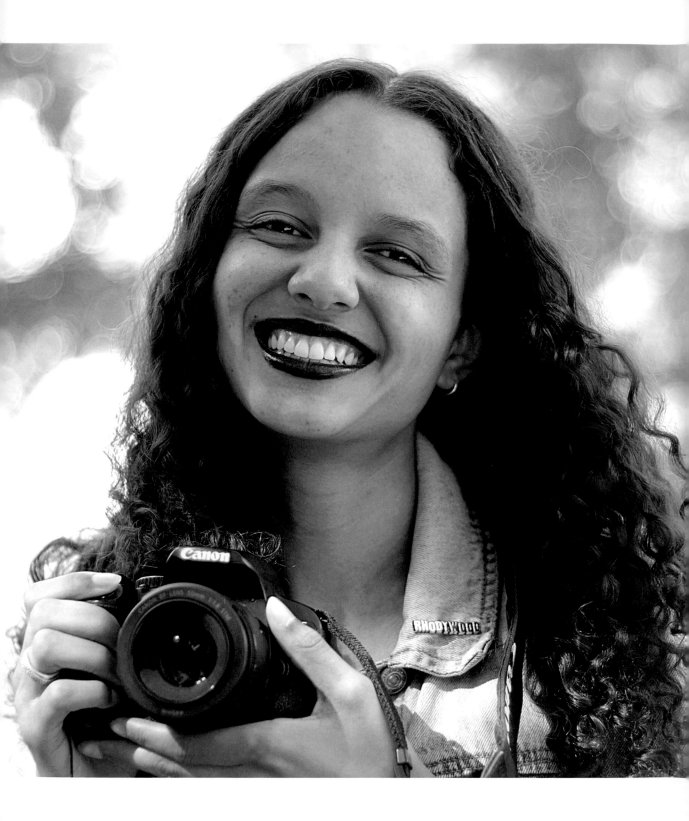

Thanks

I'm grateful for my beautiful little sister Khloe, for whom this book was created, for inspiring me to delve deeper into the beautiful yet complex topic of Black hair.

I'm equally grateful for the rest of my family. My mom spent months sitting next to me in front of my computer for ten hours at a time, helping me piece together my photos and interviews. My husband, Victor, an electrical engineer who somehow knows how to do everything from setting up tripods to using Adobe InDesign, was my go-to person whenever I needed support. My dad, stepmother, and two other siblings—Kenzo and Zoé—consistently sent me their love and encouragement from France.

This book would not have been possible without all the Black women who agreed to be a part of it, who offered me their time and their vulnerability as they let me record their natural hair stories and photograph them—and never complained about standing for hours under a hot sun, or in the middle of thunderstorms, or in the freezing cold. There would be no book without these women and the sister-hood they showed to help a young Black girl on her journey to self-love.

Daniel Honemann, Turiya Vallis, Naïma Msechu, and Alice Markham-Cantor and her family all helped immensely throughout the process of creating this book.

Finally, I'm forever thankful for my agent, Rita Rosenkranz, who believed in this project and took me under her formidable wing and gave me all kinds of great ideas, without which this book might never have been. And it was Rita who brought this book to the doorstep of Chronicle Books, where I met the truly brilliant and deeply thoughtful editor Deanne Katz, as well as the talented Vanessa Dina, who brought her design genius to the book. Thanks also to AJ Hansen, Cynthia Shannon, Magnolia Molcan, Cecilia Santini, Maddie Moe, Meghan Legg, Barbara Genetin, Joyce Lin, Shasta Clinch, Pat Morris, Tami Schwartz, and everyone else at Chronicle who helped this book come to life.

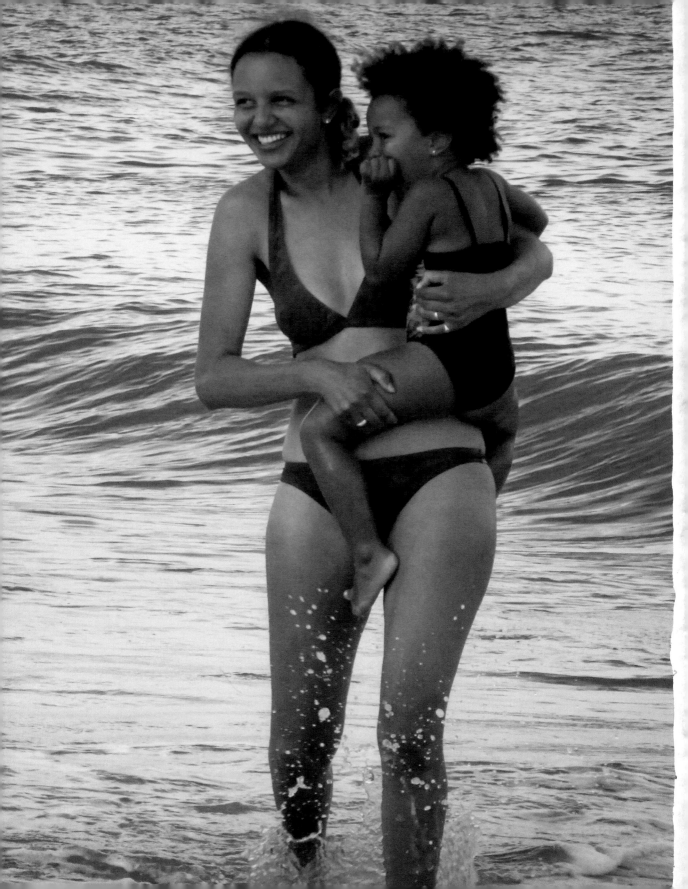